KU-720-800

NEW YORK AT NIGHT

1

JS10040083_Text F1 B 00:28:49

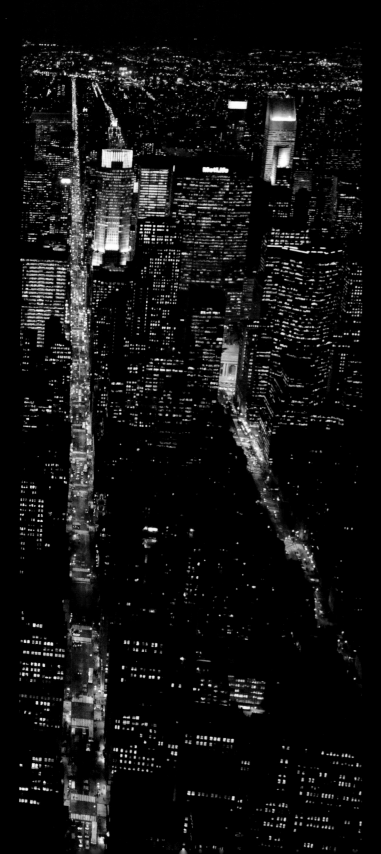

NEW YORK AT NIGHT

JASON HAWKES

TEXT BY CHRISTOPHER GRAY

MERRELL

LONDON • NEW YORK

MORAY COUNCIL LIBRARIES & INFO.SERVICES	
20 30 93 81	
Askews	
917.471002	

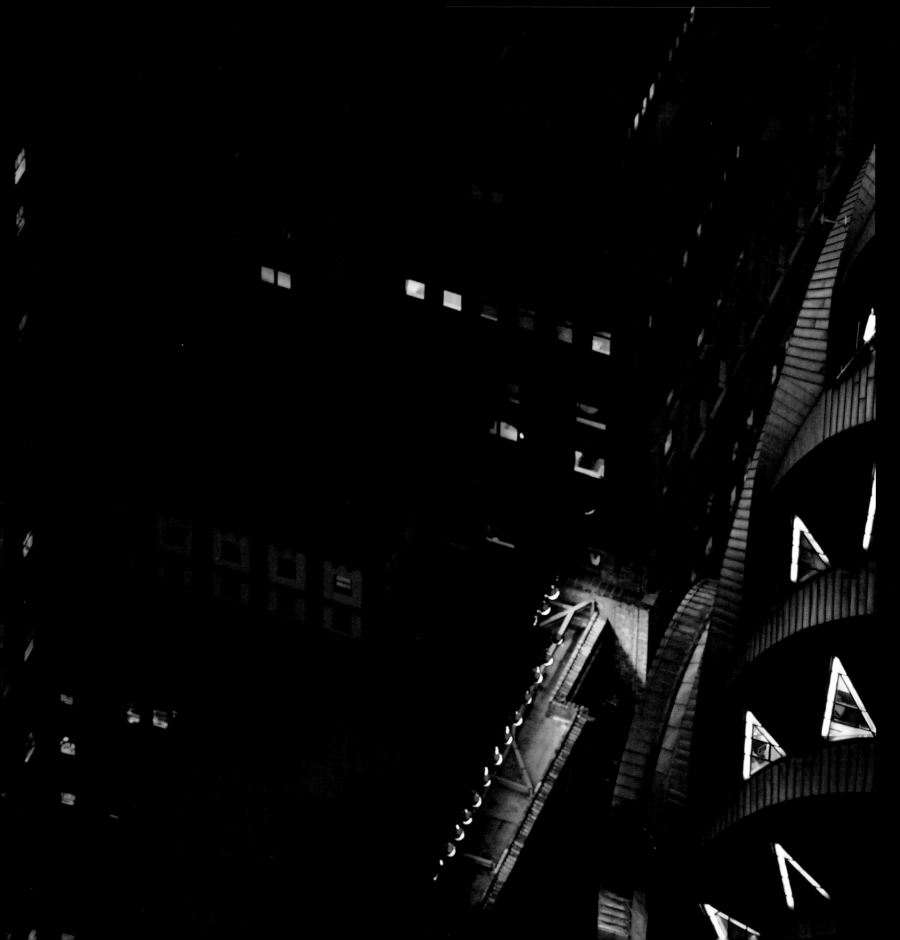

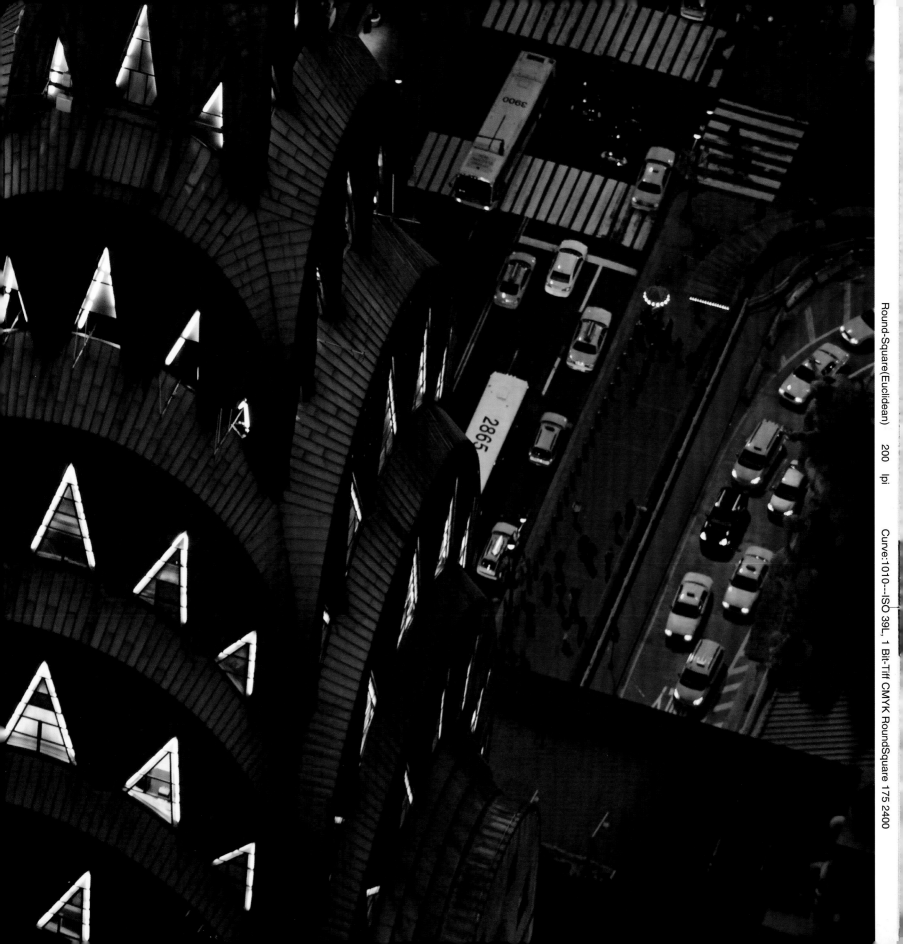

Round-Square(Euclidean)　　200　lpi　　Curve:1010---ISO 39L, 1 Bit-Tiff CMYK RoundSquare 175 2400

From the air, night is a blessing for most cities. The darkness wipes out the wretched, ragged roofscape of air-conditioning machinery, cell-phone towers, tar beaches, and similar litter. In the daylight, from ground level, almost any city has variation and life, but in the air you quickly see that architects design their buildings to be seen from the ground.

The dark also conceals that awful, itching plague of cities: the automobile. By day, they overrun the streets from curb to curb. But from a helicopter, after sundown, they are transformed into strings of lights, like a conga line of red-and-white fireflies.

This is how Jason Hawkes has transformed New York, from Hyde to Jekyll, simply by changing his flight plan to the off hours. He has metamorphosed a city of parking lots and metal-choked roofs into a mysterious web of twinkling lines and occasional flares of color. The actual pattern of Manhattan's relentless grid system doesn't show off that well. But after dark, from on high, the sweeping, ancient pathways of the main roads of Brooklyn, Queens, and the Bronx spread out like the routes of the American Indians and the explorers who first saw a similar pattern, a landscape empty of buildings, just threads of travel.

It wasn't until the late seventeenth century that house owners were required to hang candles outside their homes on moonless nights, and by the mid-eighteenth century oil lamps were installed on a number of streets in built-up areas. But these could not possibly have interfered with the night sky: "sunset" still carried its original meaning. Thus, bellmen still patrolled the streets, ringing a bell and giving the weather report and the hour; by day, the sun is the workingman's clock, which stops after dark.

Gaslights edged into the market by 1810, and soon there were several thousand on the streets. However, they depended on the peregrinations of the lamplighter, and the flickering gaslight made barely a pinhole-sized dent in the night sky. Thus, an account in the *National Advocate* in 1822 reported that "a brilliant, beautiful meteor passed over this city and proceeded majestically over the intersection of Maiden-lane and Nassau-street, visible for 10 or 15 seconds." These days, it would take a supernova to attract

attention on the street; except to mariners, even the phases of the moon are irrelevant in New York City.

Likewise, it's doubtful that anyone today could make $18 in one evening by offering views of the stars from Chambers Street and Broadway, as did the theatrical manager Sol Smith in 1824—when a dollar was worth a dollar. And still he had to turn people away.

Even in the Civil War period, as street illumination spread throughout New York, night was a sinful time, as in Matthew Hale Smith's moralizing *Sunshine and Shadow in New York* (1869). No streetwalker plied her trade at breakfast time, and no drunken laborer gambled away his family's money at noon.

Moral improvement seemed likely when Thomas Edison opened the first electrical generating station in 1882, on Pearl Street. Electric streetlights were the beginning of the end, if not for immorality, then certainly for the career of lamplighting and the dark skies over New York. The latter first disappeared over Broadway and then Fifth Avenue, where property owners had the most clout. In 1900, a librarian prefigured our current dismay over computeritis by lamenting that children now "know nothing of nature. Wild flowers—they rarely see them. They never see the stars, though the sky is above them—the street lamps blind their eyes." Even as it harbored sinfulness, darkness was also the last refuge of the natural world of New York. By 1920, the inefficient gaslights were gone, and true darkness finally disappeared.

There are a few—but only a very few—works of art depicting an outside scene after dark before the gaslight period. (Did any Renaissance artist ever paint the Virgin Mary at night?) But in the early twentieth century, an emerging cadre of photographers and painters saw night in a different way. Edward Steichen's foggy, misty photograph of the Flatiron Building from 1904, for example, depends on it. Likewise, New York's Ashcan school of artists—John Sloan, Robert Henri, and others—loved to paint gaslight crowds, lonely street scenes, and people backlit against illuminated shop windows. By the time of photographer Berenice Abbott's great documentary series of the 1930s, *Changing New York*, night lighting in the city was "normal."

In a parallel but popular aesthetic plane was another kind of canvas: the sides and tops of buildings, covered by advertising signs. In 1892, the city's first big illuminated sign flashed the message "Manhattan Beach/Swept by Ocean Breezes" from the site of the present Flatiron Building, at Twenty-third Street. This was succeeded by a Heinz company sign, a green, electric cucumber 30 feet long. Both were "unimaginable except in nightmare," said one critic; they were, perhaps, worse than the sin that accompanied darkness.

That the cucumber competed for some time with the patriotic Dewey Arch across Twenty-third Street, which stood between 1899 and 1901 to commemorate Admiral George Dewey, particularly incensed the critics of commerce. (The arch had been lit at least once, but with a demure string of white lights.) And just before the First World War, millions at Herald Square saw Roman chariots galloping past the billboards of whichever advertiser was willing to bear the cost.

Such giant displays, which could indeed be seen only at night, bathed the sidewalks, and even whole buildings, in light far stronger than any streetlamp could supply. At first, these adverts consisted of rather rude folk art. In the 1920s, however, they evolved into something more ambitious, such as the illuminated cascades of imitation water for American Standard, the bathroom supplier; and the 15,000 lightbulbs conveying spear carriers across a huge billboard on behalf of Wrigley's Spearmint gum. Both were in Times Square, where one could now read a book at night, with ease.

These electric spectaculars reached their creative summit in 1948, when impresario Douglas Leigh produced a block-long sign for Bond clothing in Times Square: a waterfall of colored lights running down the figures of a man and a woman, each 50 feet high. By night, the figures were obscured by the illuminated "water" tumbling over them; but by day, they appeared nude—a nice reversal of the nineteenth-century moral code.

Although advertising moved large-scale night lighting forward, non-commercial, even civic uses gently learned from it. New York's Hudson-Fulton Celebration of 1909 was a patriotic spectacular, with more than a dozen prominent buildings, including St. Patrick's

Pages 12–13

In 1609, explorer Henry Hudson arrived in what is now Upper Bay, seen here from the northeast; also visible are the southern tip of Brooklyn (far left), Governors Island (left, center), Staten Island (top, center), and part of New Jersey (far right). Although he noticed what would become Manhattan Island, Hudson was really in search of a northwest passage to the Orient. Of course, that didn't work out too well: as have many people since then, he stopped at Albany, roughly 135 miles to the north. Four hundred years ago, Manhattan was just a forested hummock in the middle of nowhere; today, many call it the center of the world.

Cathedral, outlined in light. But everything was white, massive firework displays providing the only color. Unsurprisingly, the Edison Illuminating Company—its electric service in bitter competition with Consolidated Gas—was a big booster of electrical displays.

Skyscrapers took up the lighting trend. Early photographs show both the Singer and the Woolworth buildings (1908 and 1913 respectively) with particularly ambitious electrical illumination. Together, they set out the alternate paths of architectural night lighting that persist today. The lighting of the Singer tower—a sheer, Beaux Arts-style skyscraper with a bulbous top—emphasizes the shadows and recesses of its intricate façade, with areas of light and dark set off dramatically against each other. But the Woolworth Building is simply awash with light, like a floodlit parking lot. Although impressive, it's a victory of candlepower over art.

It's the Singer approach that has triumphed, from the angled fluorescents in the triangular windows of the Chrysler Building to the moody, underlit effects on the Citicorp Tower. At first, the Empire State Building was lit with sheer white floods, without any real

artistry. In 1976, however, it began to use constantly changing ceremonial colors: orange for Halloween, red and green for Christmas, and blue and white for the Yankees.

It could be argued that the use of color is where New York lets itself down. There are some red navigation lights on the bridges, and a few of the towers, such as the New York Life Insurance Building, use gold. But with the exception of the Empire State Building, pretty much everything else is white, although that encompasses a variety of shades, all the way out to fluorescent and sodium vapor. It's a shame to note, too, that more recent structures, such as the Time Warner Center at Columbus Circle, have timidly kept to the straight and narrow, as if there were some sort of penalty for experimenting. One can only hope that, with time, attitudes to color will change.

All these things are hidden by day, and become clear only at night. Jason Hawkes has photographed New York as the first satellites captured the far side of the Moon. Everyone knew it was there, but no one had really seen it. *New York at Night* is like that: the other half of New York.

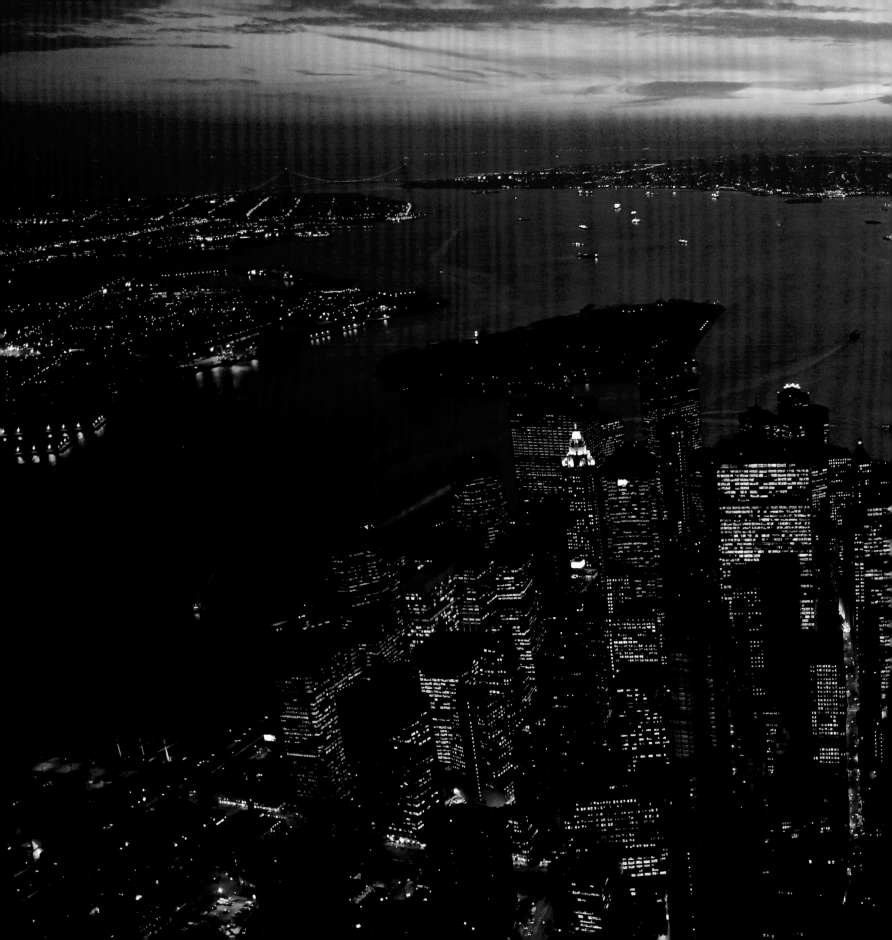

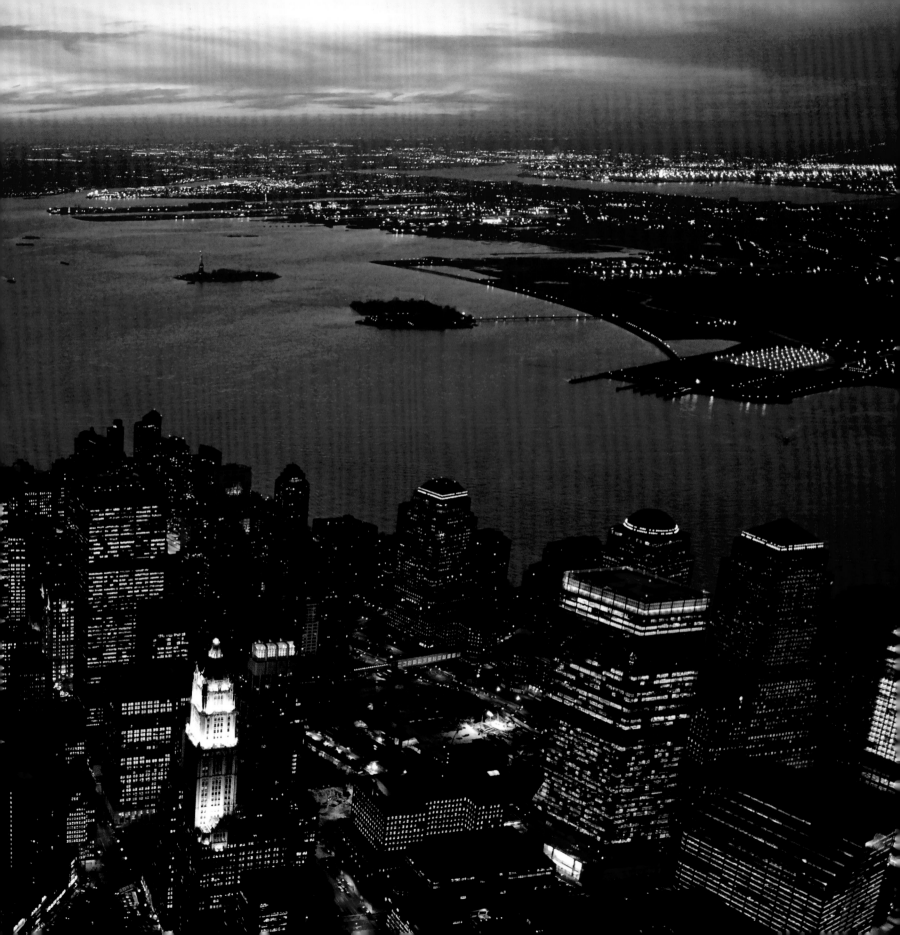

DOWNTOWN

For the first arrivals from Europe, downtown was the beginning. Indeed, the first actual settlers, the Dutch, lived below downtown: when they arrived in 1624, they set up on Governors Island, just off the southern tip of Manhattan.

Drawings from the seventeenth century show the downtown area as a city of gabled roofs and church towers, like a cute little town on the Connecticut shore. It gradually expanded outward into the harbor via landfill: the present Water Street, running along the east side, was originally the waterfront; now, it is two blocks inland.

At first, downtown was a movable feast. When there was a line of wooden stakes stretching from river to river across present-day Wall Street, what are now irretrievably downtown names, such as Tribeca, Soho, and Noho, were beyond uptown; in fact, they were no-town. As time went on, although downtown and uptown became directional signifiers, a consensus developed that downtown was below Fourteenth Street; that midtown stretched between Fourteenth Street and the southern edge of Central Park, at Fifty-ninth Street; and that uptown was north of that.

It wasn't until the late nineteenth century that the last real residents began vanishing from what is now the financial district. This included the above-the-store merchants still living in their brick warehouses/stores/dwellings.

The advent of the skyscraper began after the Civil War. Initially, the race to the clouds was a stately one, with towers reaching seven, ten, and then fifteen stories; by the start of the First World War, thirty or forty was the norm. Soon, the shipping, banking, finance, insurance, and other industries became synonymous with downtown, the large sums of money passing through their hands making taller and taller skyscrapers possible.

This influx of capital culminated in the World Trade Center, a project conceived in controversy, with the local Port Authority using the power of eminent domain to evict the surviving, and thriving, businesses of Radio Row and others from its multi-block site for what was essentially a private purpose. The original claim that the WTC would be only for "world trade" was soon forgotten, and it gradually emptied the older skyscrapers, leading to their decline.

Instead of revitalizing the office market, however, the destruction of the Twin Towers in 2001 accelerated an uptown migration of banks and financial companies, a flight from which downtown is still recovering, a decade later.

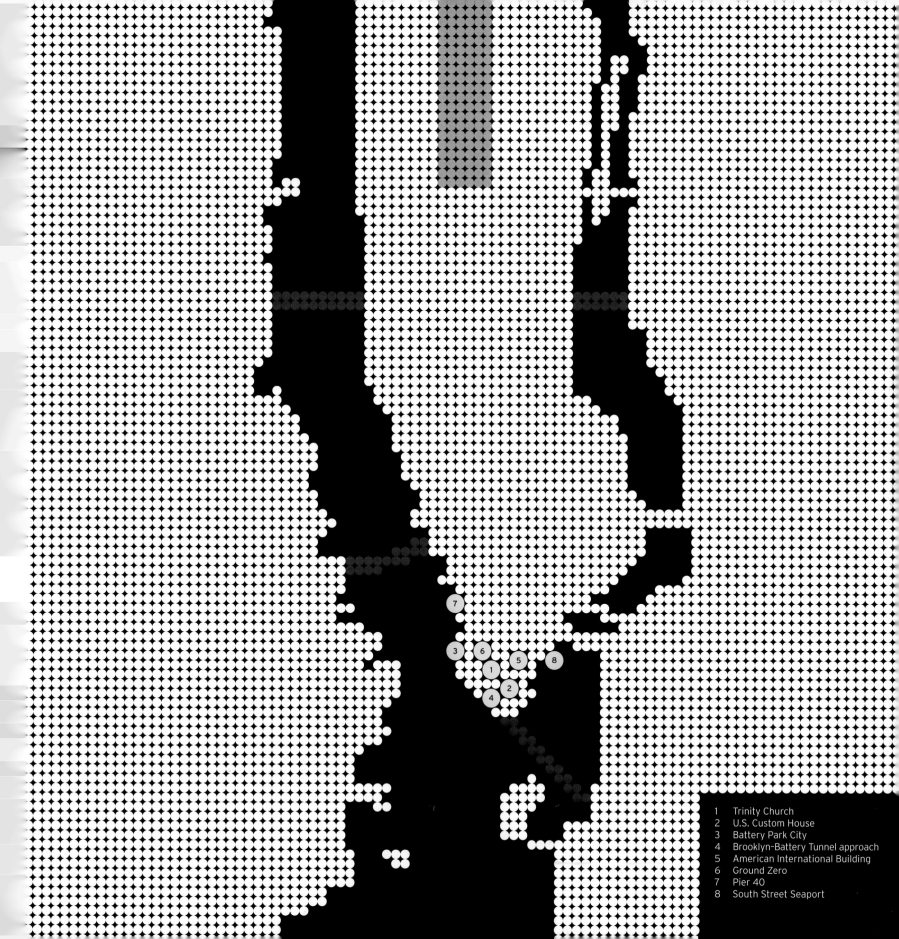

1 Trinity Church
2 U.S. Custom House
3 Battery Park City
4 Brooklyn–Battery Tunnel approach
5 American International Building
6 Ground Zero
7 Pier 40
8 South Street Seaport

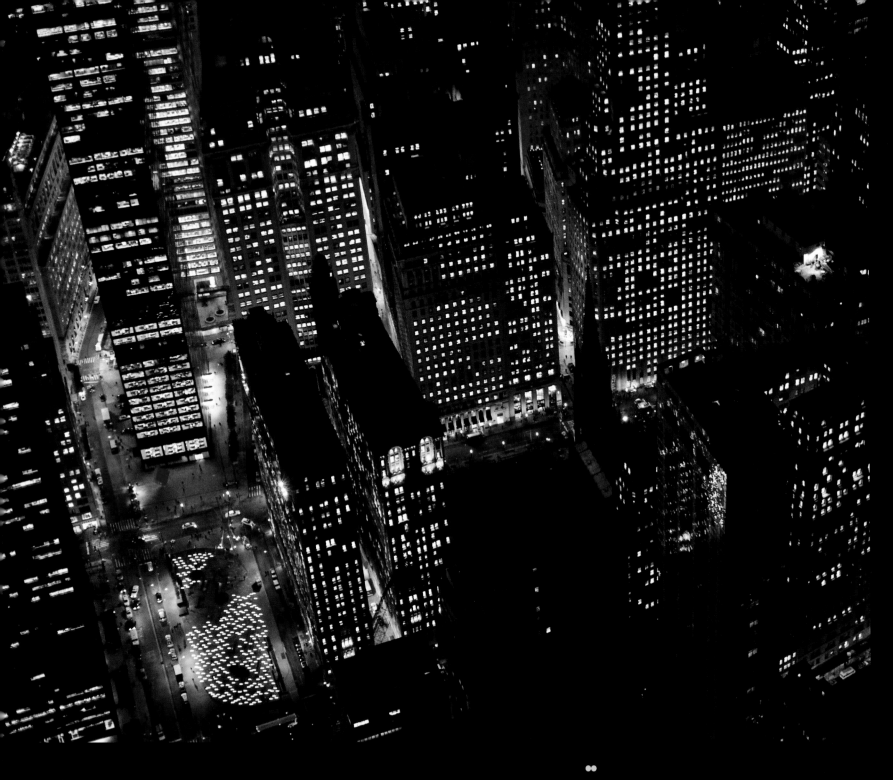

●●

At the bottom of the photograph, a crane angles across
tiny Thames Street, squeezed between the Gothic-style
skyscrapers of 111 and 115 Broadway. Designed in 1904,
this peculiar pair responded to the mid-nineteenth-
century Gothicism of Trinity Church, which stands to
the right of the towers, across from the start of Wall
Street. Amid the intensity of the financial center of
the world, the church's sombre yard offers a reflective
pause to the thousands who walk through it.

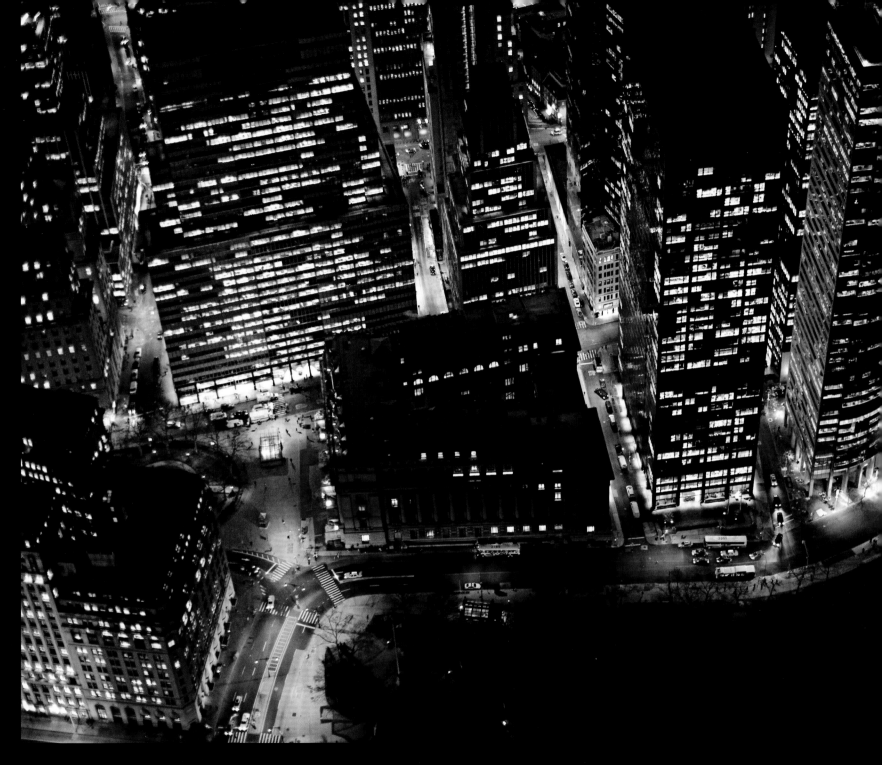

Completed in 1907, the trapezoidal building in
the center of the image is the U.S. Custom House.
Today, it serves as the headquarters of the National
Museum of the American Indian, where frontier
craftsmanship in feathers, beads, and leather coexists
with one of New York's most ebullient Beaux Arts
interiors. The U.S. Customs Service left the building
in 1973, for the World Trade Center.

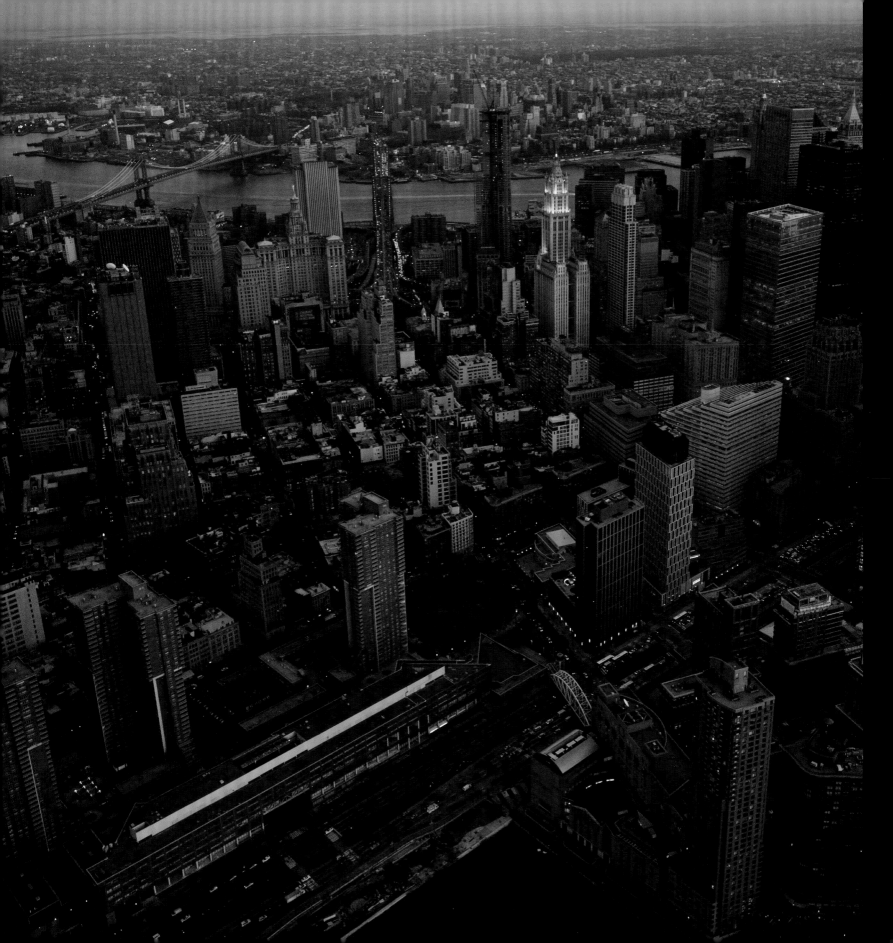

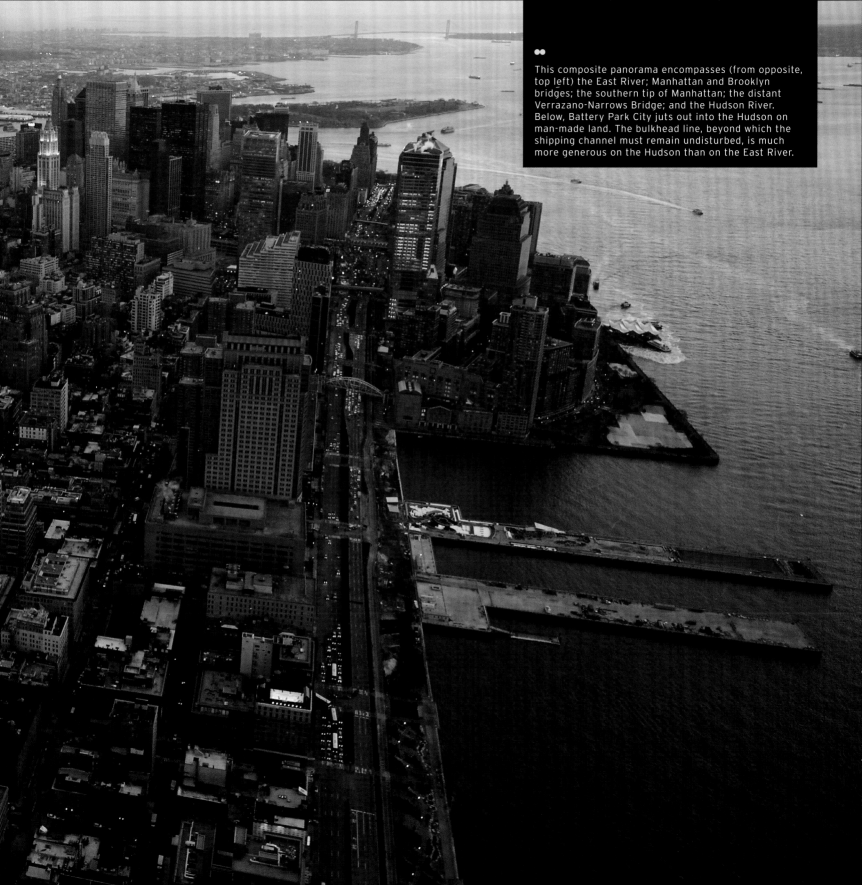

This composite panorama encompasses (from opposite, top left) the East River; Manhattan and Brooklyn bridges; the southern tip of Manhattan; the distant Verrazano-Narrows Bridge; and the Hudson River. Below, Battery Park City juts out into the Hudson on man-made land. The bulkhead line, beyond which the shipping channel must remain undisturbed, is much more generous on the Hudson than on the East River.

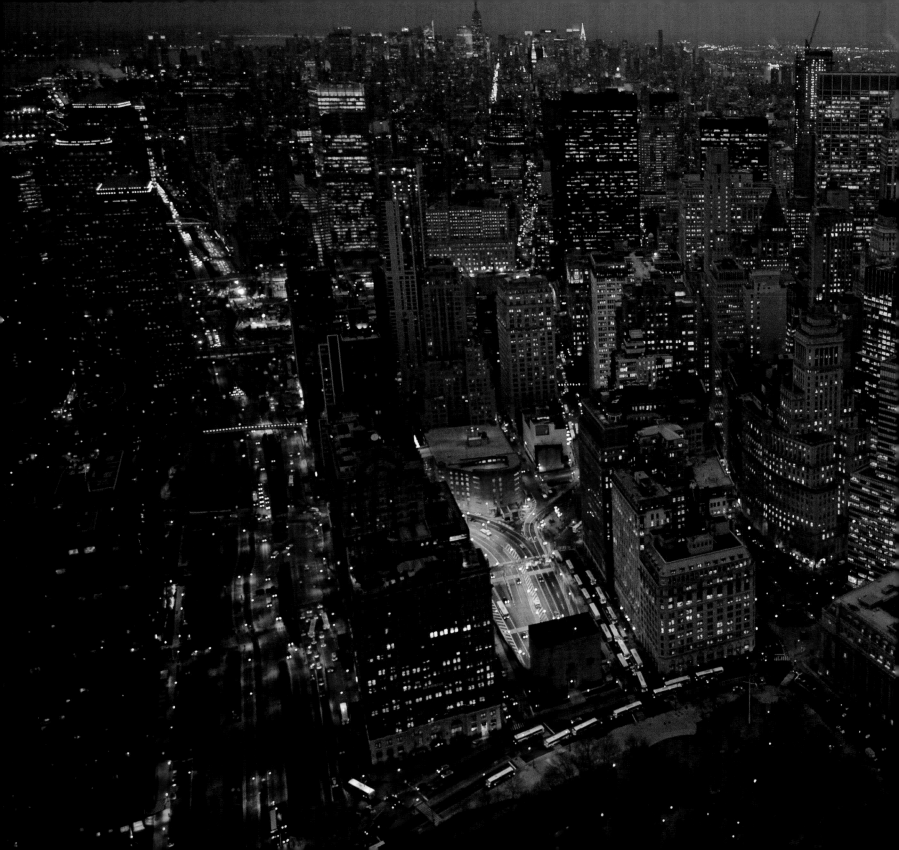

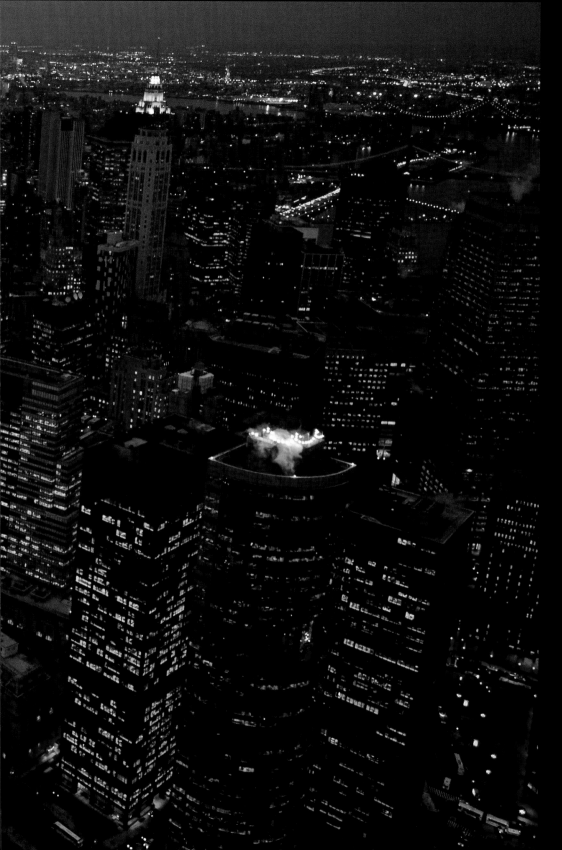

As one looks north into the tangled mass of skyscrapers, the only open spaces are the West Side Highway, running north-south, and, to its right, the deep throat of the Brooklyn-Battery Tunnel approach, soft and golden like the Piazza Navona at dusk—except that the exhaust fumes may kill you. To the northeast is the illuminated pyramid of the sixty-six-story American International Building, completed in 1932 by the Cities Service Company. Immediately below the illuminated red cube is a sort of crystal room, perhaps 20 feet square; standing there, surrounded by glass, it feels like you're on top of the world.

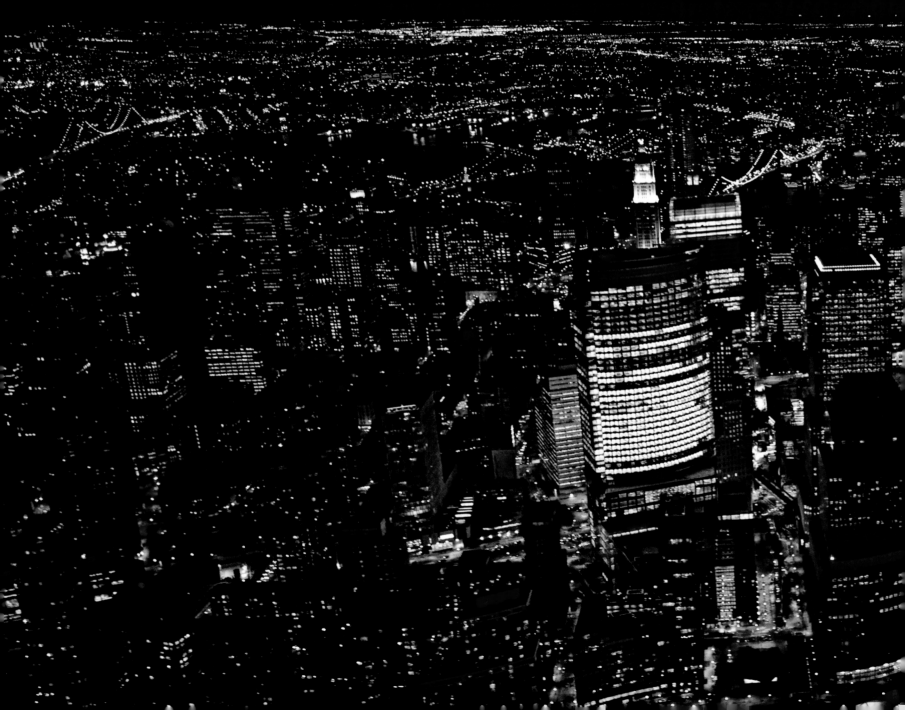

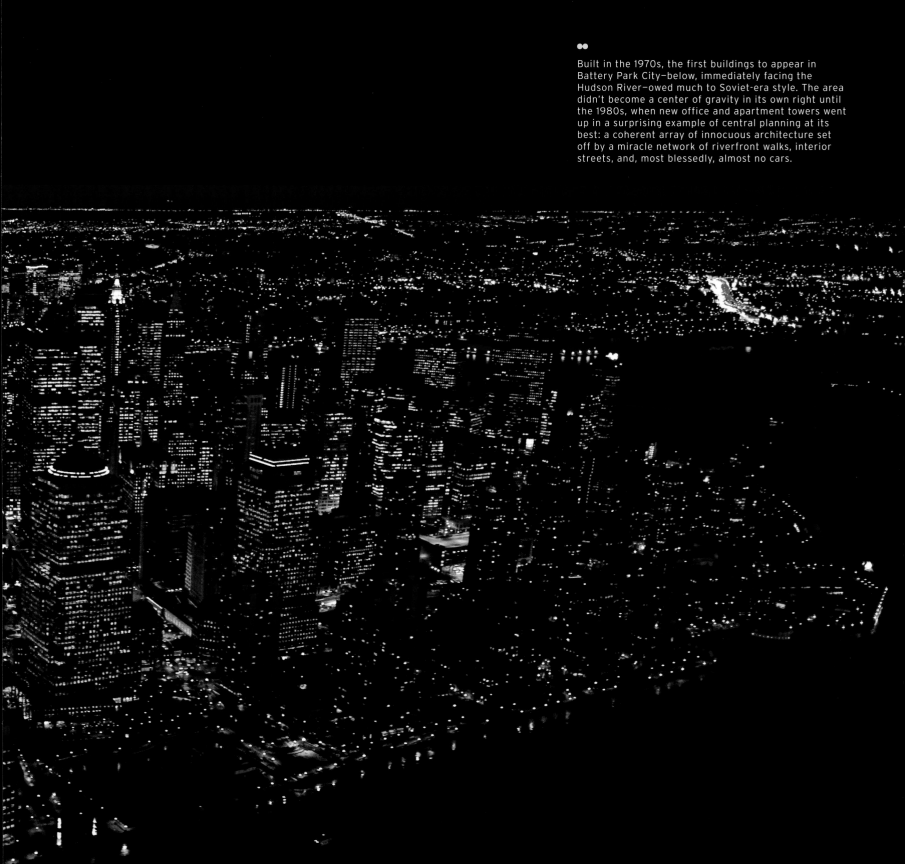

Built in the 1970s, the first buildings to appear in
Battery Park City—below, immediately facing the
Hudson River—owed much to Soviet-era style. The area
didn't become a center of gravity in its own right until
the 1980s, when new office and apartment towers went
up in a surprising example of central planning at its
best: a coherent array of innocuous architecture set
off by a miracle network of riverfront walks, interior
streets, and, most blessedly, almost no cars.

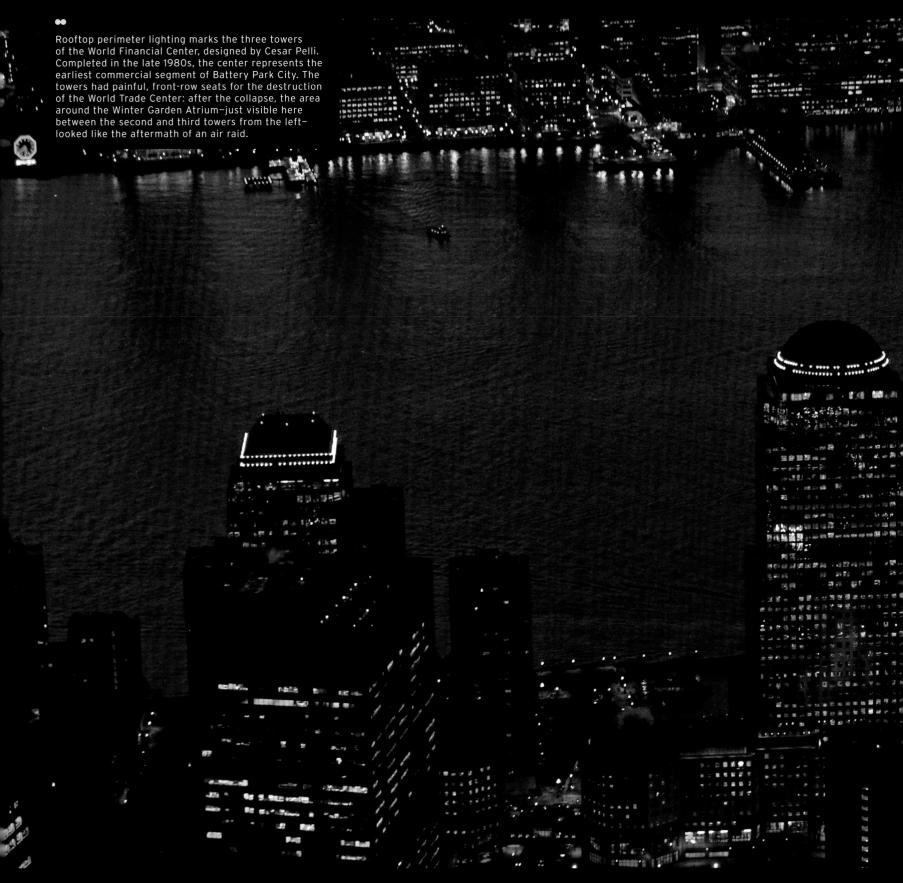

Rooftop perimeter lighting marks the three towers of the World Financial Center, designed by Cesar Pelli. Completed in the late 1980s, the center represents the earliest commercial segment of Battery Park City. The towers had painful, front-row seats for the destruction of the World Trade Center: after the collapse, the area around the Winter Garden Atrium—just visible here between the second and third towers from the left—looked like the aftermath of an air raid.

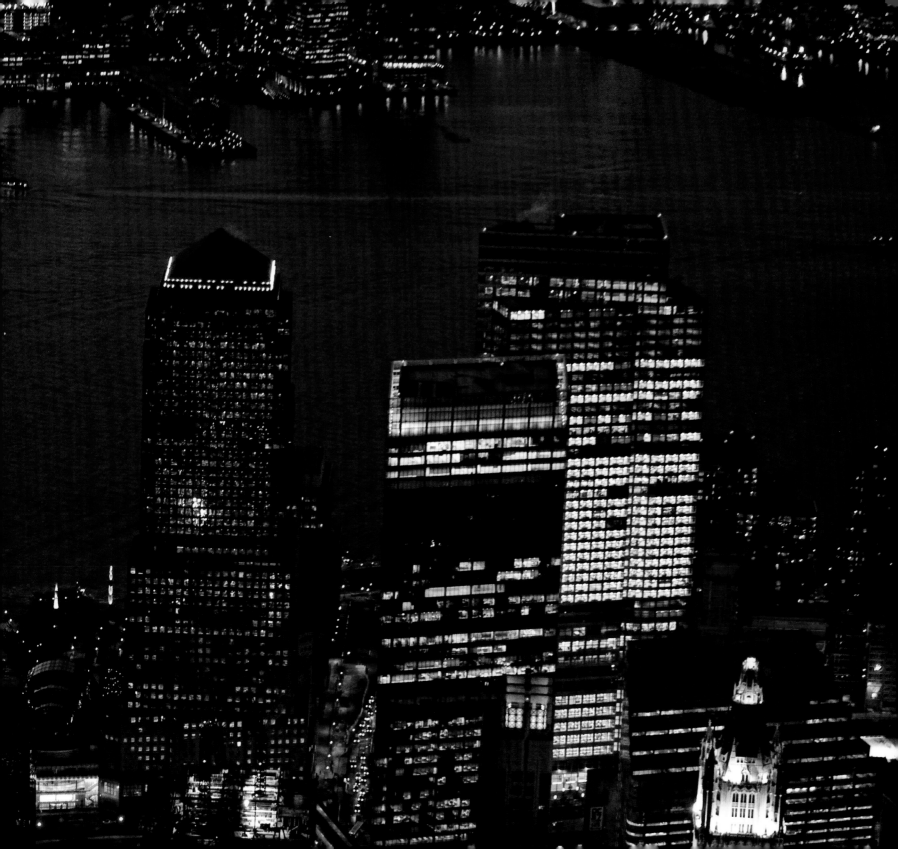

This view looks eastward, past the towers of Battery Park City and across the World Trade Center cleanup site. On September 11, 2001, the entire area was enveloped in a mushrooming cloud of dust, and refugees fled to New Jersey by boat from the marina at the bottom of the photograph. Today, the horror is all tidied up, like a fresh crop of green grass on the site of a massacre. But few walk through the district without silent remembrance.

After the last bodies, the last steel beams, the last pieces of concrete were brought up the ramp—illuminated at bottom-right—there was nothing but emptiness at Ground Zero. Incrementally, the area came back to life, like the landscape after the Mount St. Helens eruption: a deli opened, then a discount shoe store, a swank hotel, a law firm's offices. Finally, after months of sheltering tired firefighters and rescue workers, St. Paul's Chapel, almost invisible in the gloom, got back to normal—the new normal, that is.

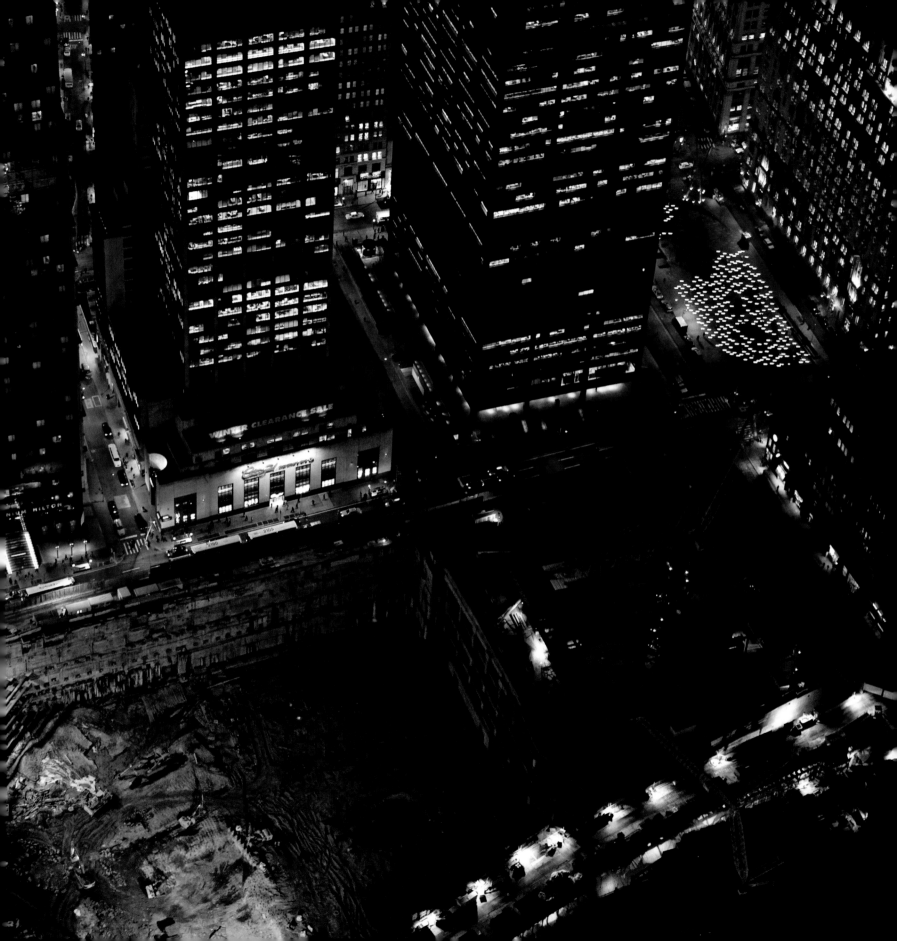

Along the Hudson, the disappearance of freighters and
ocean liners transformed many of Manhattan's piers
into rusting, moldering, rotting, and, occasionally,
burning industrial relics. However, with real estate at
a premium, they have gradually reemerged as the ideal
location for recreational spaces: nobody is displaced
when you build out over the water. Shown here is
Pier 40 and its luminous artificial turf, used for such
field sports as soccer and lacrosse. A little to its right,
Canal Street—a sewage ditch two hundred years ago—
waddles away toward the East River.

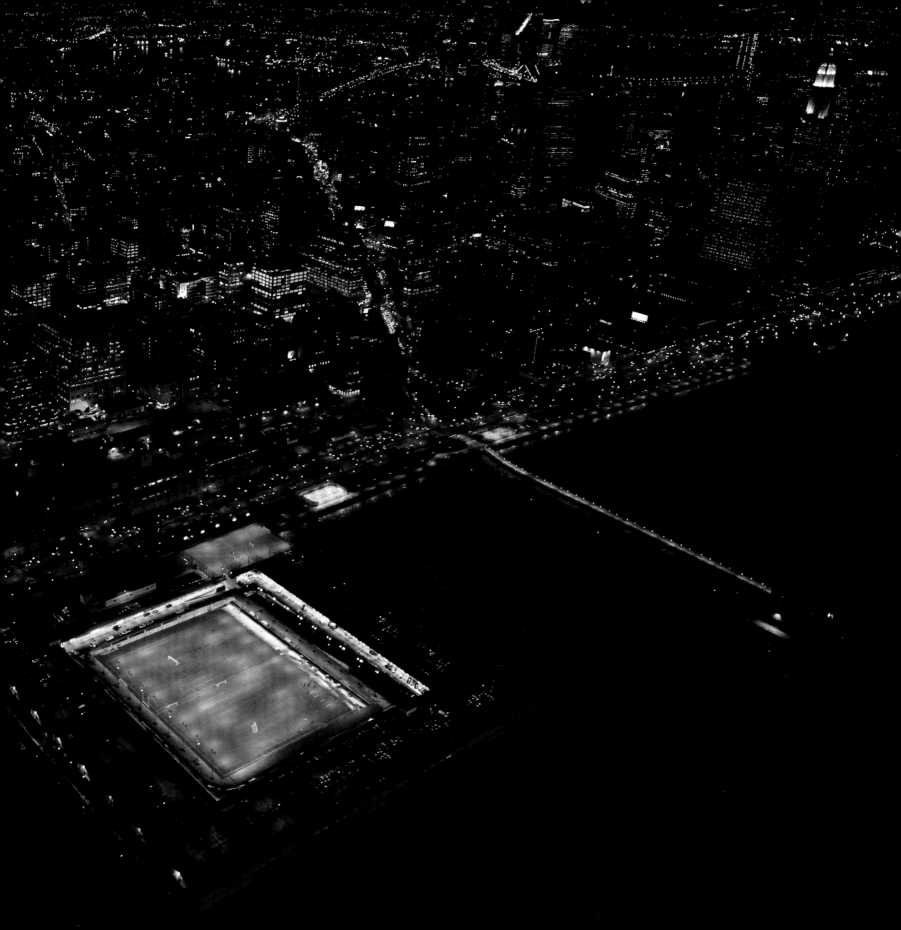

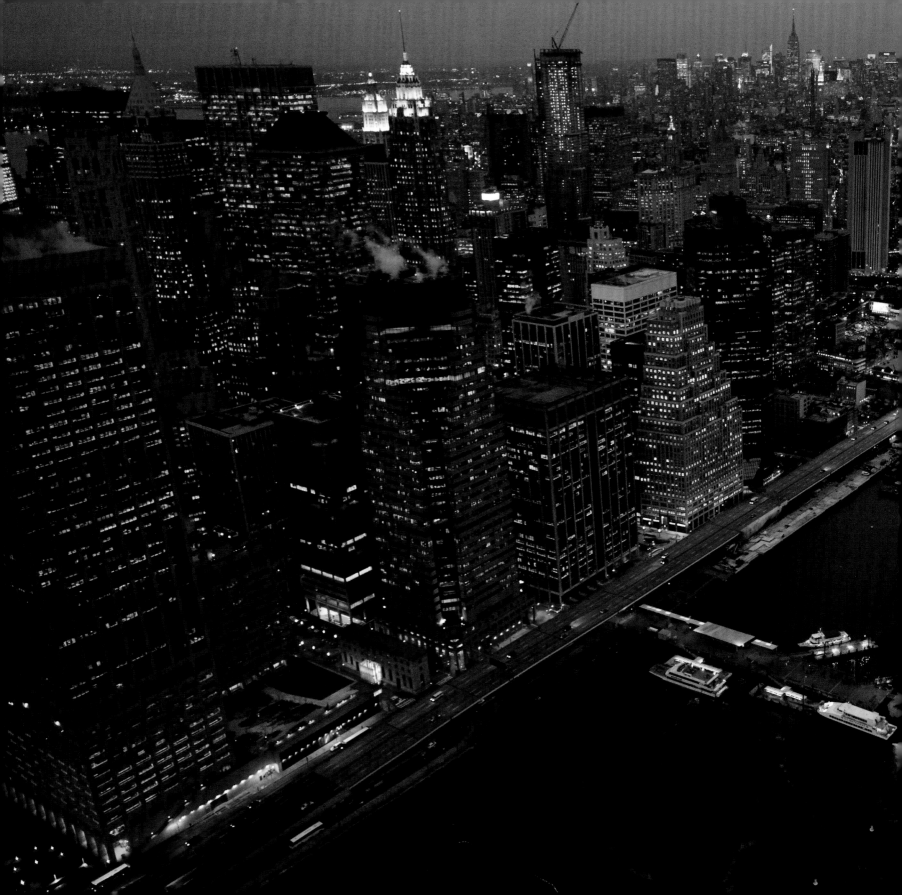

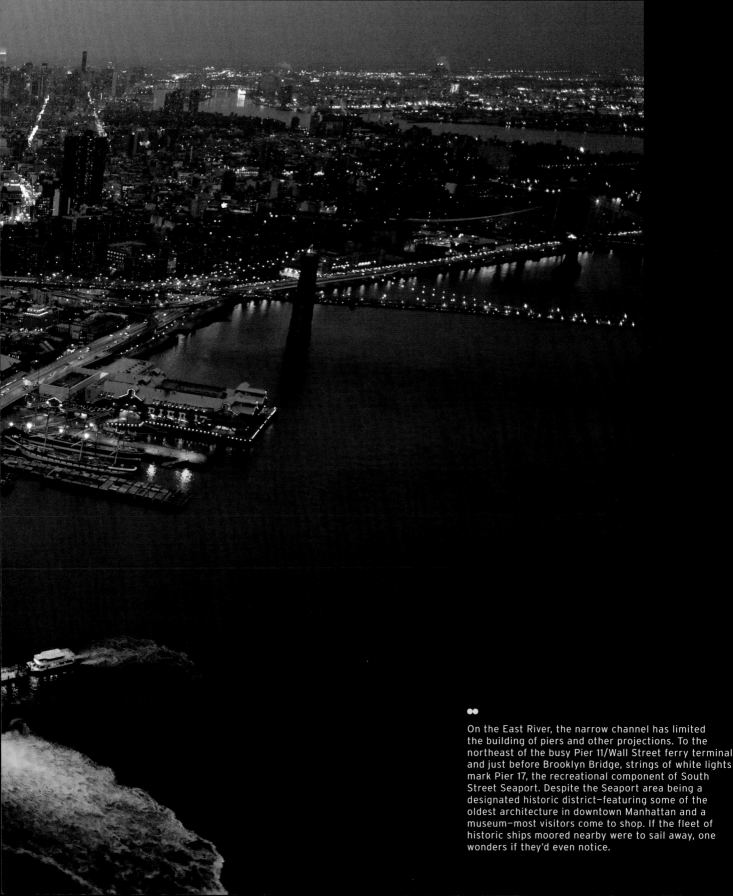

On the East River, the narrow channel has limited
the building of piers and other projections. To the
northeast of the busy Pier 11/Wall Street ferry terminal
and just before Brooklyn Bridge, strings of white lights
mark Pier 17, the recreational component of South
Street Seaport. Despite the Seaport area being a
designated historic district—featuring some of the
oldest architecture in downtown Manhattan and a
museum—most visitors come to shop. If the fleet of
historic ships moored nearby were to sail away, one
wonders if they'd even notice.

Despite the presence of such famous sights as Tiffany's, Grand Central Station, the Empire State Building, and Union Square, midtown isn't really a single thing. Rather, it's like a series of big, separate lumps under the quilt. The east-to-west band between Union Square at Fourteenth Street and Herald Square at Thirty-fourth is a sideways layer cake, consisting of housing projects and hospitals on the East River; a patch of old brownstones and miscellaneous buildings from First Avenue to Park; a dense concentration of pedestrian loft buildings and distinguished skyscrapers at the center; and, over to the west, the newly minted million-dollar loft and artistic district of Chelsea, which has succeeded Soho as the new art center of New York.

From Thirty-fourth Street to the southern edge of Central Park, the band is just as varied, with the United Nations Headquarters and such elite residential districts as Tudor City along the East River; the old brownstones and walk-up flats of Murray Hill, and what's left of First, Second, and Third avenues; the office towers, exclusive shops, and Broadway theater district in the middle; and an old industrial area along the Hudson River, its rail yards and factories still gradually yielding to the most recent burst of housing towers. A $5-million apartment in Hell's Kitchen? Two decades ago you would have been laughed out of town.

Wherever it is, midtown is "New York" to almost everyone, from German tourists and Japanese businessmen to out-of-state families and the native-born. At night, midtown glows more distinctively and more intensely than any other section of the city, the skyscrapers bursting with a greater variety of colors and shapes. Then, of course, there's the Times Square area, a blocks-long glow of advertising signs and theater lights, ably living up to its nickname of the "Great White Way." To many, midtown is the center of the most important city of the most important country in the world. Which is exactly why people visit.

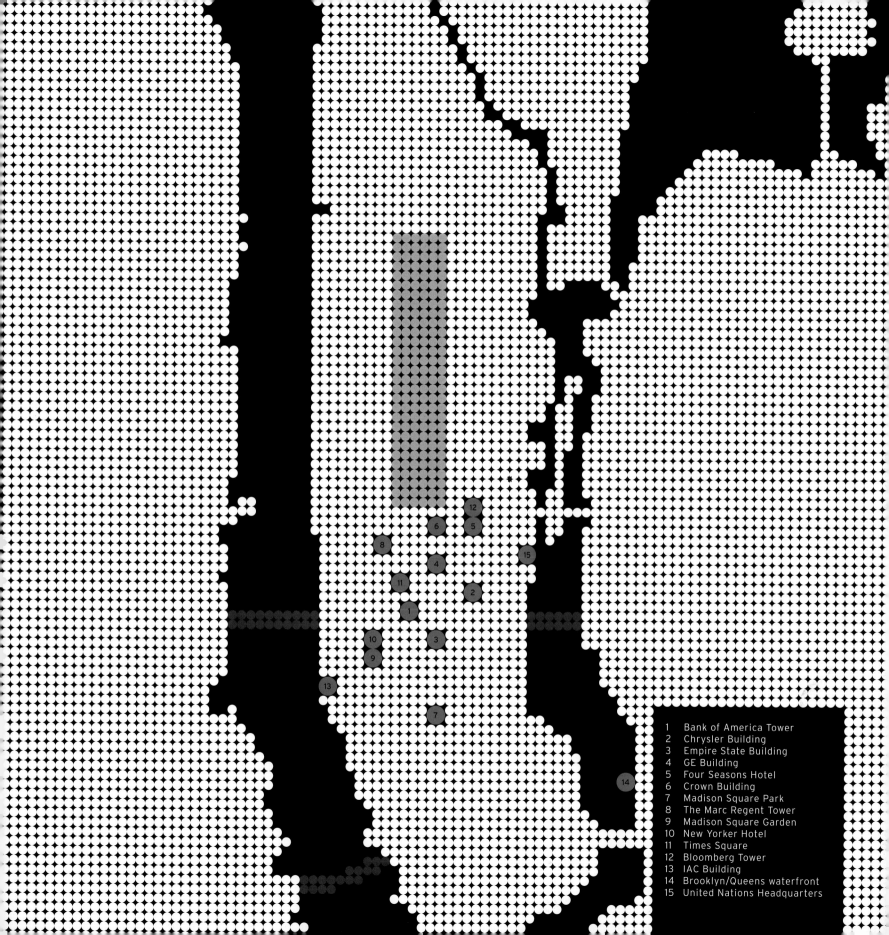

1 Bank of America Tower
2 Chrysler Building
3 Empire State Building
4 GE Building
5 Four Seasons Hotel
6 Crown Building
7 Madison Square Park
8 The Marc Regent Tower
9 Madison Square Garden
10 New Yorker Hotel
11 Times Square
12 Bloomberg Tower
13 IAC Building
14 Brooklyn/Queens waterfront
15 United Nations Headquarters

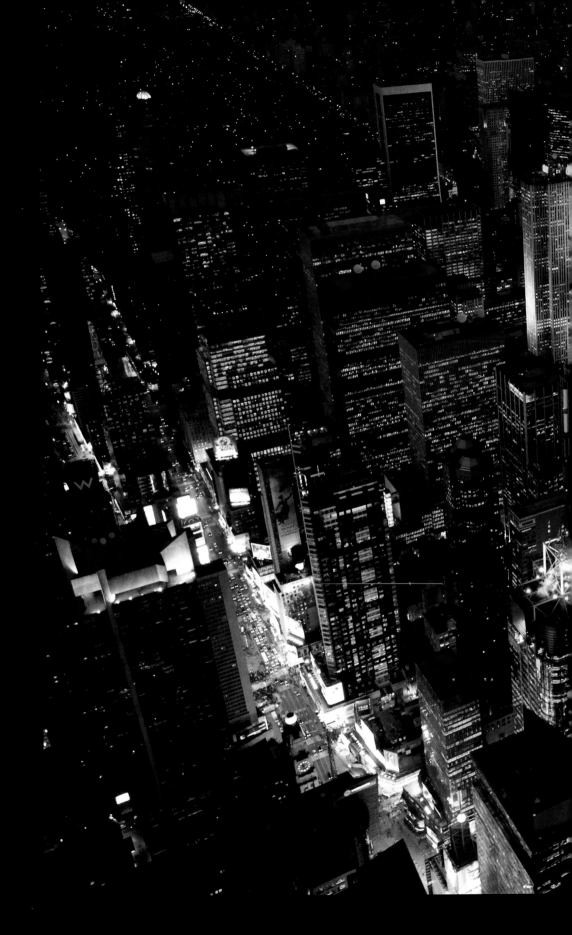

In the last three decades, west midtown has been transformed from a threadbare, porn-selling wasteland into America's urban Disneyland, part of a miraculous revival of American cities once unthinkable. The block containing the angled Bank of America Tower— its needle-like "architectural spire" making it New York's second-tallest building—was, within living memory, a throwaway street of leftover pawnshops and peepshows.

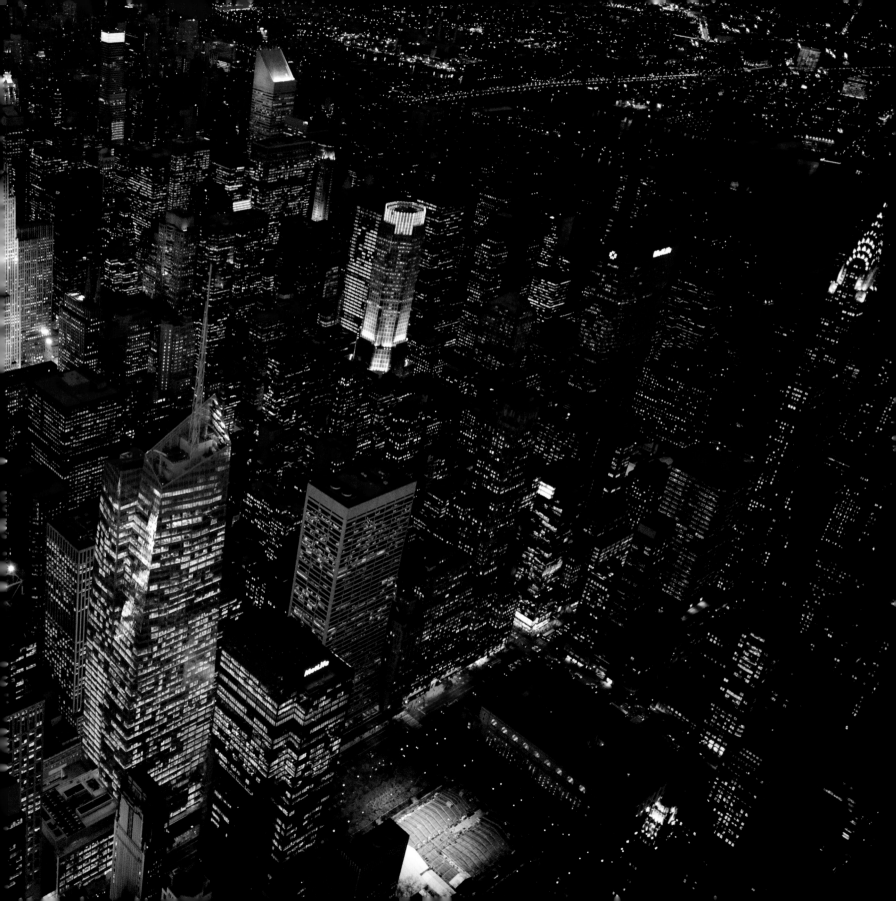

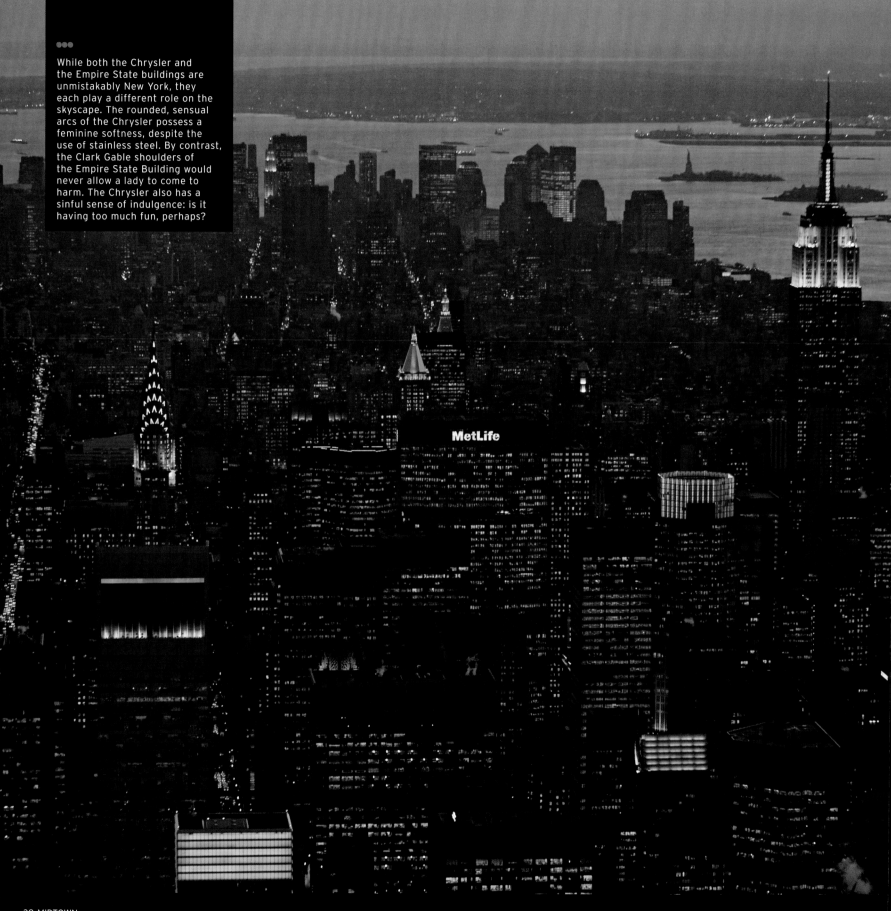

While both the Chrysler and the Empire State buildings are unmistakably New York, they each play a different role on the skyscape. The rounded, sensual arcs of the Chrysler possess a feminine softness, despite the use of stainless steel. By contrast, the Clark Gable shoulders of the Empire State Building would never allow a lady to come to harm. The Chrysler also has a sinful sense of indulgence: is it having too much fun, perhaps?

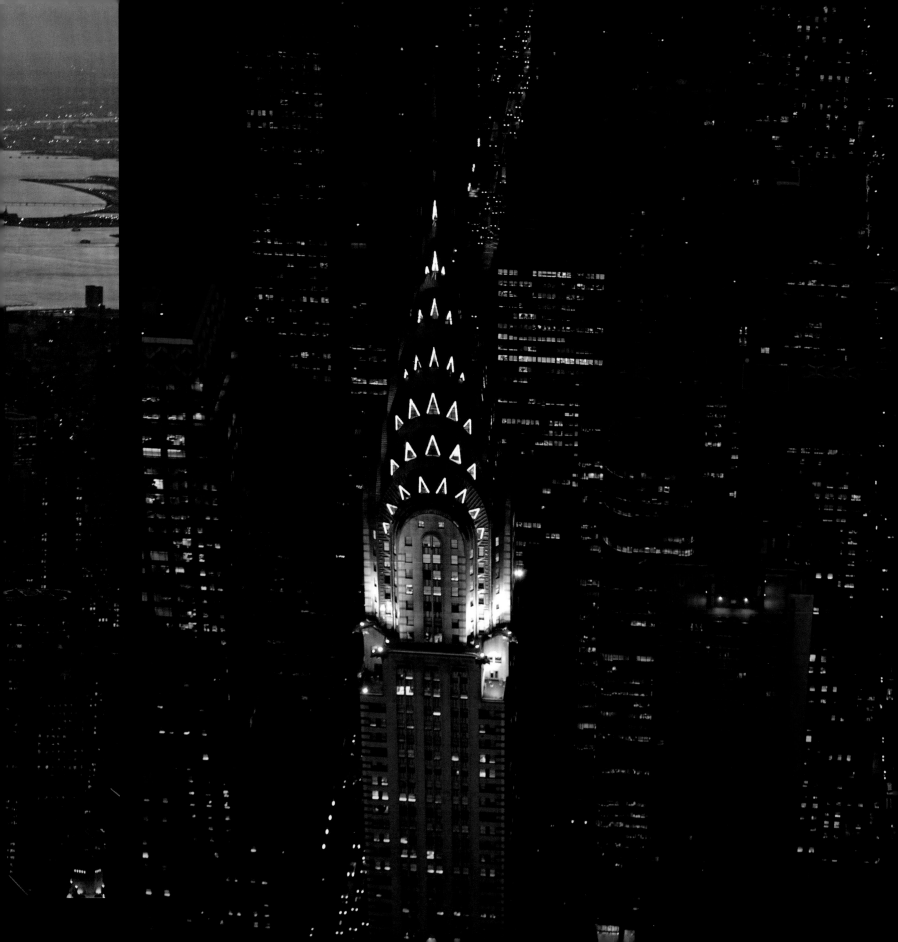

Completed in 1931, the Empire State Building was presented as a dead-sober real-estate operation. Indeed, it was a miracle of pre-planning: from the moment construction began in 1930, the prefabricated steel components arrived right on schedule, and were put into place within hours. And the big limestone slabs of the exterior skin popped into place a lot faster than the brick-by-brick construction of the Chrysler tower. That the upper floors of the Empire State Building were just as economically untenable as the fancy stuff on the Chrysler, no one seems to have worried about.

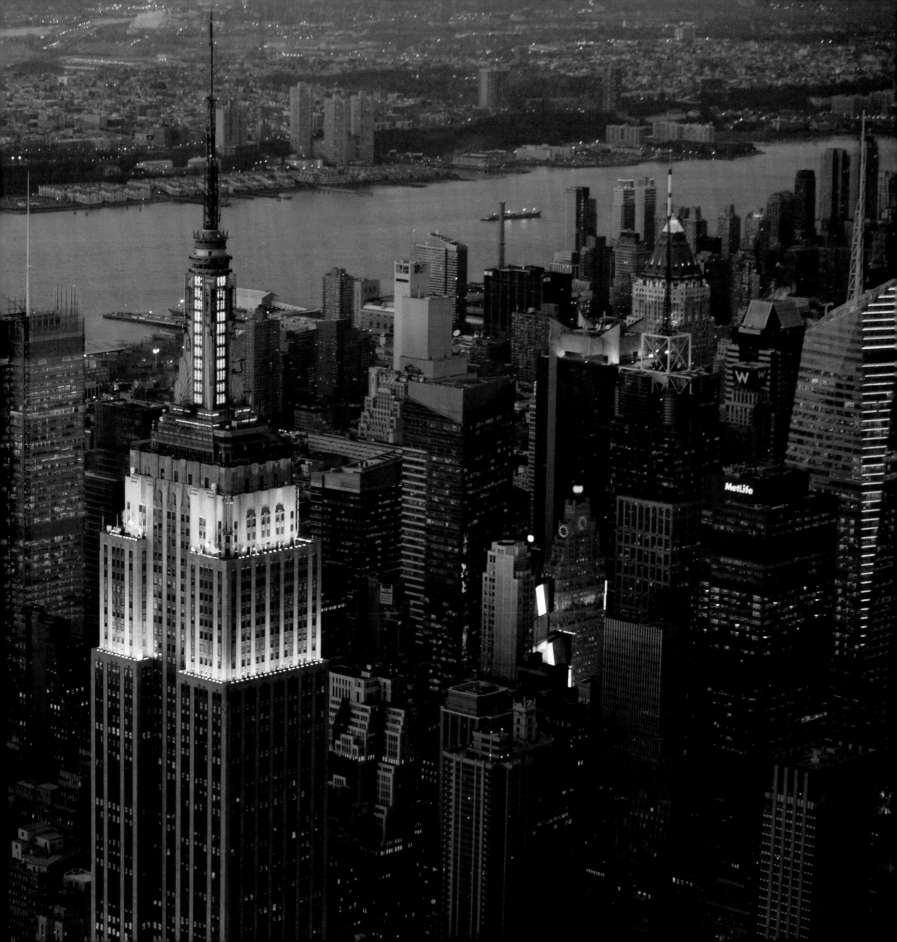

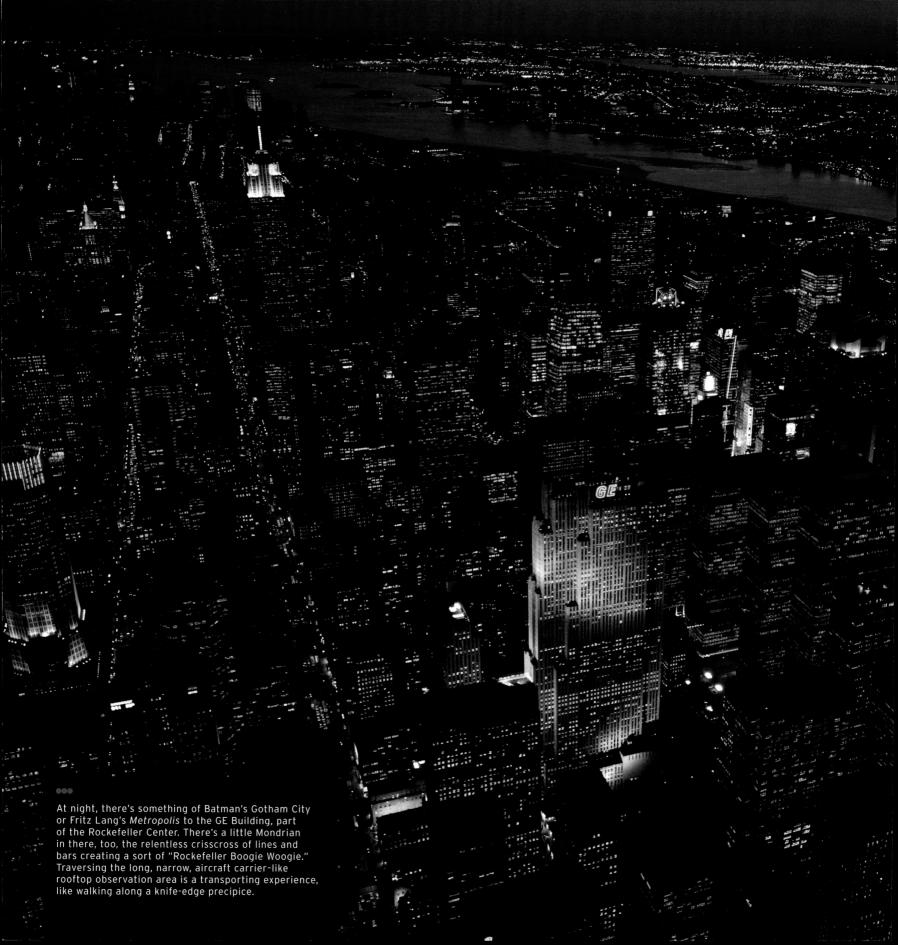

At night, there's something of Batman's Gotham City
or Fritz Lang's *Metropolis* to the GE Building, part
of the Rockefeller Center. There's a little Mondrian
in there, too, the relentless crisscross of lines and
bars creating a sort of "Rockefeller Boogie Woogie."
Traversing the long, narrow, aircraft carrier-like
rooftop observation area is a transporting experience,
like walking along a knife-edge precipice.

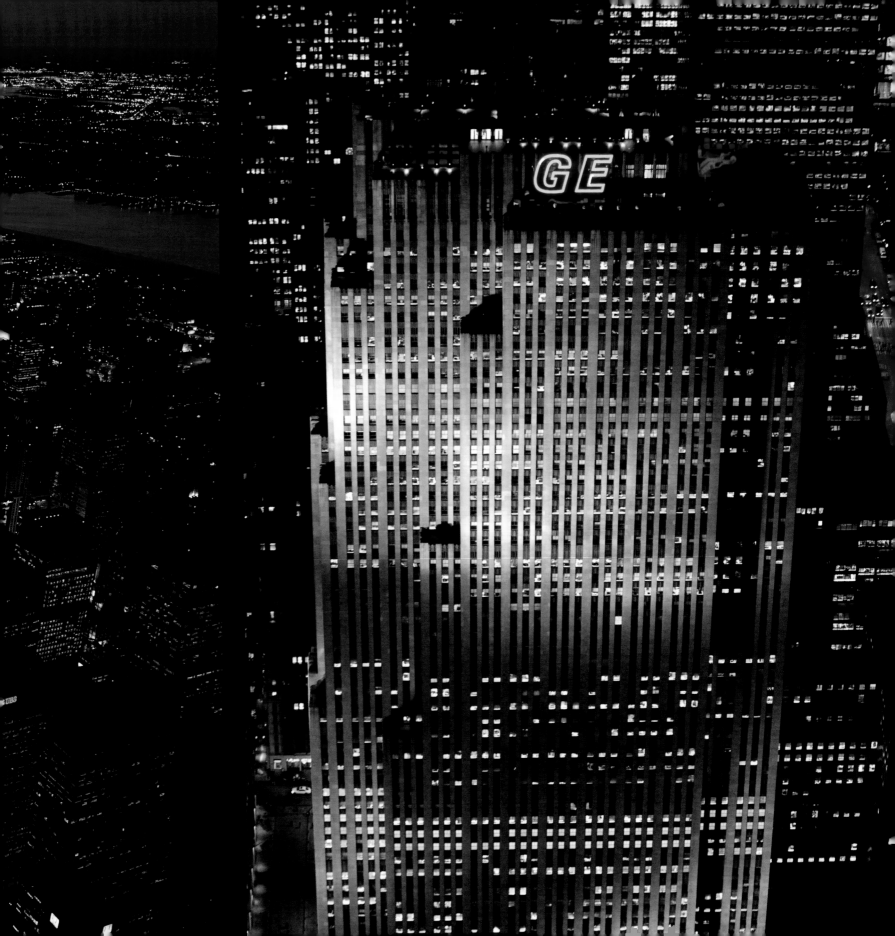

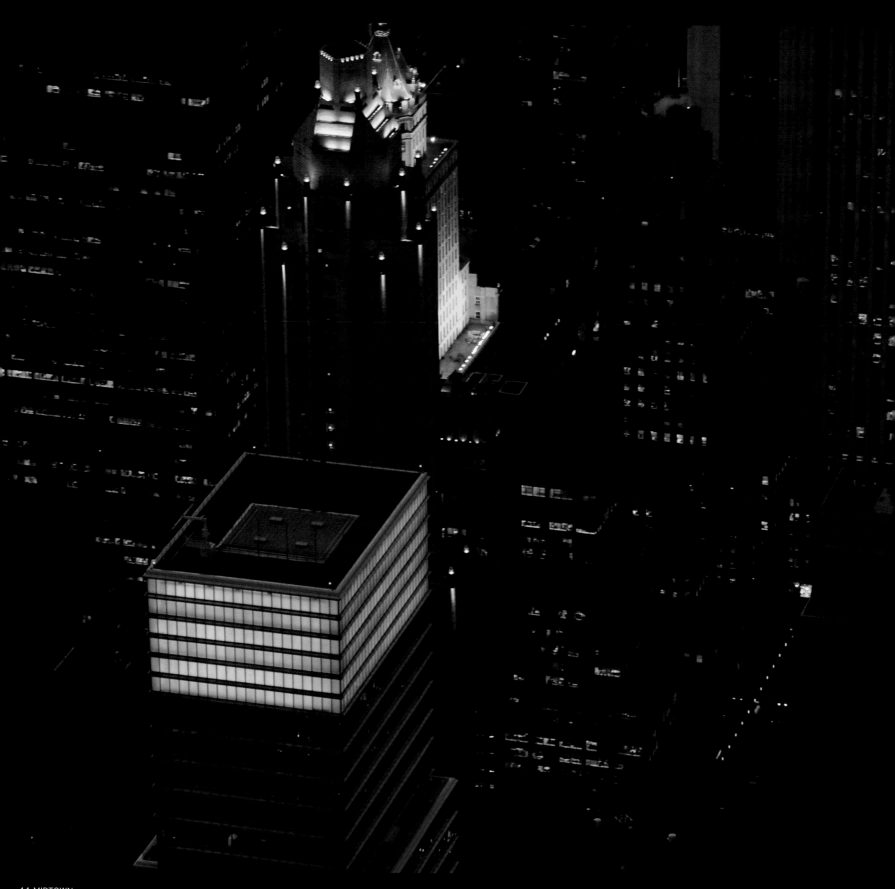

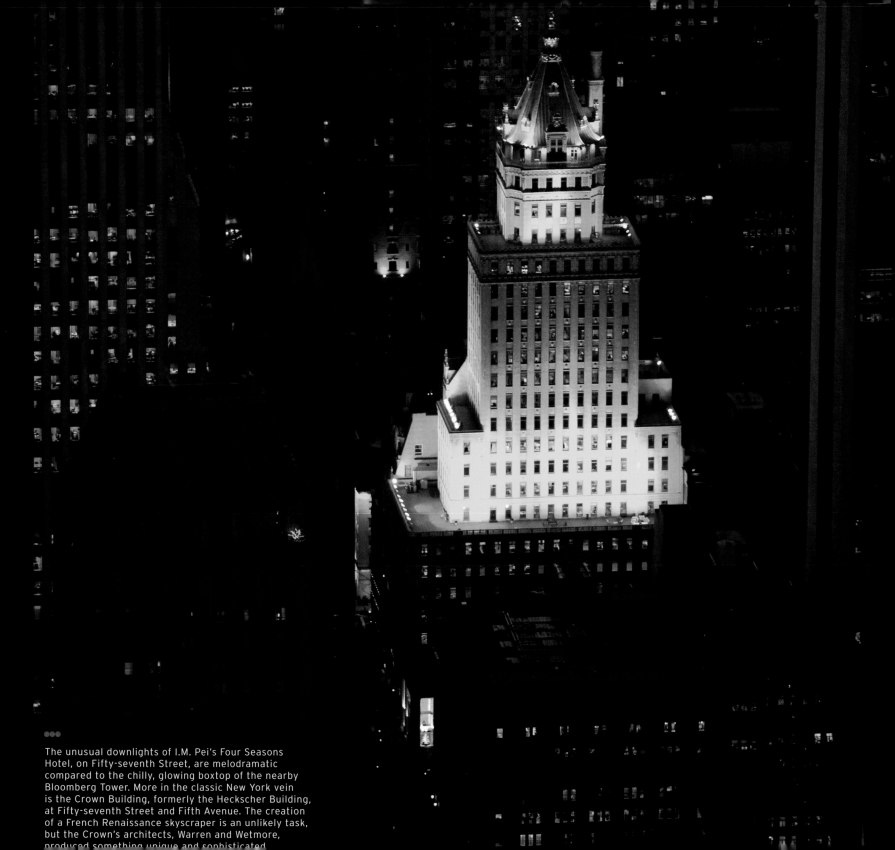

The unusual downlights of I.M. Pei's Four Seasons
Hotel, on Fifty-seventh Street, are melodramatic
compared to the chilly, glowing boxtop of the nearby
Bloomberg Tower. More in the classic New York vein
is the Crown Building, formerly the Heckscher Building,
at Fifty-seventh Street and Fifth Avenue. The creation
of a French Renaissance skyscraper is an unlikely task,
but the Crown's architects, Warren and Wetmore,
produced something unique and sophisticated.

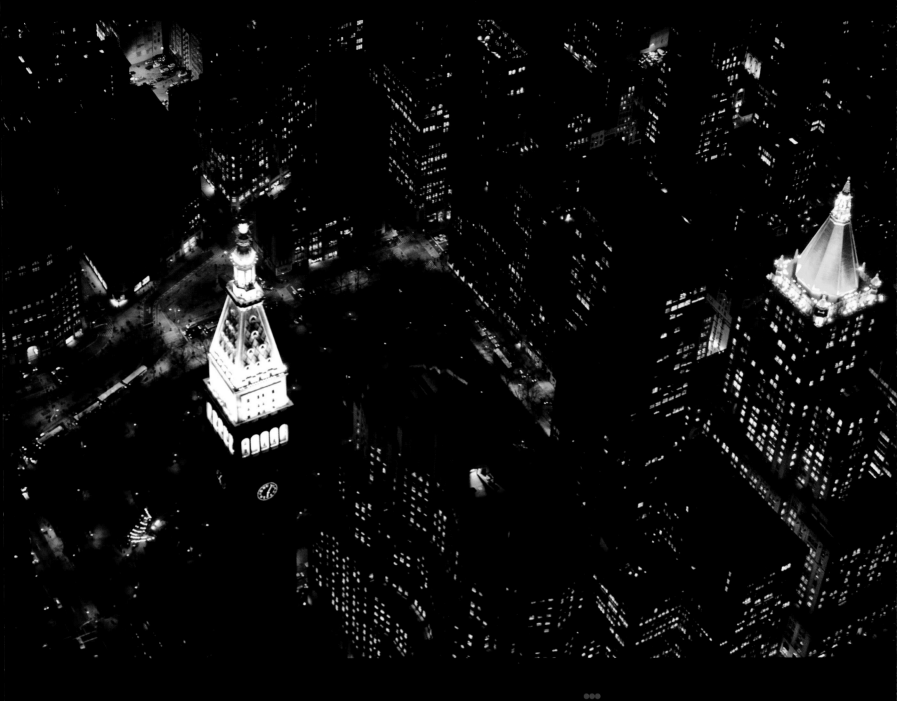

Looming over Madison Square Park, the Metropolitan
Life Tower (left) and New York Life Insurance Building
duel it out with white and gold light. Almost invisible
between the two is the Metropolitan Life's faceted,
undulating annex, a striking Modernist structure from
the 1930s, wholly without presumption—and all the
better for it. Opposite, the old "illuminated steeple"
skyscraper-lighting paradigm is overturned by the Marc
Regent Tower, a residential building at Eighth Avenue
and Fifty-third Street designed by the late Frank
Williams. With its open-concrete framework and interior
lighting in violet and blue, the tower stands as a
testament to an architect who re-thought the entire
concept of nighttime lighting, with novel results.

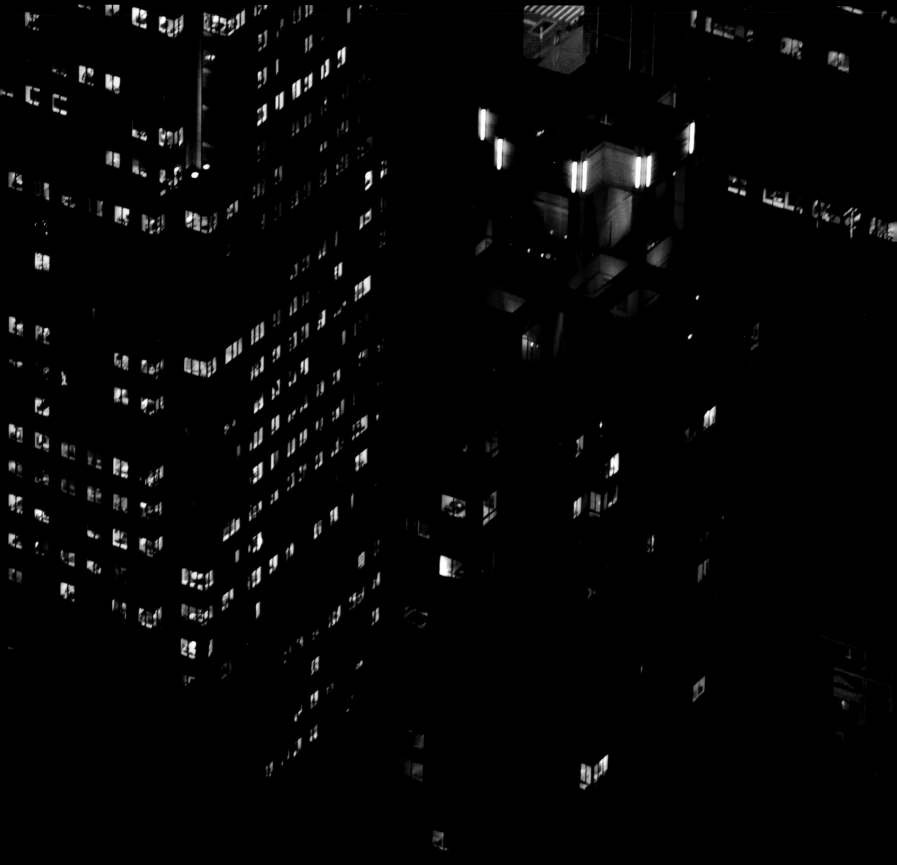

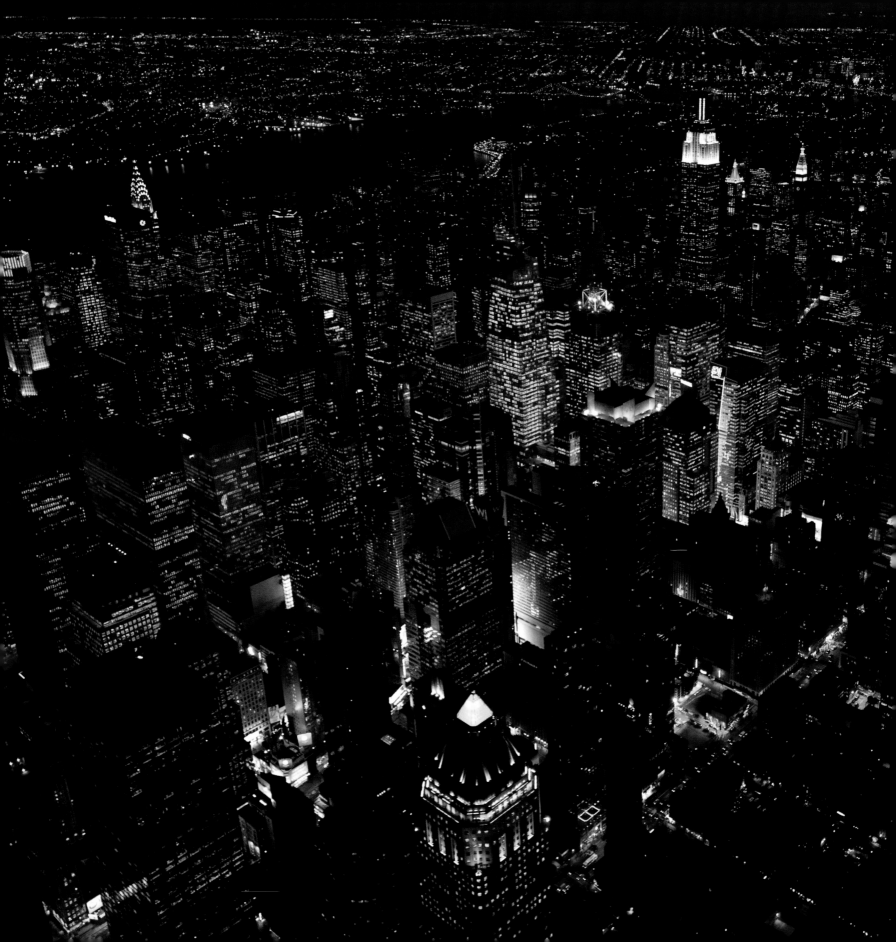

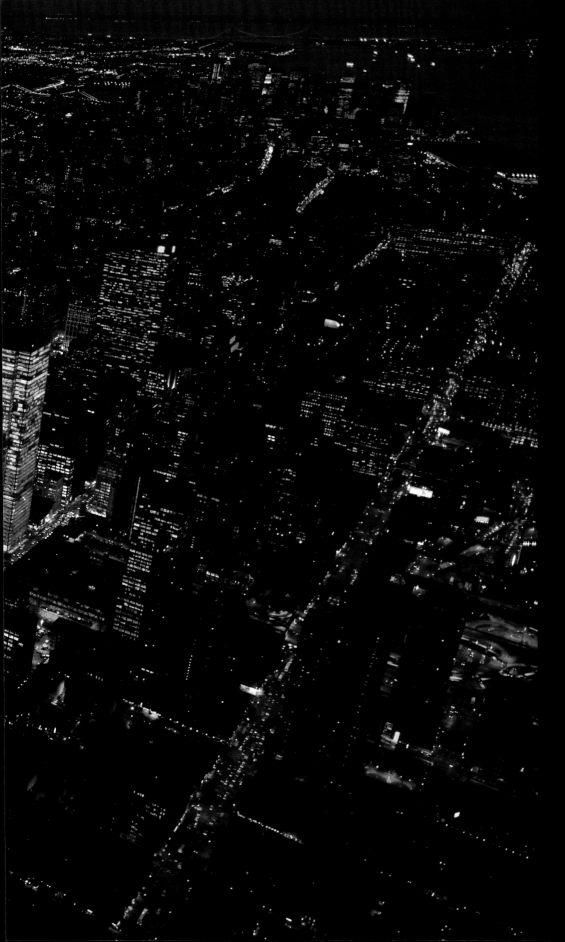

●●●

Snaking its way through west midtown, Broadway is visible only as a series of bright-white reflections on the adjacent buildings. From this perspective, it's like hearing an animal in the grass, but not seeing it. By contrast, workaday Ninth Avenue reveals itself through the relative darkness of the buildings on either side. Separated by only a few blocks, the two thoroughfares seem worlds apart.

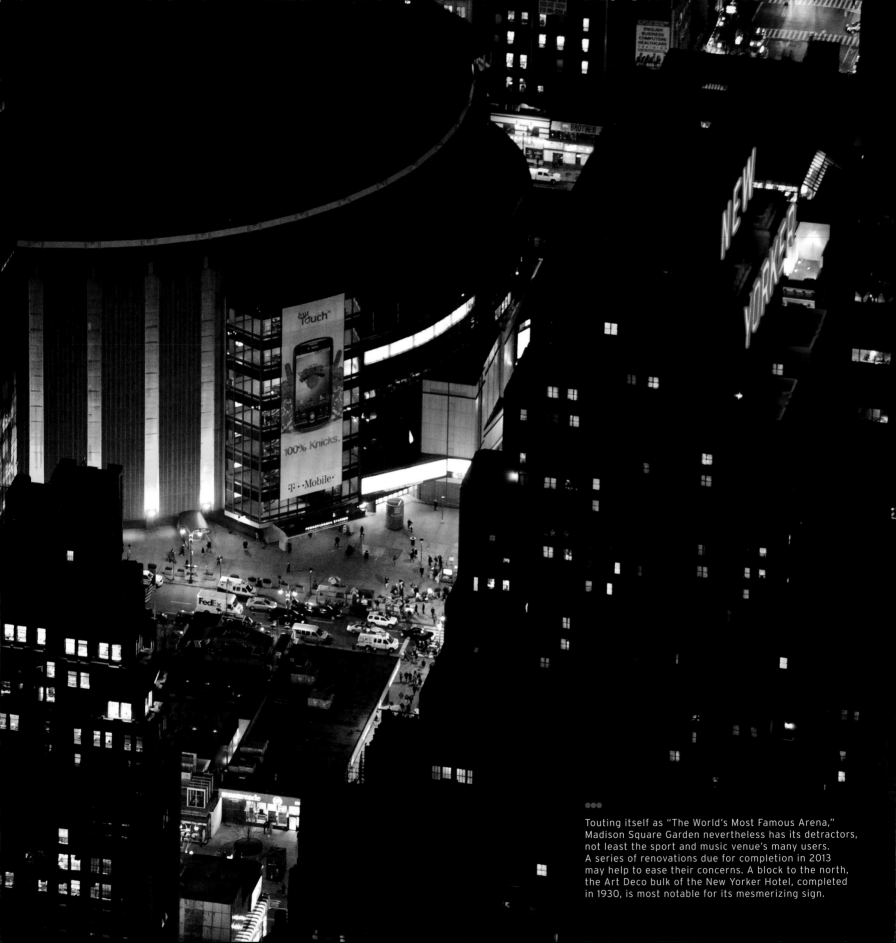

Touting itself as "The World's Most Famous Arena,"
Madison Square Garden nevertheless has its detractors,
not least the sport and music venue's many users.
A series of renovations due for completion in 2013
may help to ease their concerns. A block to the north,
the Art Deco bulk of the New Yorker Hotel, completed
in 1930, is most notable for its mesmerizing sign.

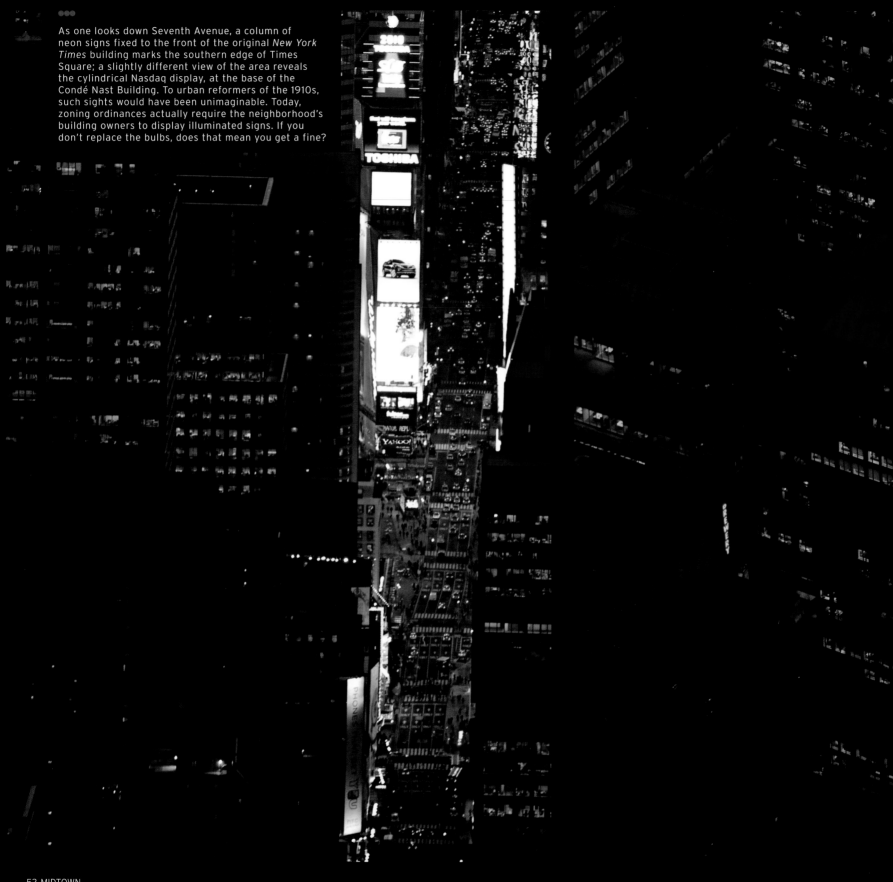

As one looks down Seventh Avenue, a column of neon signs fixed to the front of the original *New York Times* building marks the southern edge of Times Square; a slightly different view of the area reveals the cylindrical Nasdaq display, at the base of the Condé Nast Building. To urban reformers of the 1910s, such sights would have been unimaginable. Today, zoning ordinances actually require the neighborhood's building owners to display illuminated signs. If you don't replace the bulbs, does that mean you get a fine?

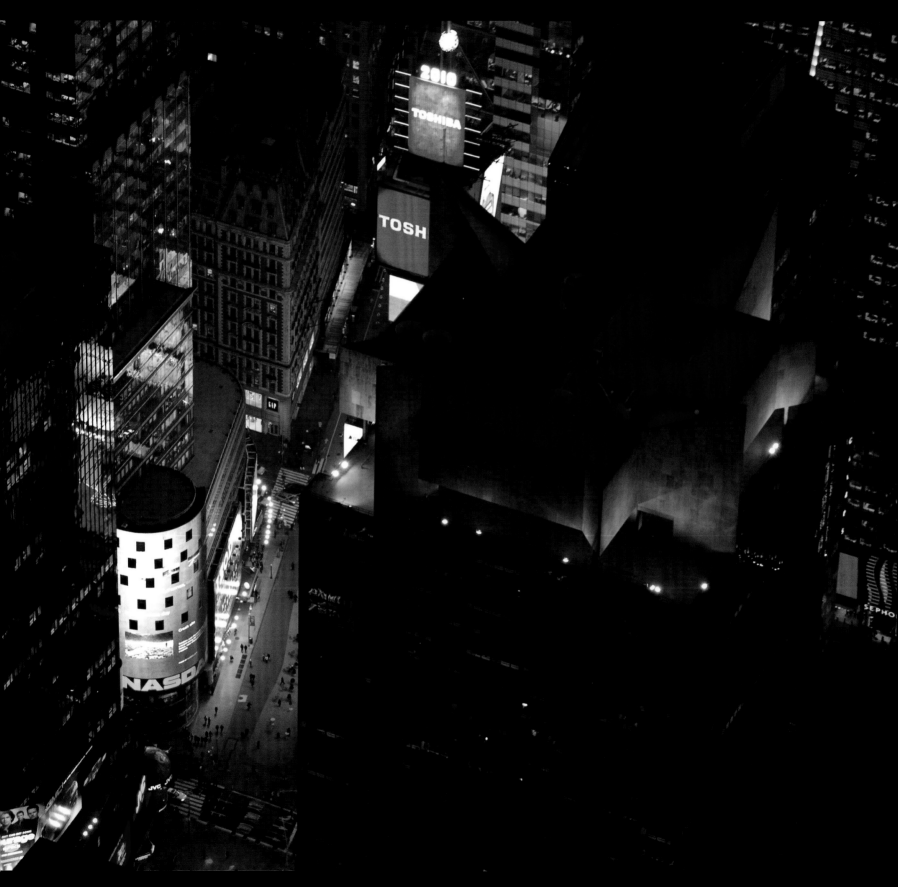

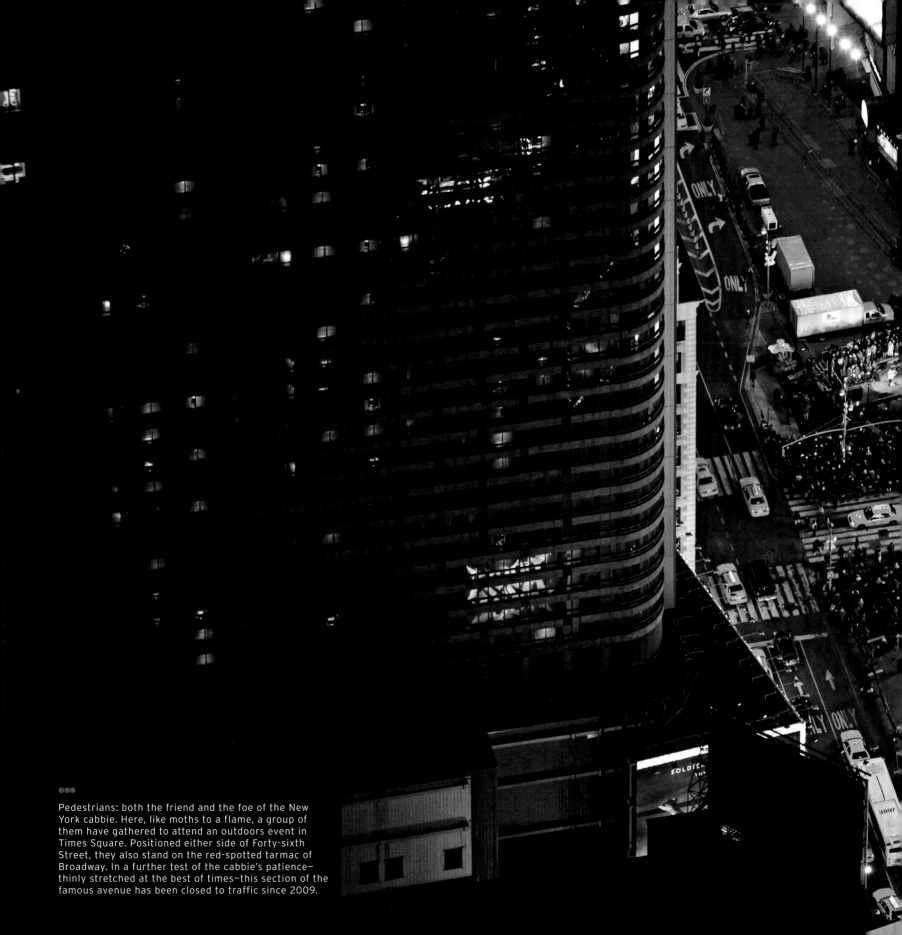

Pedestrians: both the friend and the foe of the New York cabbie. Here, like moths to a flame, a group of them have gathered to attend an outdoors event in Times Square. Positioned either side of Forty-sixth Street, they also stand on the red-spotted tarmac of Broadway. In a further test of the cabbie's patience—thinly stretched at the best of times—this section of the famous avenue has been closed to traffic since 2009.

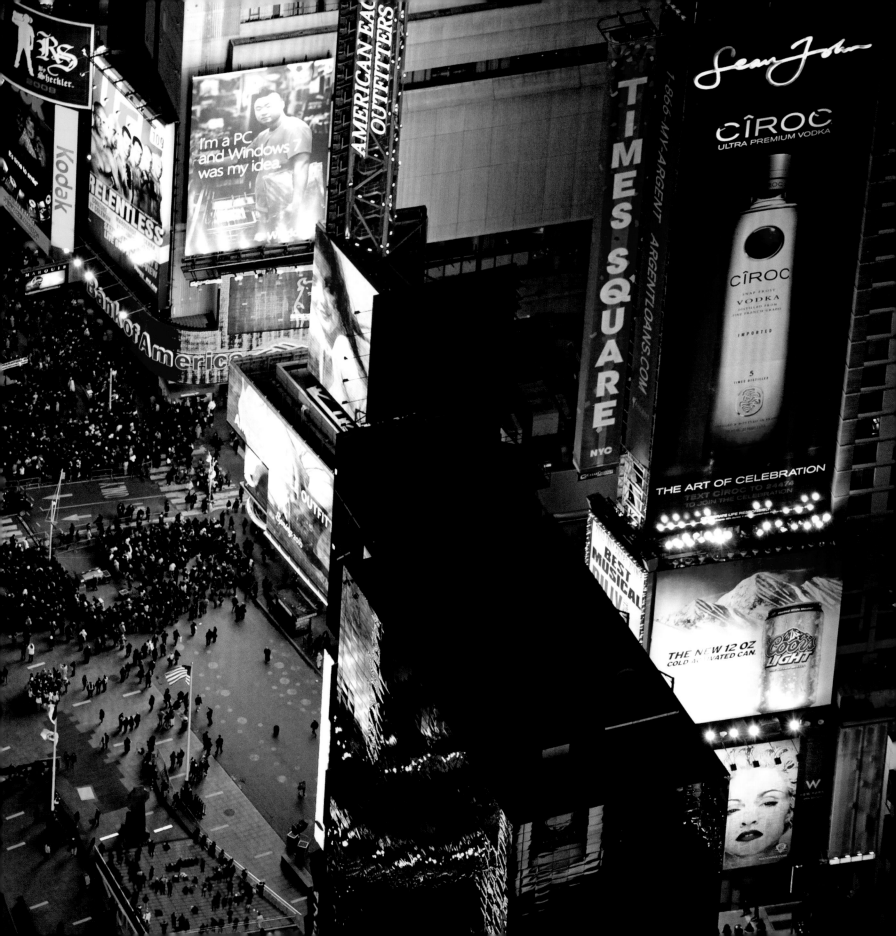

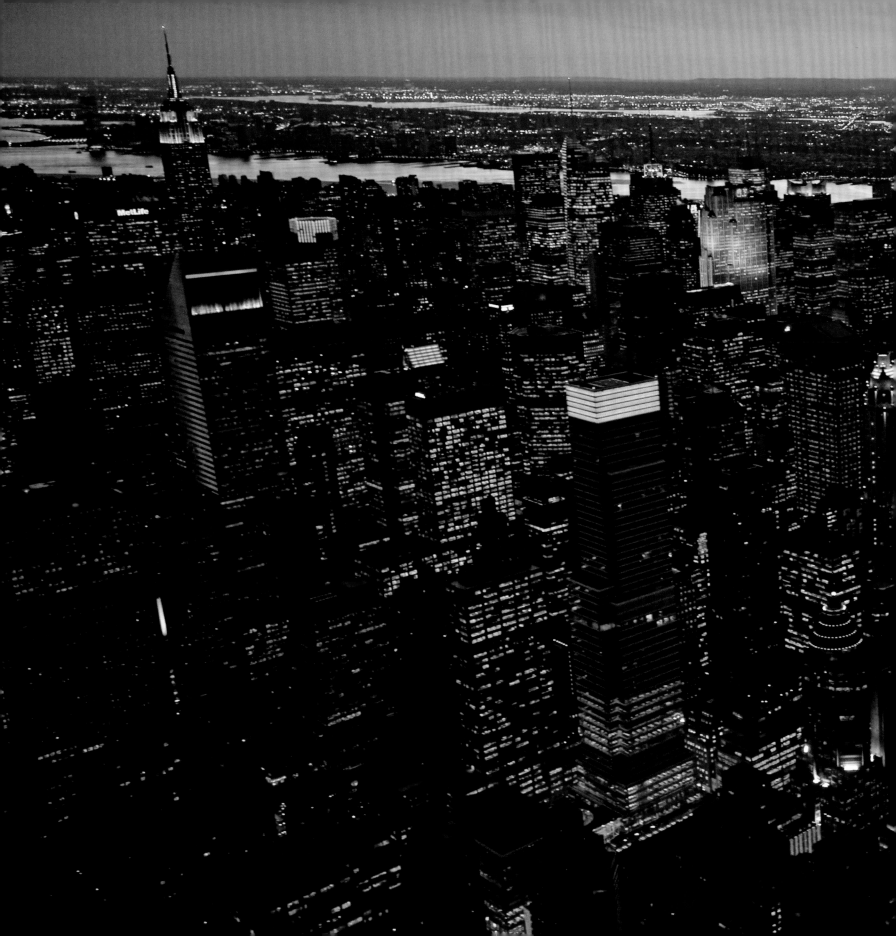

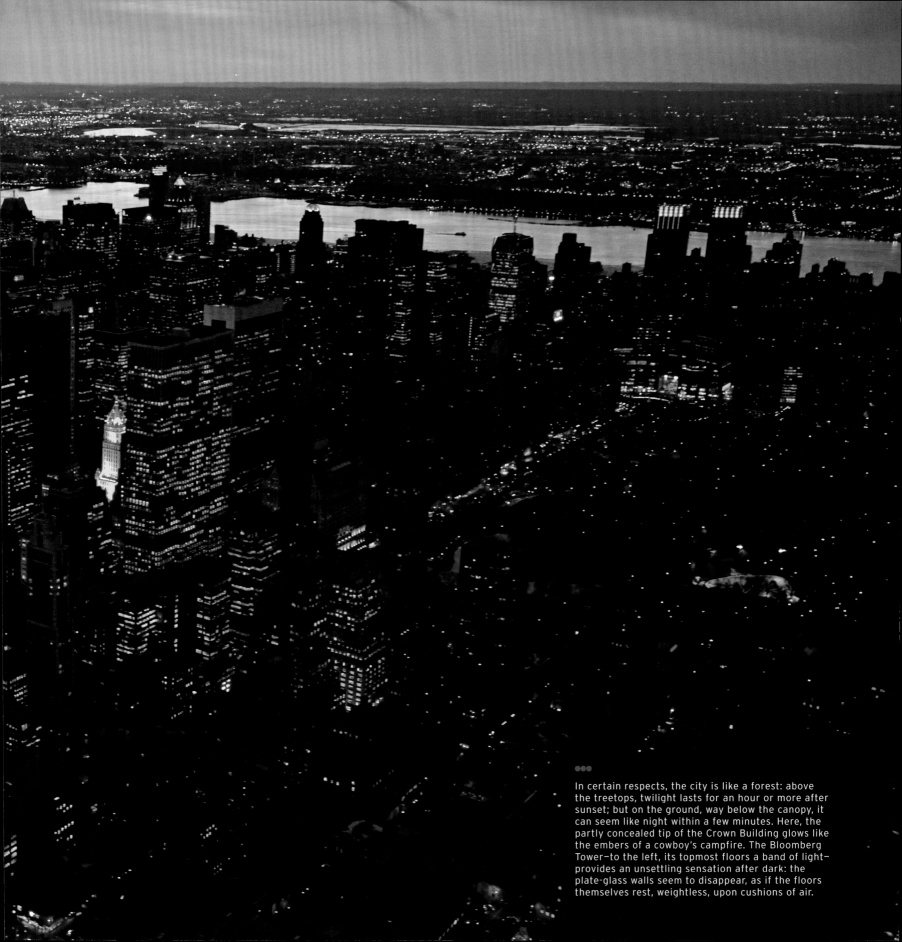

In certain respects, the city is like a forest: above the treetops, twilight lasts for an hour or more after sunset; but on the ground, way below the canopy, it can seem like night within a few minutes. Here, the partly concealed tip of the Crown Building glows like the embers of a cowboy's campfire. The Bloomberg Tower—to the left, its topmost floors a band of light—provides an unsettling sensation after dark: the plate-glass walls seem to disappear, as if the floors themselves rest, weightless, upon cushions of air.

On the far west side, ultra hip has arrived in Chelsea, much of it moving from its old downtown locales, including Soho and Tribeca. Hippest of all, below, is Frank Gehry's "sails" building, headquarters of internet company IAC. While white is not a particularly inventive color, the architect has created a structure that seems to flap in the wind, like a mainsail luffing on a clipper. Also of interest is the translucent façade: by night, it appears to dissolve away completely, transforming the building into a transparent waterfront beacon.

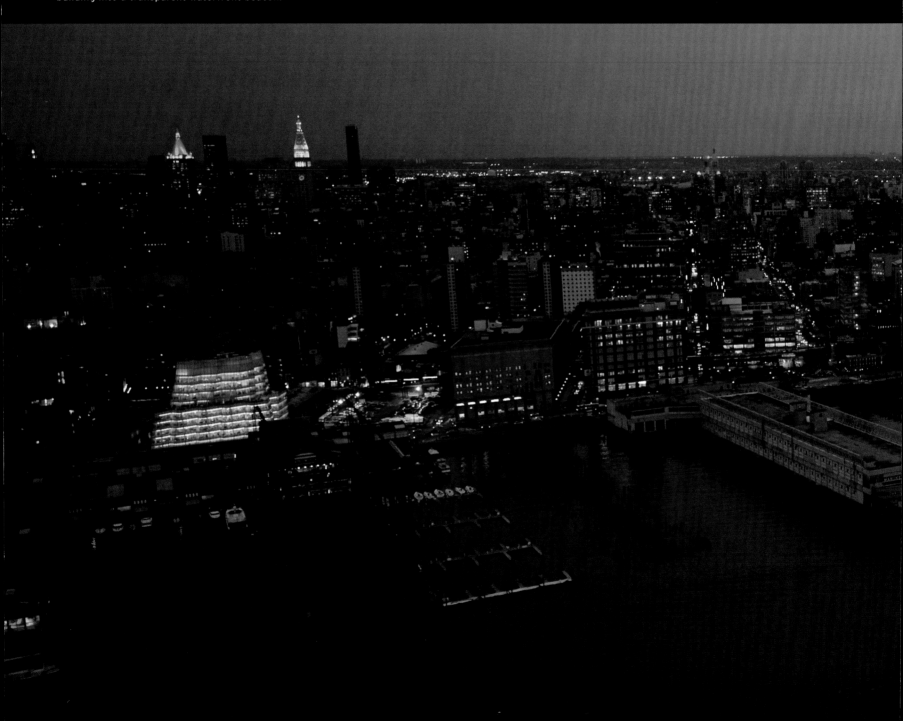

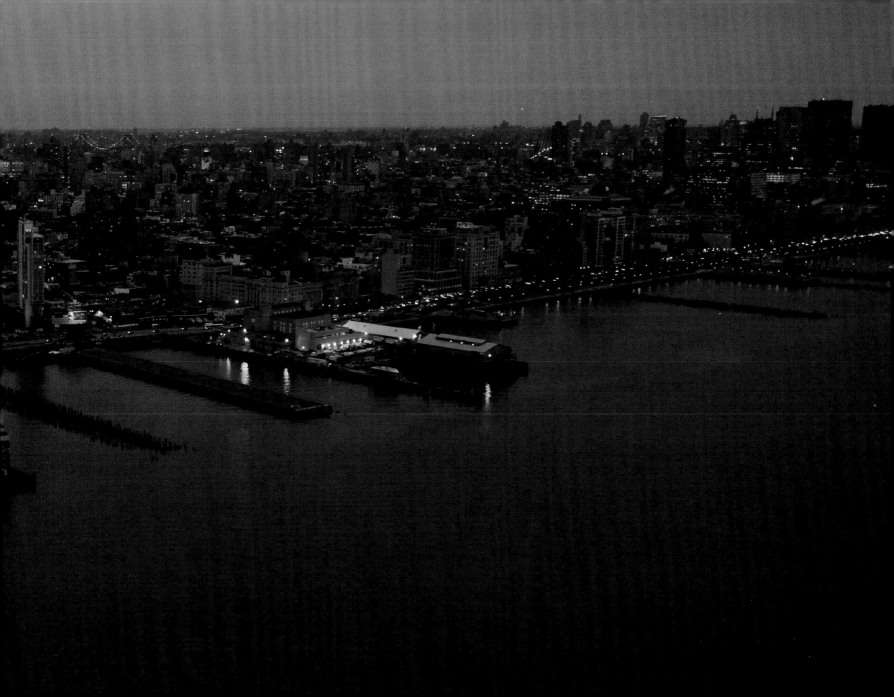

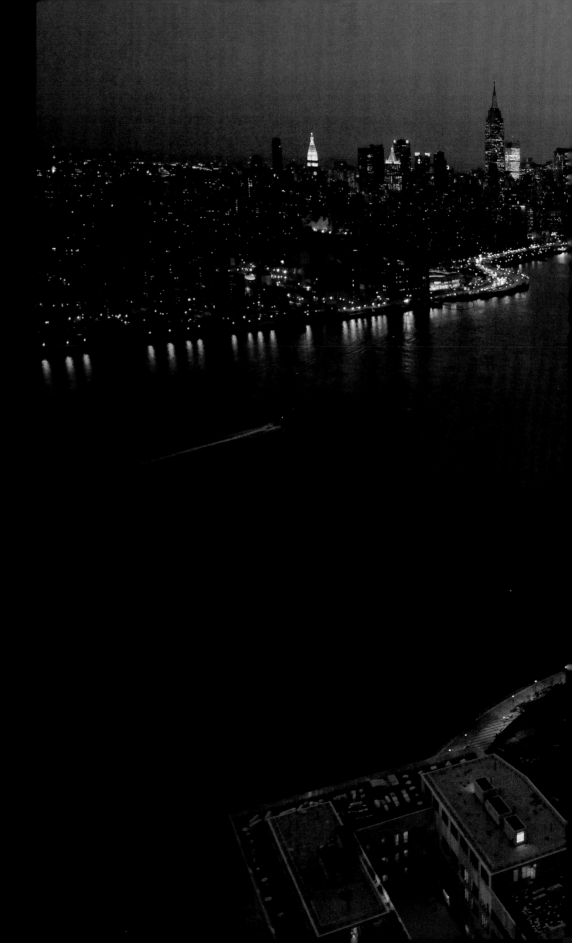

From this vantage point, looking west over the new towers on the formerly industrial Brooklyn/Queens waterfront, the Manhattan shoreline has a distant, bumpy quality that wouldn't have been strange to the area's first explorers. While Manhattan is girdled by roadways, the streets on this side of the East River run right up to the water's edge. The circumferential highways may offer spectacular views to the driver, but the dead ends are all peaceful, solitary contemplation.

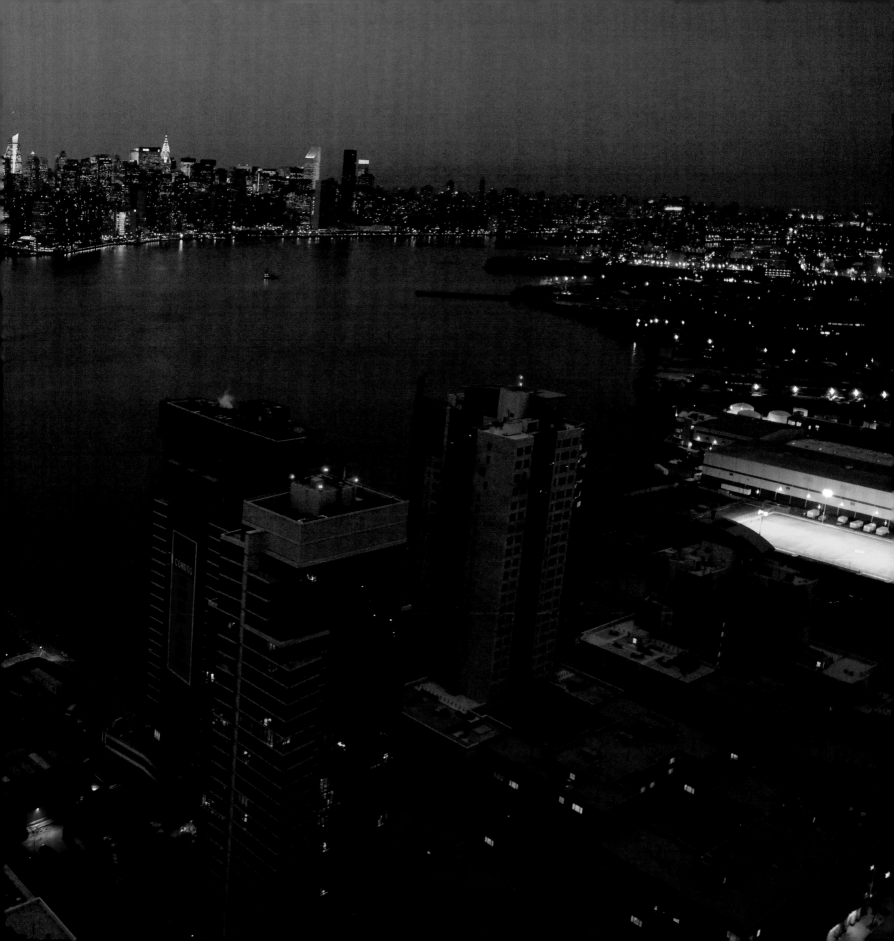

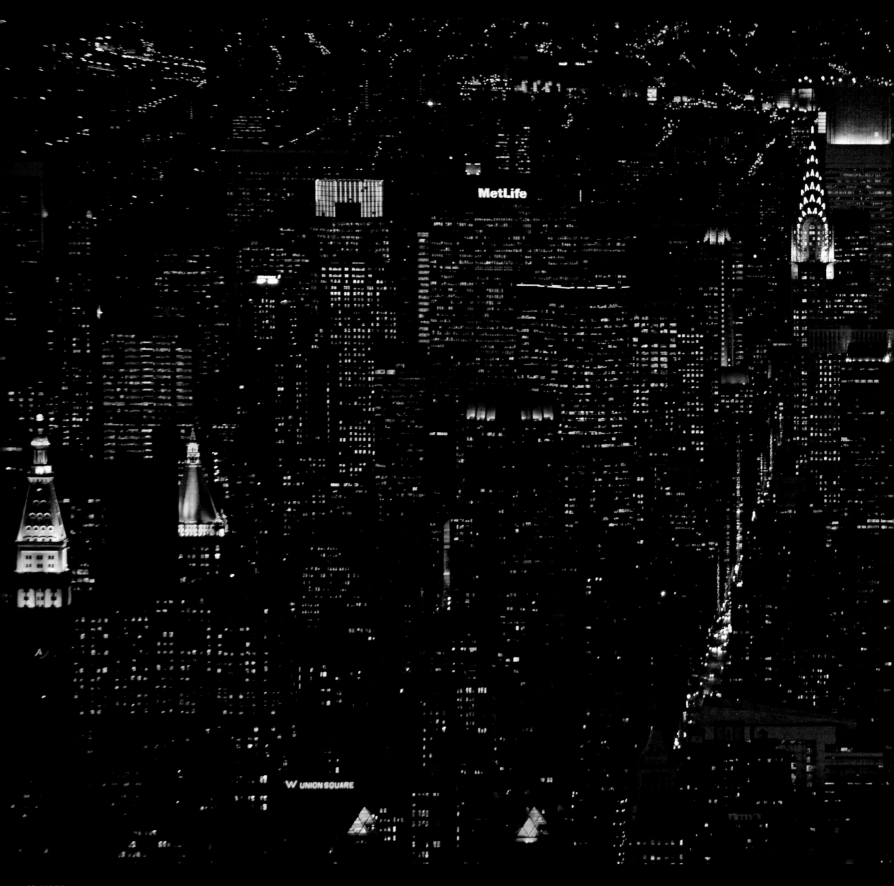

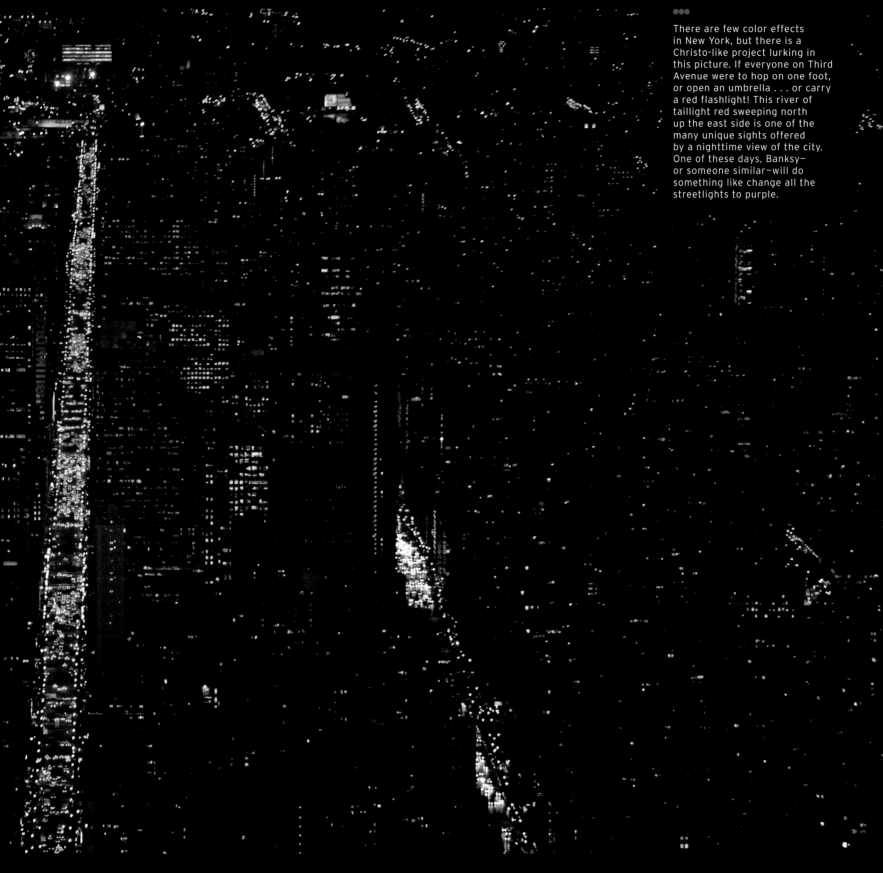

There are few color effects
in New York, but there is a
Christo-like project lurking in
this picture. If everyone on Third
Avenue were to hop on one foot,
or open an umbrella . . . or carry
a red flashlight! This river of
taillight red sweeping north
up the east side is one of the
many unique sights offered
by a nighttime view of the city.
One of these days, Banksy—
or someone similar—will do
something like change all the
streetlights to purple.

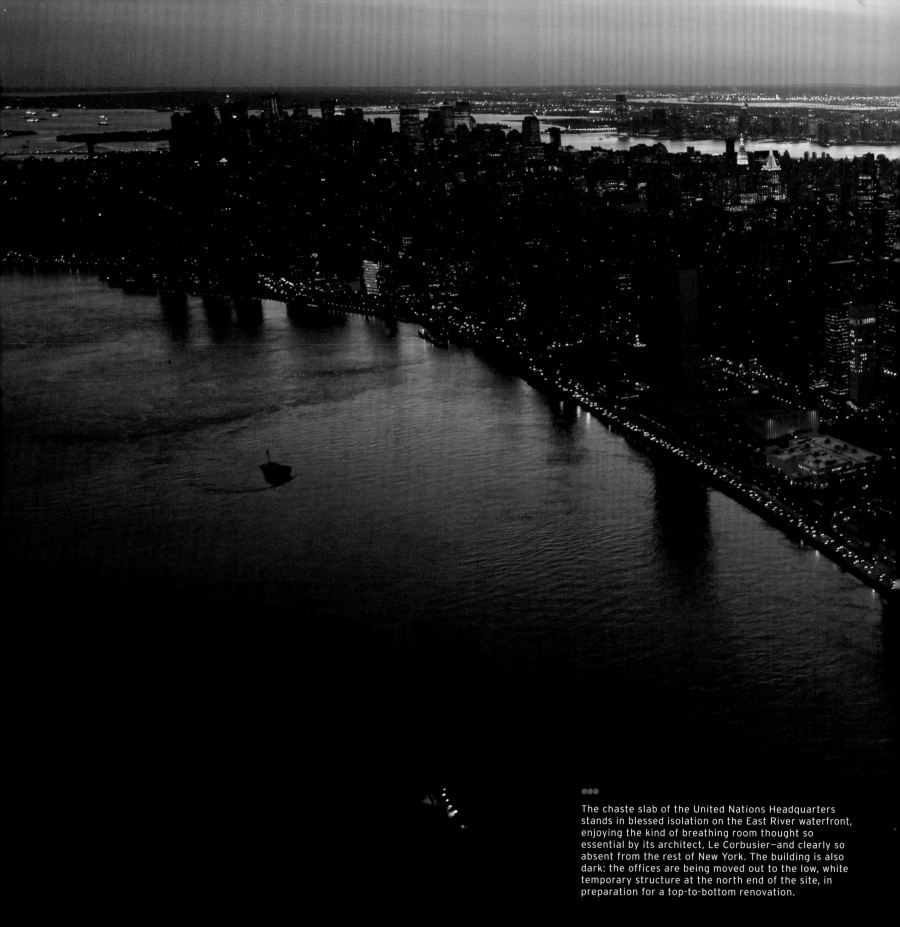

●●●
The chaste slab of the United Nations Headquarters stands in blessed isolation on the East River waterfront, enjoying the kind of breathing room thought so essential by its architect, Le Corbusier—and clearly so absent from the rest of New York. The building is also dark: the offices are being moved out to the low, white temporary structure at the north end of the site, in preparation for a top-to-bottom renovation.

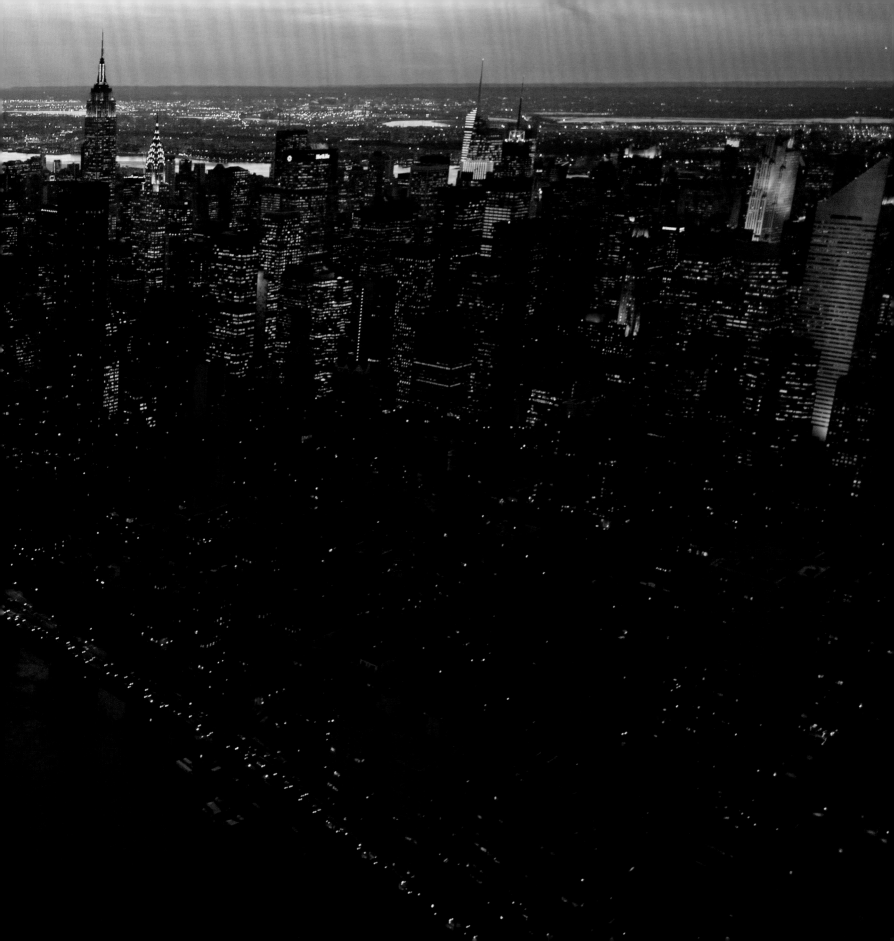

UPTOWN

To New Yorkers, "uptown" is mostly a direction: "Uptown and the Bronx," it reads on subway signs. New Yorkers know the sun sets in the west, but are a little hazy when it comes to the other cardinal points.

To black New Yorkers, "uptown" has a homeland connotation: uptown is Harlem, north of 110th Street, the center of black life since the early 1900s, a refuge from the white (or, these days, formerly white) city. A linguistic curiosity is that the black uptown ends around 155th Street; indeed, it's possible to journey downtown to get to uptown.

But that uptown is a minority usage: in most lexicons, uptown begins at the residential districts flanking Central Park. Each district developed in different ways. The upper east side was initially populated with early nineteenth-century summer estates along the East River. These estates were then supplanted, first by a broad spine of development on either side of the intercity Boston Post Road (roughly Third to Second avenues), and secondly by the building of a series of successively rapid-er transit systems over the course of a century, from a railroad under Fourth (now Park) Avenue in the 1830s to the Lexington Avenue subway of the 1910s. This staggered creation of a transportation network resulted in the east-side bouillabaisse of old frame farmhouses, mid-century brownstones, mansions from the Belle Epoque, and fancy apartment houses of the 1920s and their post–Second World War glitzy substitutes.

The west side, by contrast, was built up in just two episodes, the first following the arrival of an elevated train in 1881, and the second the opening of the Broadway subway in 1904. Thus, while the east side is like a porcupine, with tall apartment buildings sprinkled evenly across its breadth, the west side still has that sawtooth effect, tall apartments on the avenues and prairie-like ranges of rowhouses at midblock.

In the twentieth century, it was common for eastsiders to be considered snobby, and profess ignorance of west-side geography ("Reginald, what *is* the difference between those confusing Columbus and Amsterdam avenues?"). Westsiders, meanwhile, were dyed-in-the-wool liberal democrats who would never, ever dream of living in something so haute bourgeois as an east-side coop. Today, there are plenty of $5-million apartments over on the Democrat-favoring west side, and probably a few Republicans. Times, and people, have changed.

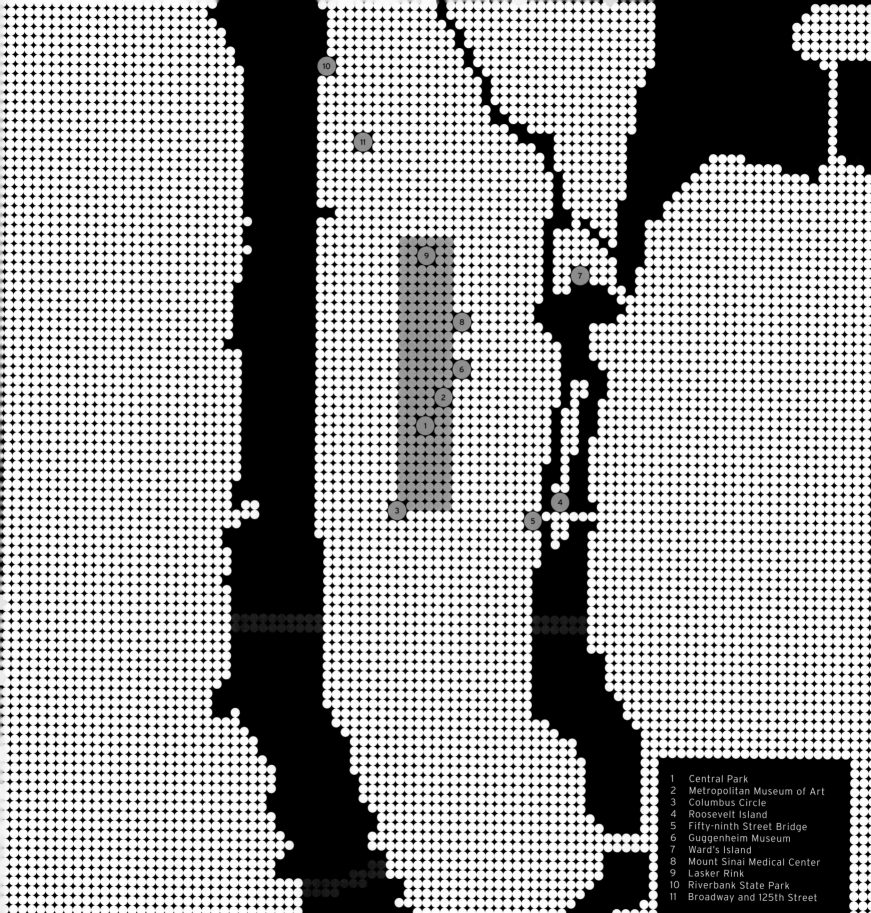

1 Central Park
2 Metropolitan Museum of Art
3 Columbus Circle
4 Roosevelt Island
5 Fifty-ninth Street Bridge
6 Guggenheim Museum
7 Ward's Island
8 Mount Sinai Medical Center
9 Lasker Rink
10 Riverbank State Park
11 Broadway and 125th Street

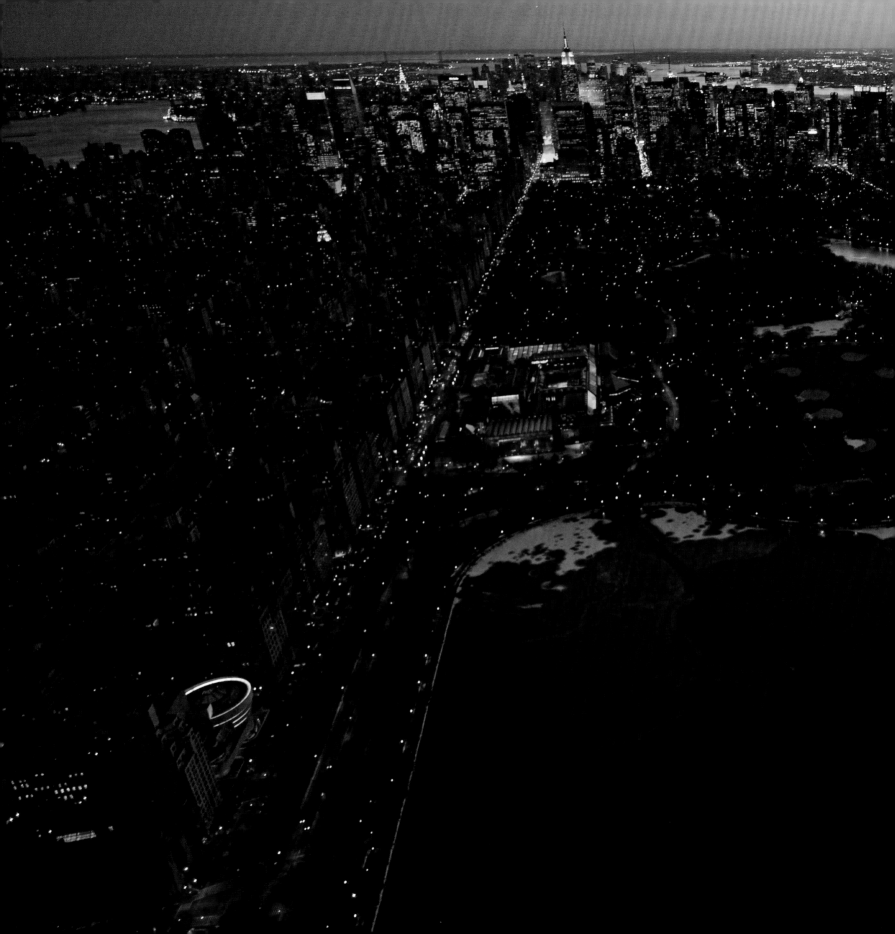

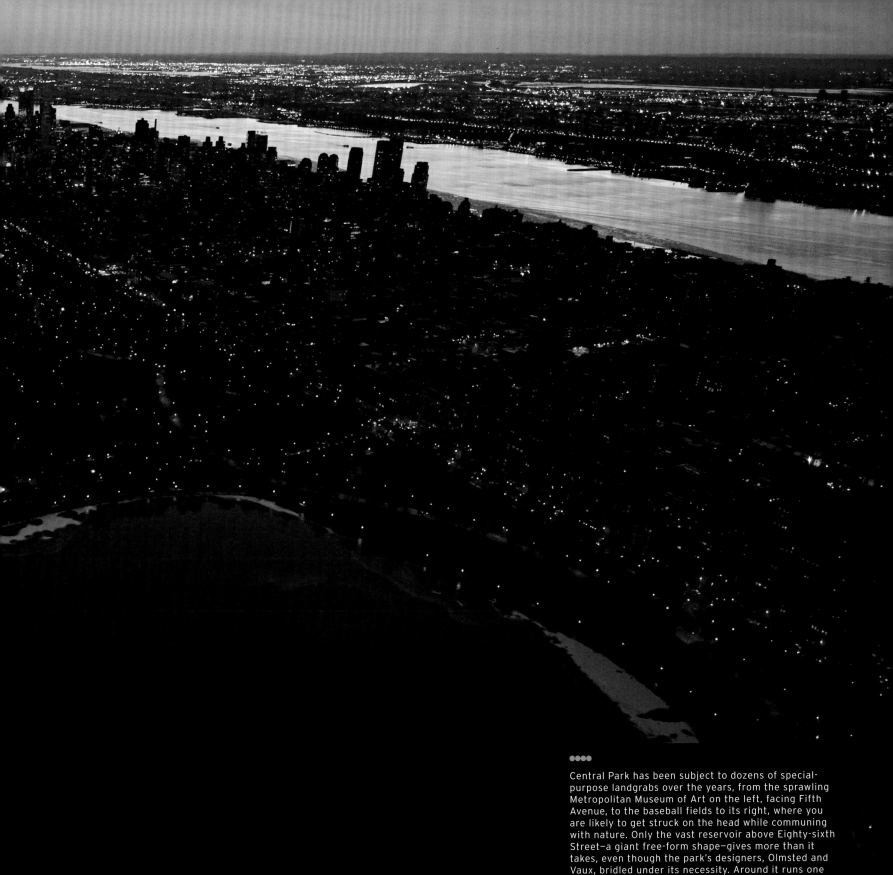

●●●●

Central Park has been subject to dozens of special-purpose landgrabs over the years, from the sprawling Metropolitan Museum of Art on the left, facing Fifth Avenue, to the baseball fields to its right, where you are likely to get struck on the head while communing with nature. Only the vast reservoir above Eighty-sixth Street—a giant free-form shape—gives more than it takes, even though the park's designers, Olmsted and Vaux, bridled under its necessity. Around it runs one of the most spectacular promenades, free of everything but wildfowl and an occasional raccoon. A blessing

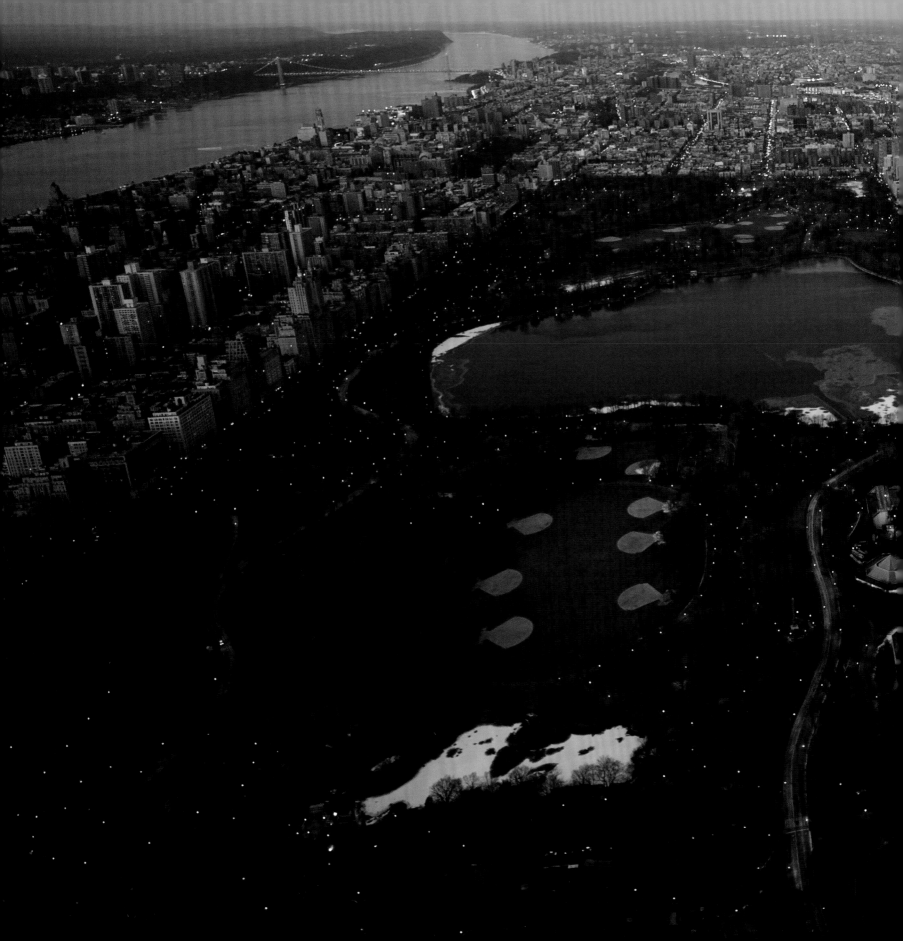

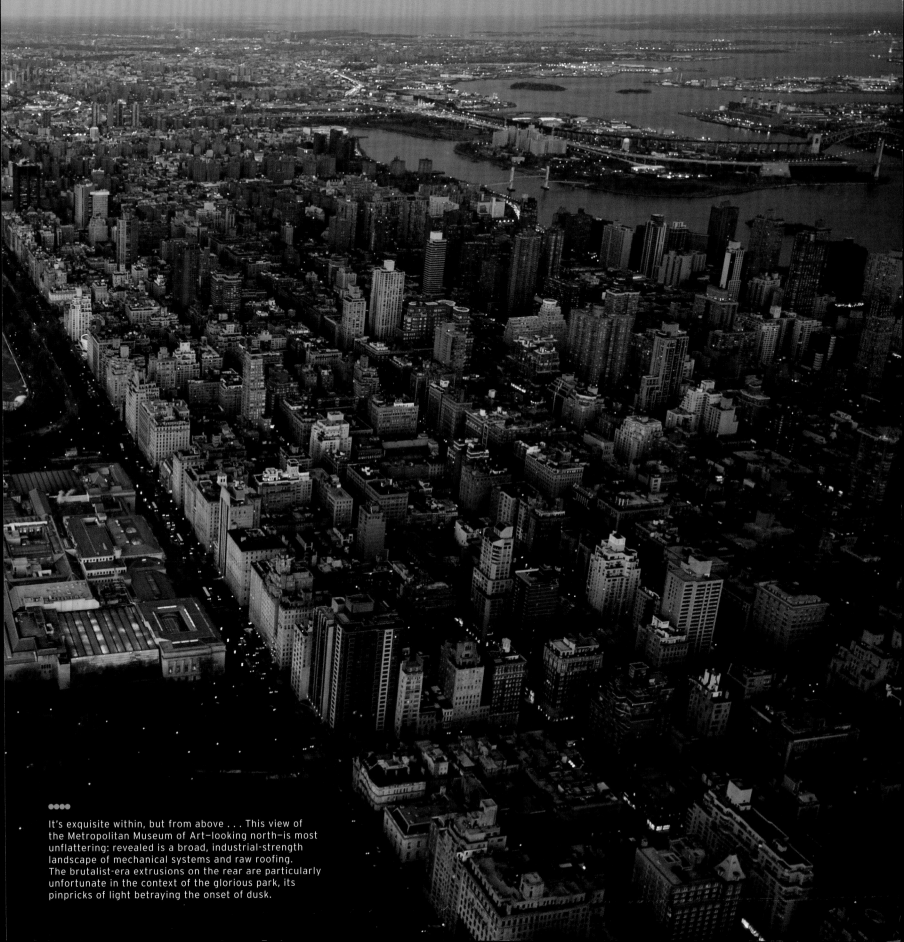

●●●●
It's exquisite within, but from above . . . This view of
the Metropolitan Museum of Art—looking north—is most
unflattering: revealed is a broad, industrial-strength
landscape of mechanical systems and raw roofing.
The brutalist-era extrusions on the rear are particularly
unfortunate in the context of the glorious park, its
pinpricks of light betraying the onset of dusk.

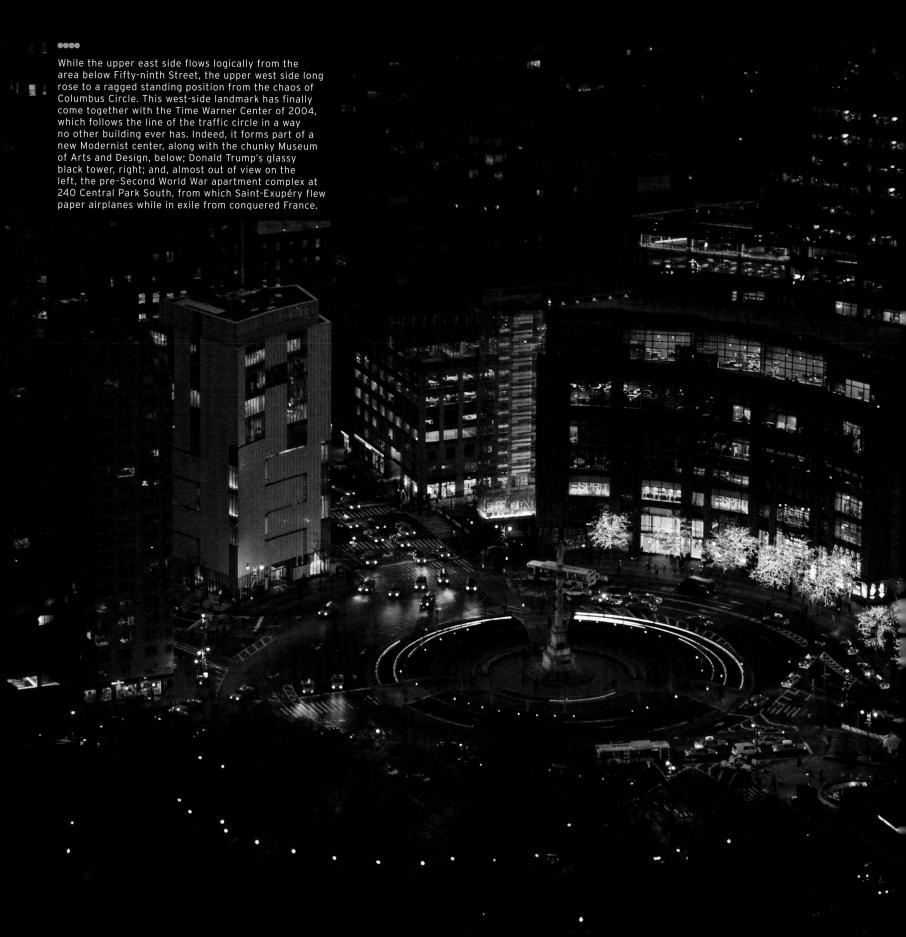

While the upper east side flows logically from the area below Fifty-ninth Street, the upper west side long rose to a ragged standing position from the chaos of Columbus Circle. This west-side landmark has finally come together with the Time Warner Center of 2004, which follows the line of the traffic circle in a way no other building ever has. Indeed, it forms part of a new Modernist center, along with the chunky Museum of Arts and Design, below; Donald Trump's glassy black tower, right; and, almost out of view on the left, the pre–Second World War apartment complex at 240 Central Park South, from which Saint-Exupéry flew paper airplanes while in exile from conquered France.

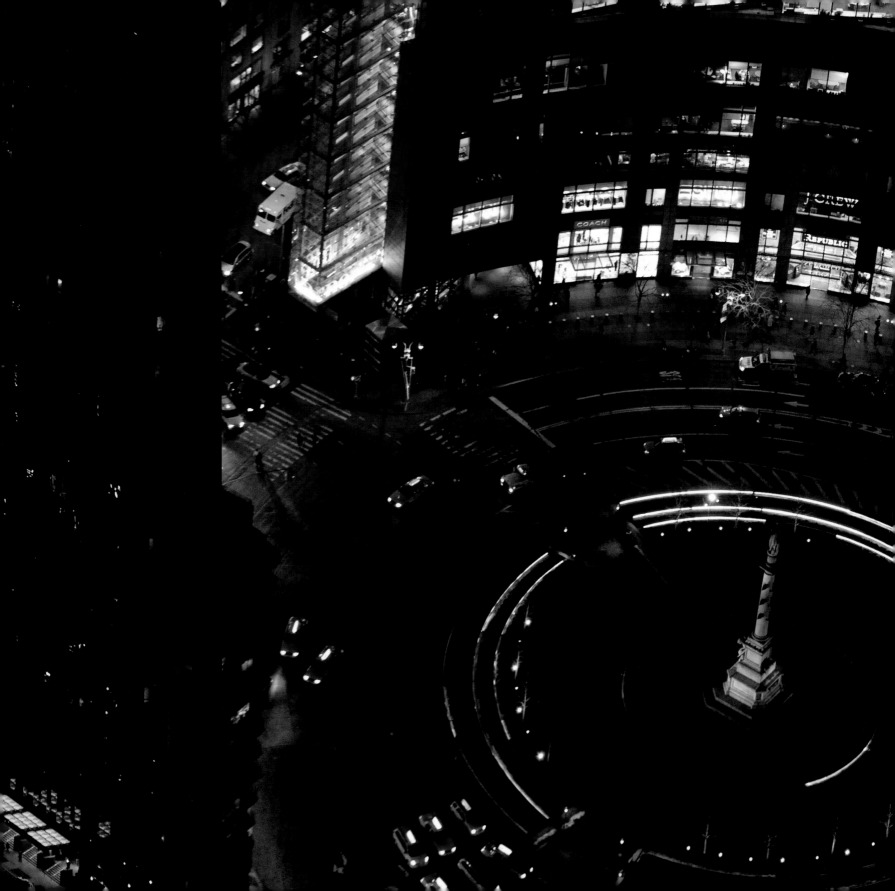

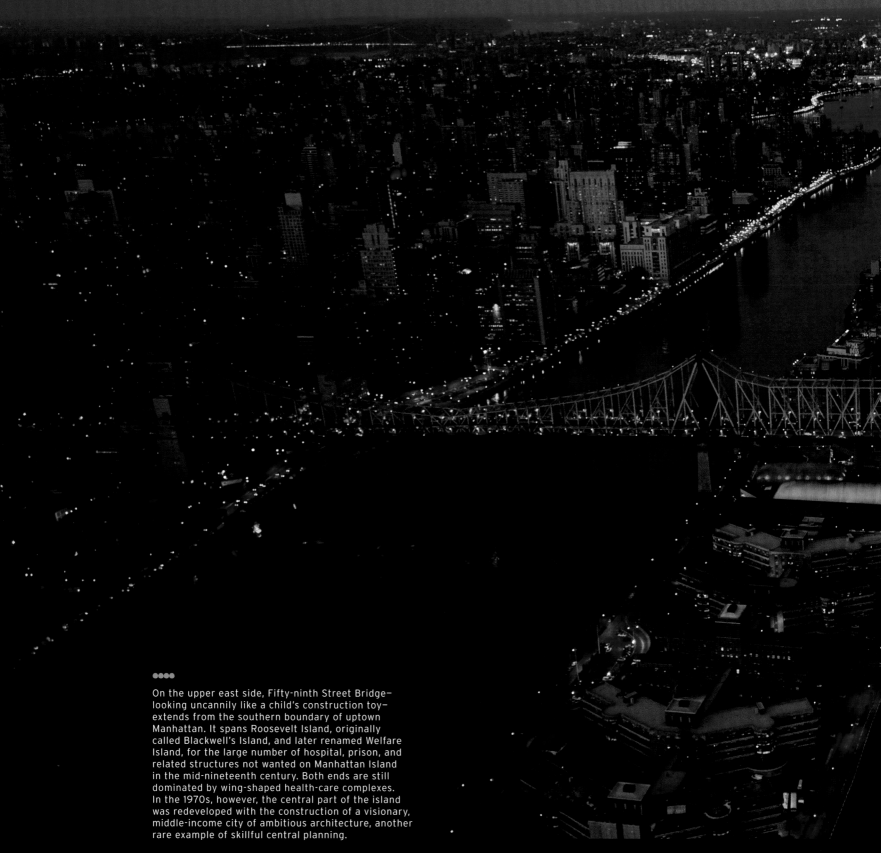

On the upper east side, Fifty-ninth Street Bridge—
looking uncannily like a child's construction toy—
extends from the southern boundary of uptown
Manhattan. It spans Roosevelt Island, originally
called Blackwell's Island, and later renamed Welfare
Island, for the large number of hospital, prison, and
related structures not wanted on Manhattan Island
in the mid-nineteenth century. Both ends are still
dominated by wing-shaped health-care complexes.
In the 1970s, however, the central part of the island
was redeveloped with the construction of a visionary,
middle-income city of ambitious architecture, another
rare example of skillful central planning.

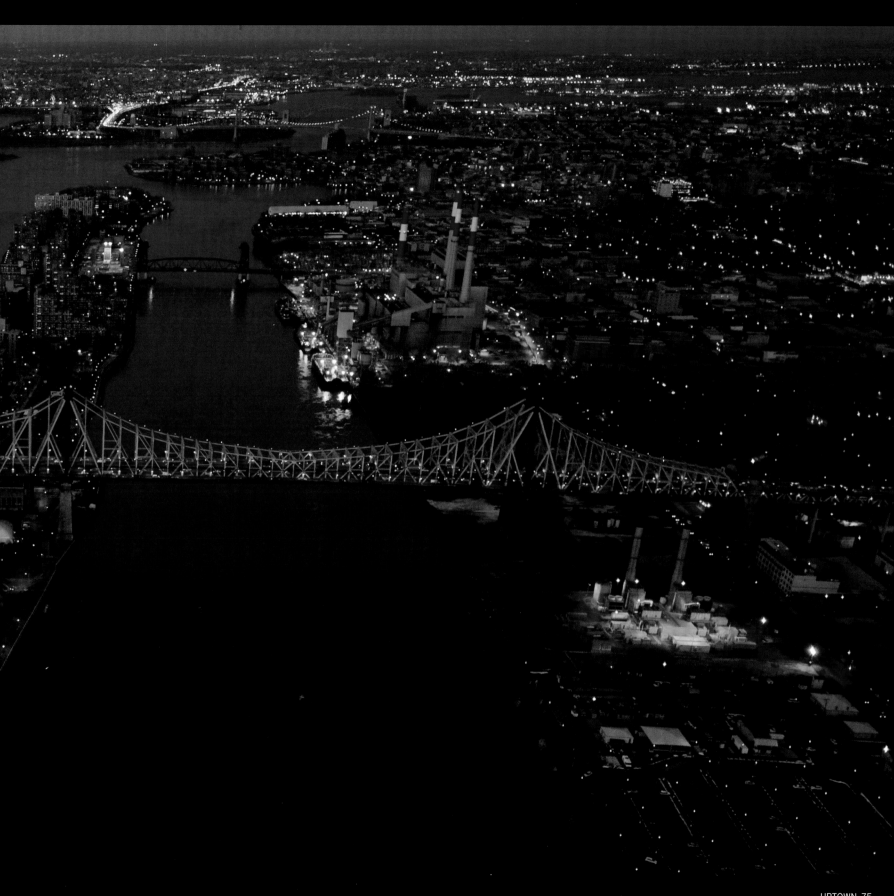

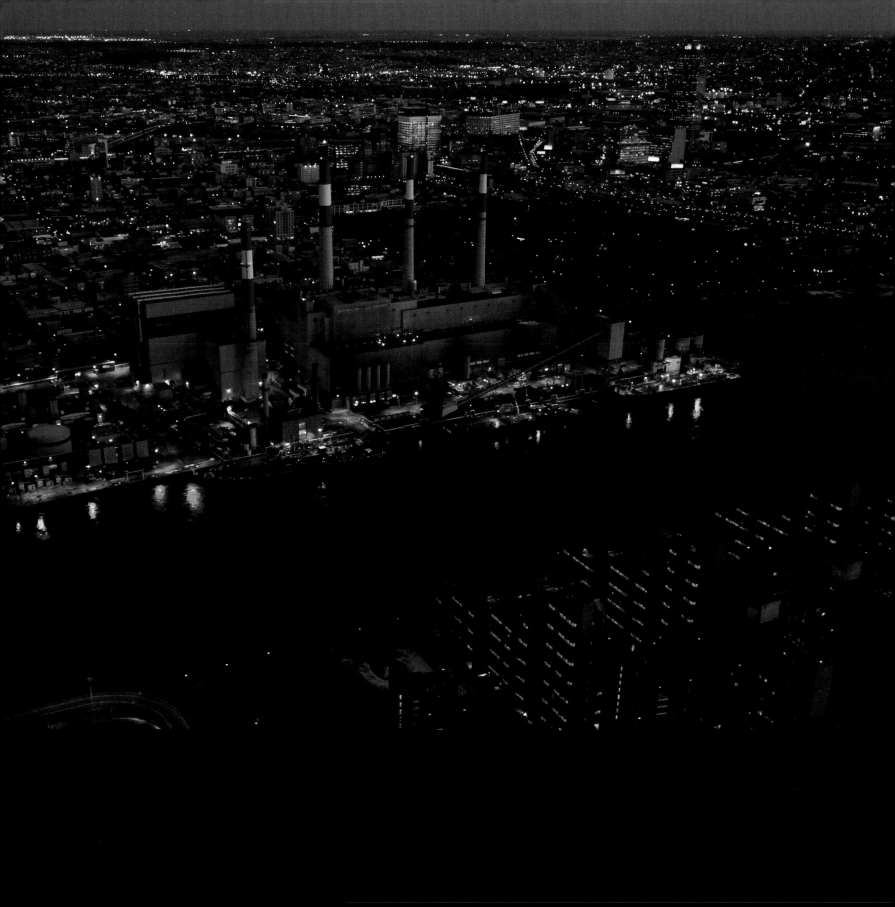

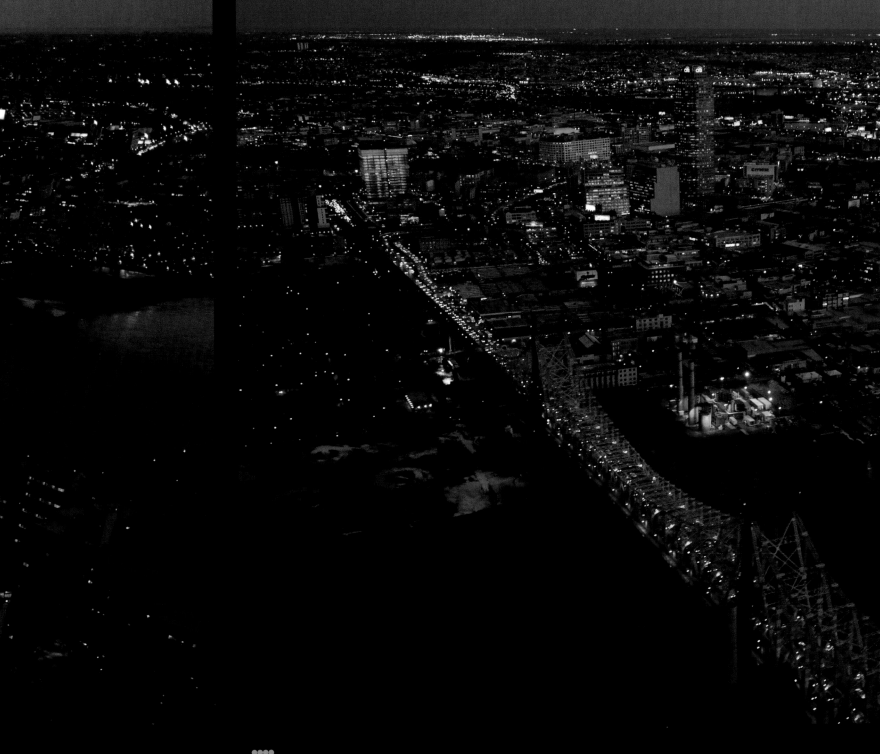

●●●●

Unlike almost all other riverfront buildings in New York,
the apartment blocks on Roosevelt Island—standing
directly opposite the Ravenswood power plant—actually
respond to the water, stepping down as they reach the
shoreline, instead of getting higher for the maximum
number of plutocratic views. Above, the Fifty-ninth
Street Bridge—located to the south of the apartment
blocks—is shown before its nighttime lighting has been
turned on. Might the internal illumination of roadway
lamps and cars suggest that the traditional necklace
of white lights is not the only way to light a bridge?

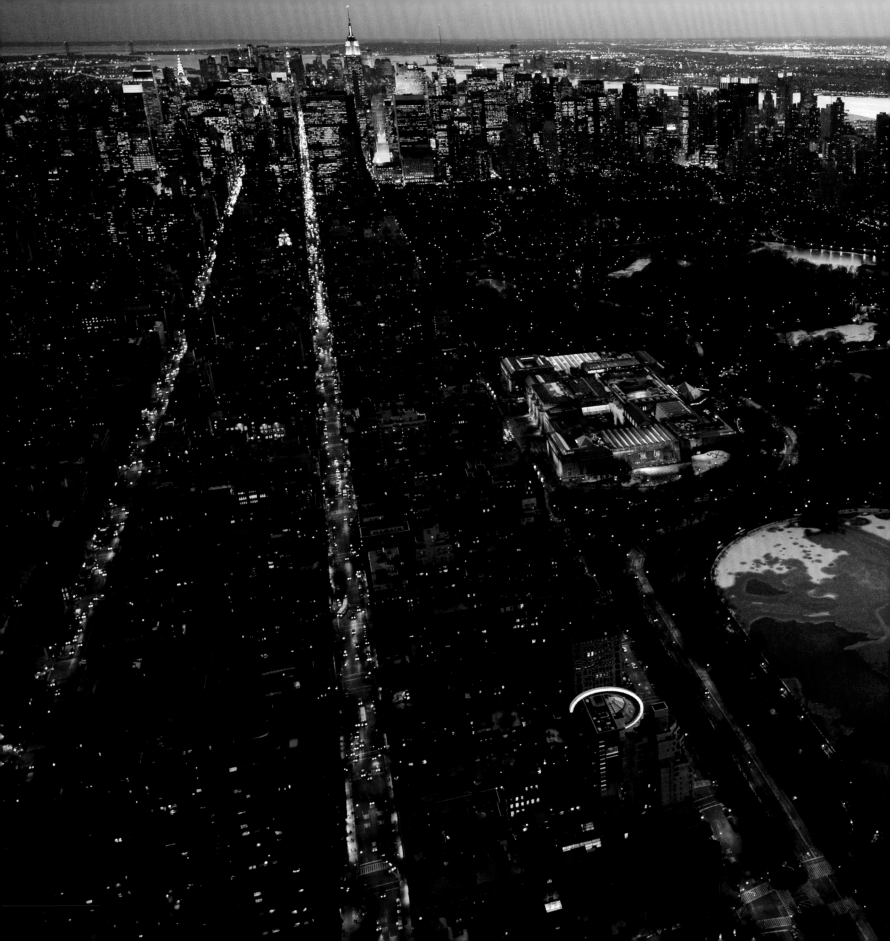

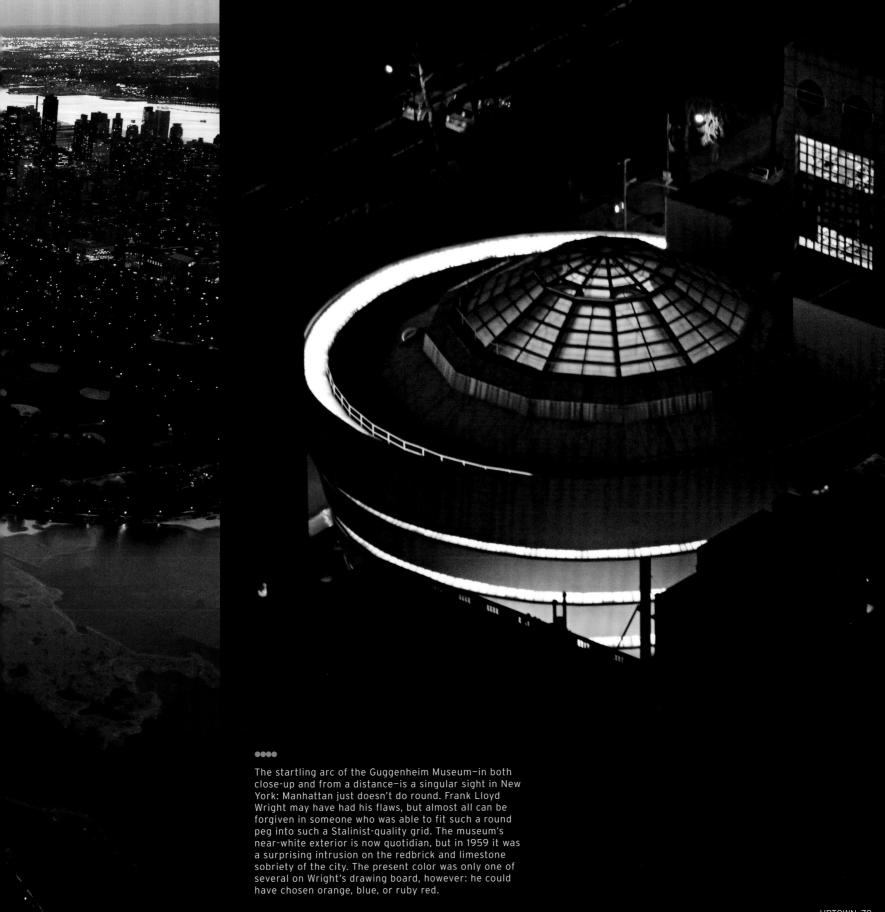

●●●●

The startling arc of the Guggenheim Museum—in both
close-up and from a distance—is a singular sight in New
York: Manhattan just doesn't do round. Frank Lloyd
Wright may have had his flaws, but almost all can be
forgiven in someone who was able to fit such a round
peg into such a Stalinist-quality grid. The museum's
near-white exterior is now quotidian, but in 1959 it was
a surprising intrusion on the redbrick and limestone
sobriety of the city. The present color was only one of
several on Wright's drawing board, however: he could
have chosen orange, blue, or ruby red.

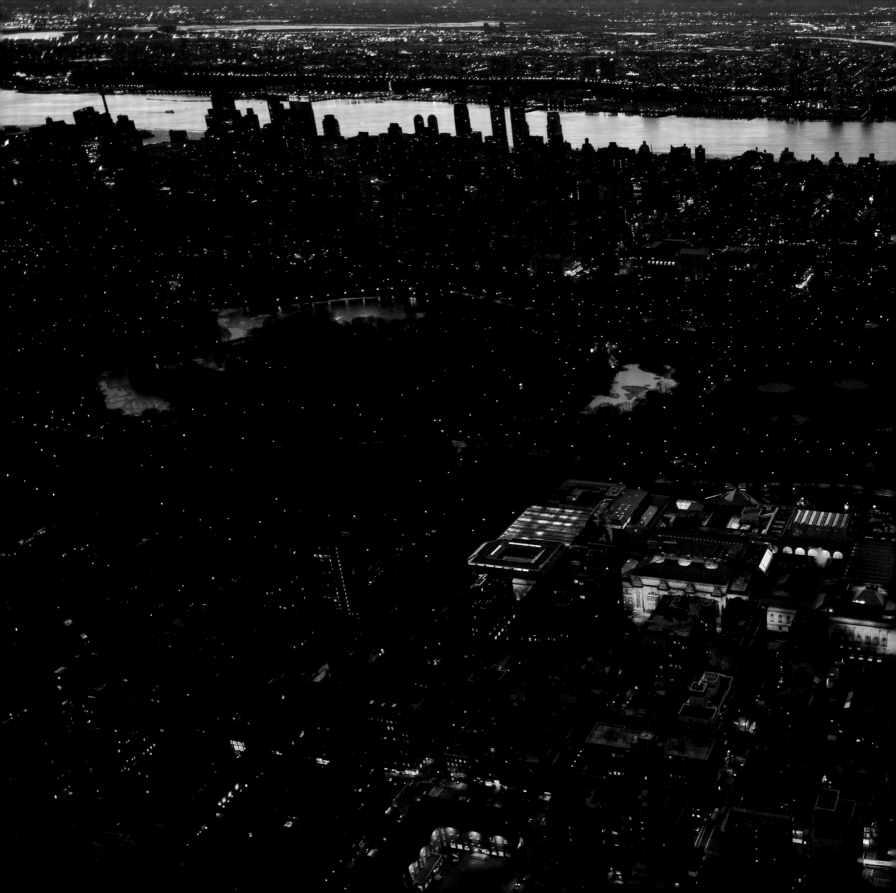

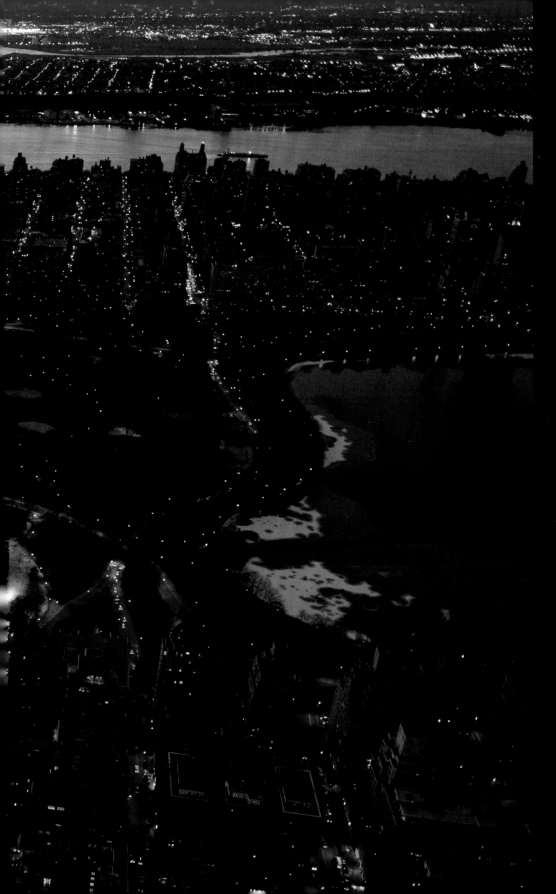

The Fifth Avenue front of the Metropolitan Museum of Art, all aglow in the twilight, is a magnificent piece of Beaux Arts city-building, especially the central portion from 1902, a kind of European opera house/rail station/palace. Unfortunately, the limestone classicism of the museum's façade has to compete with the jammed-in, by-the-yard real estate directly opposite. Unfair!

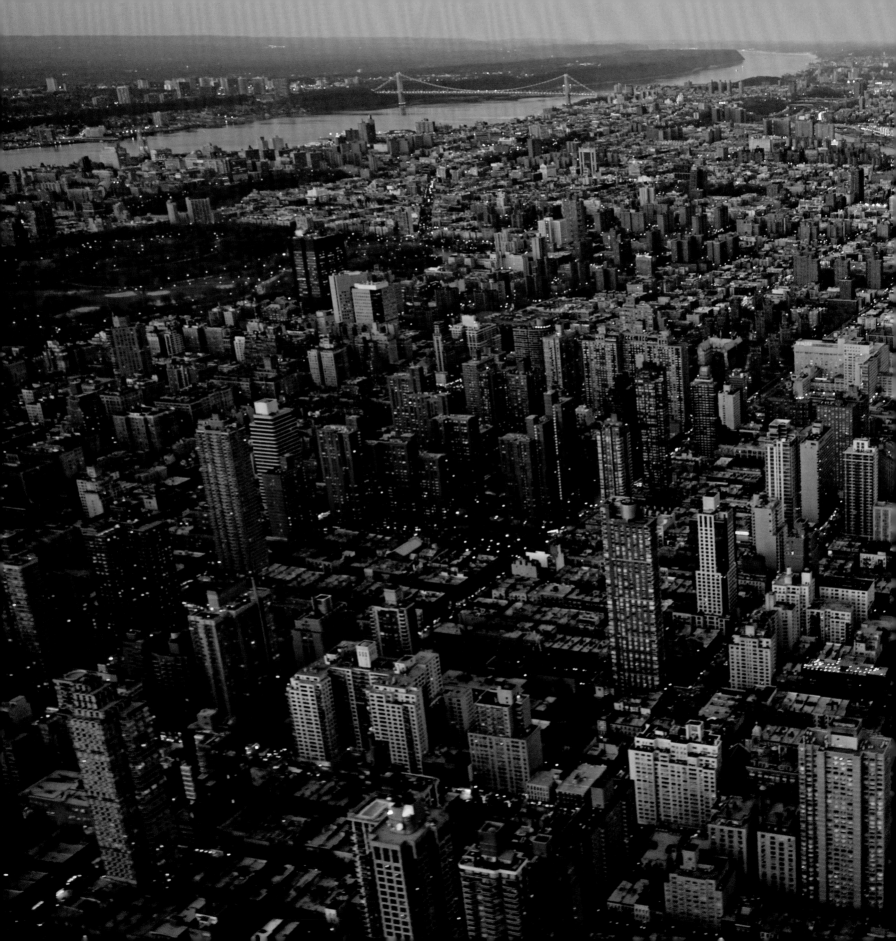

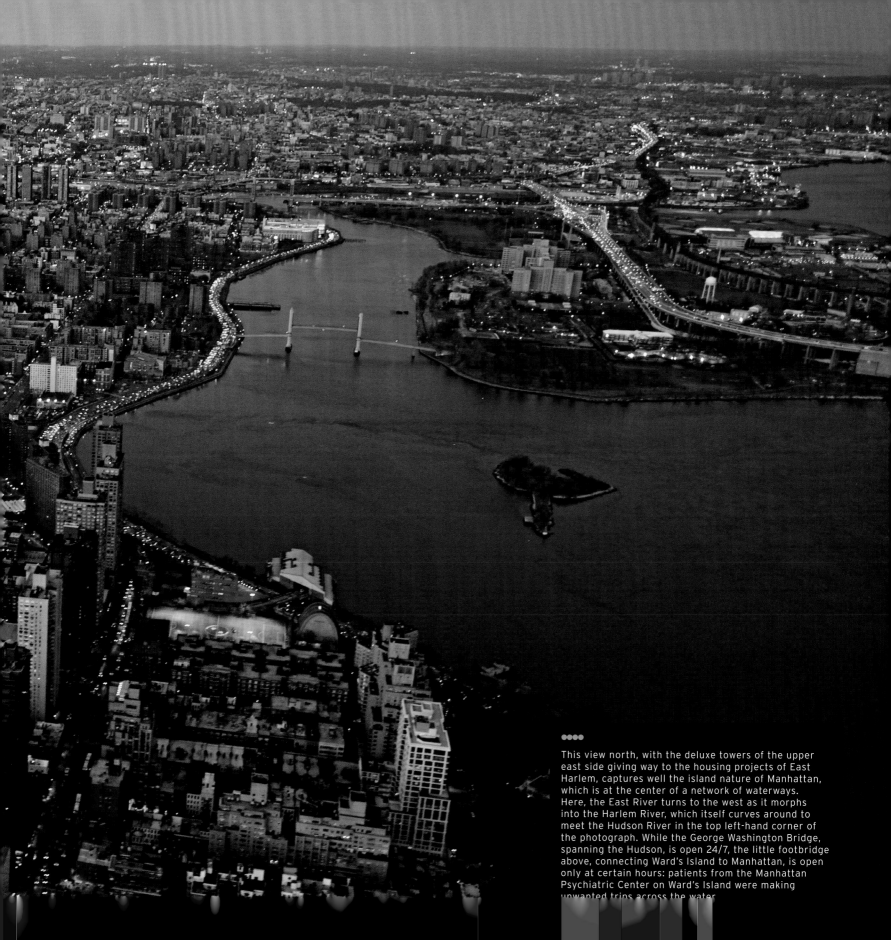

••••

This view north, with the deluxe towers of the upper east side giving way to the housing projects of East Harlem, captures well the island nature of Manhattan, which is at the center of a network of waterways. Here, the East River turns to the west as it morphs into the Harlem River, which itself curves around to meet the Hudson River in the top left-hand corner of the photograph. While the George Washington Bridge, spanning the Hudson, is open 24/7, the little footbridge above, connecting Ward's Island to Manhattan, is open only at certain hours: patients from the Manhattan Psychiatric Center on Ward's Island were making unwanted trips across the water.

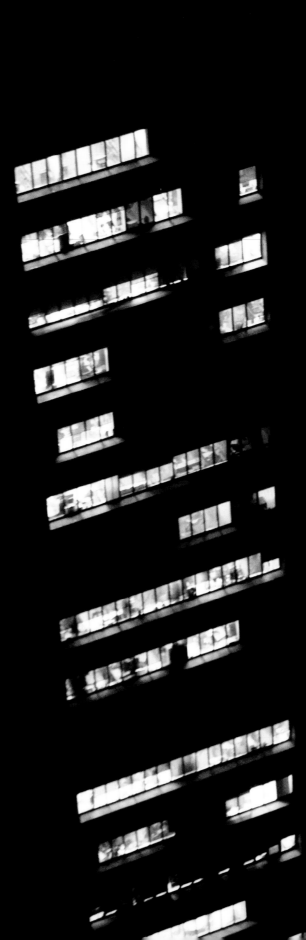
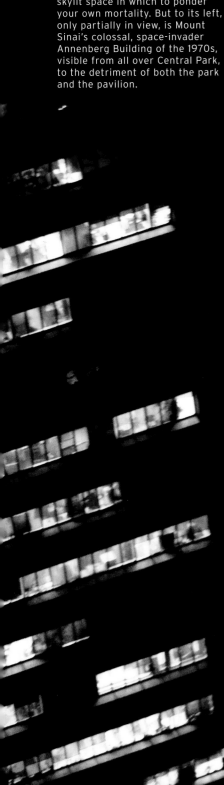

The angular Guggenheim Pavilion—part of Mount Sinai Medical Center, located on the upper east side—was designed by I.M. Pei and his firm. Built around 1990, it represents an exceptional piece of architecture for a health-care client, with a giant, hopeful, skylit space in which to ponder your own mortality. But to its left, only partially in view, is Mount Sinai's colossal, space-invader Annenberg Building of the 1970s, visible from all over Central Park, to the detriment of both the park and the pavilion.

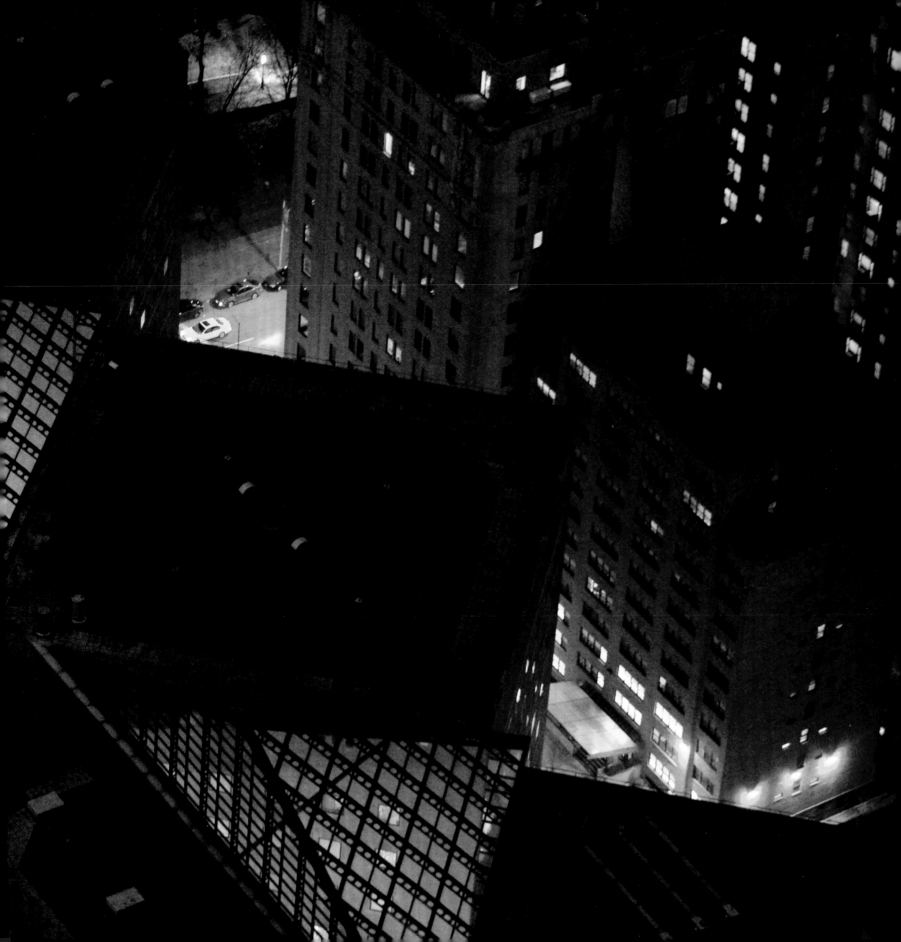

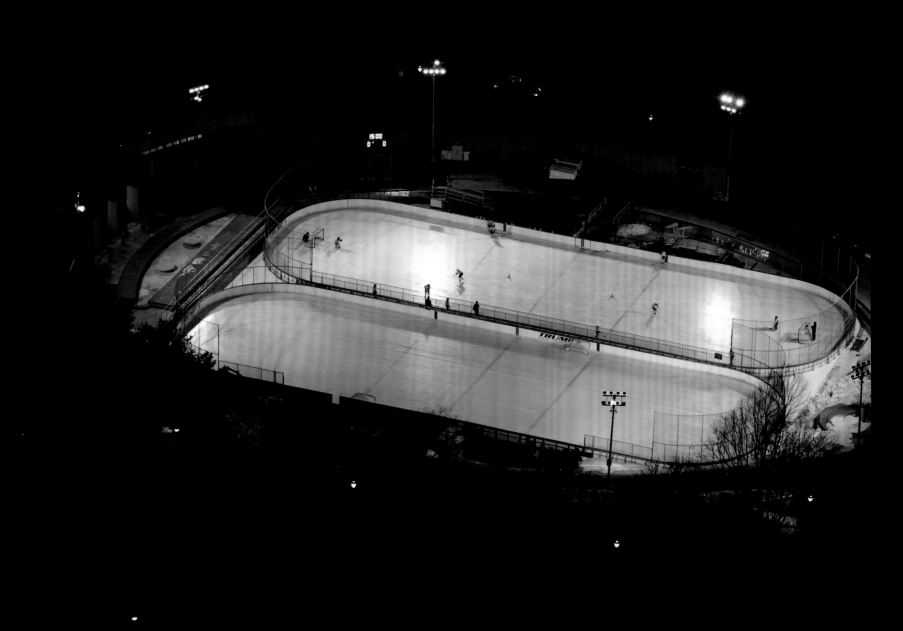

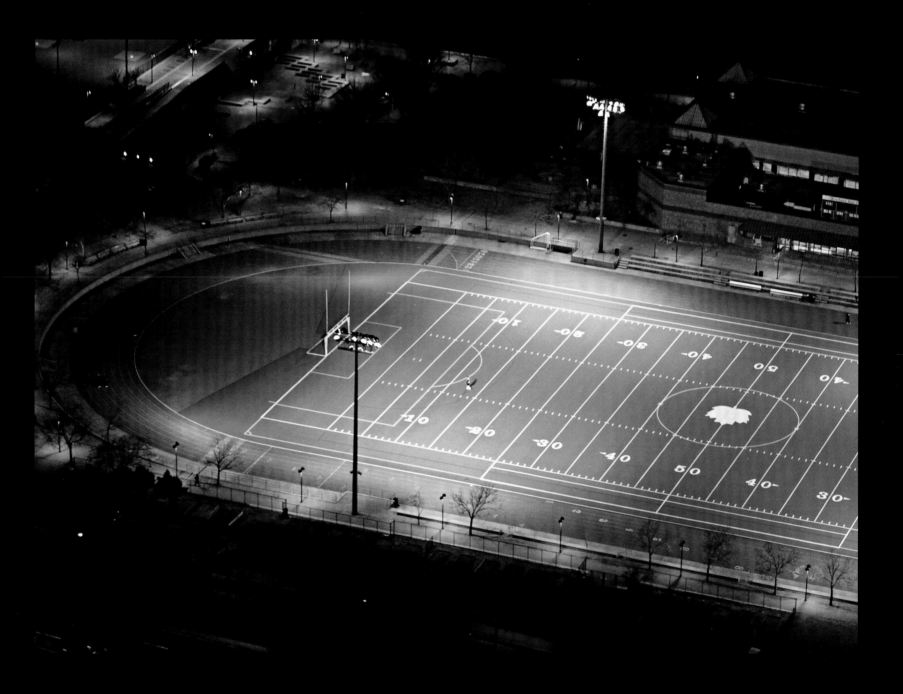

●●●●
From the air, the city's sports facilities (along with its bridges) are unmistakable landmarks of the night. Lasker Rink (opposite), at the north end of Central Park, becomes a single giant swimming pool in the summer. At Riverbank State Park, a 28-acre recreational and cultural complex overlooking the Hudson at 145th Street, floodlights illuminate the near-deserted running track.

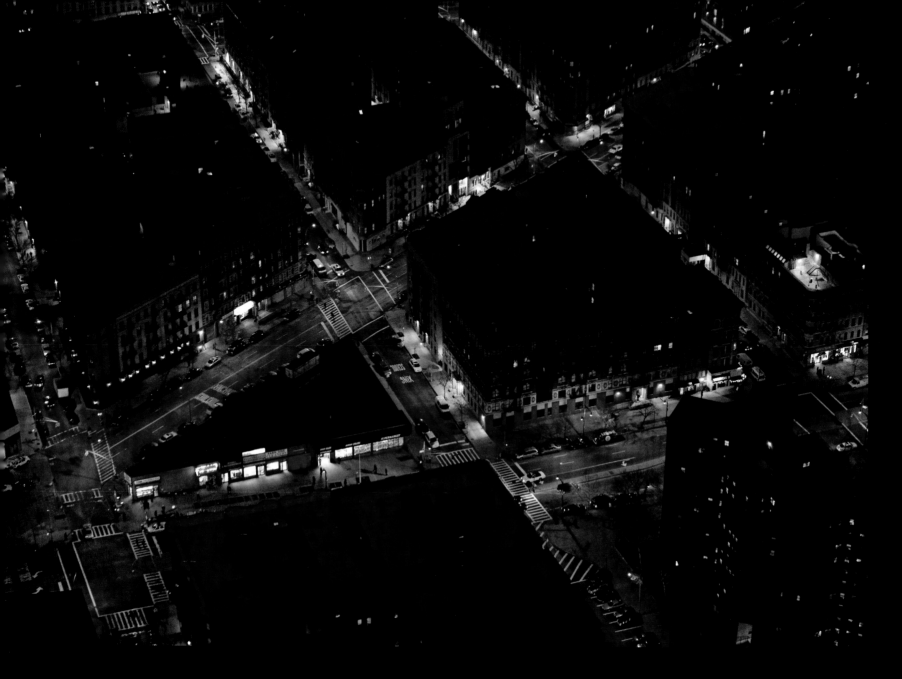

●●●●

The low-rise buildings of Harlem show off Manhattan's occasional diagonals, which the taller sections of the city often conceal. Opposite, running top to bottom, is West 125th Street, one of a handful of numbered streets that diverge from the lockstep orientation of the rest of Manhattan's (nominally) east-west thoroughfares. Harlem's principal cross-street, 125th follows an ancient fault line all the way to the Hudson River. Here, it's traversed by a majestic arch of the above-ground section of the Broadway subway system.

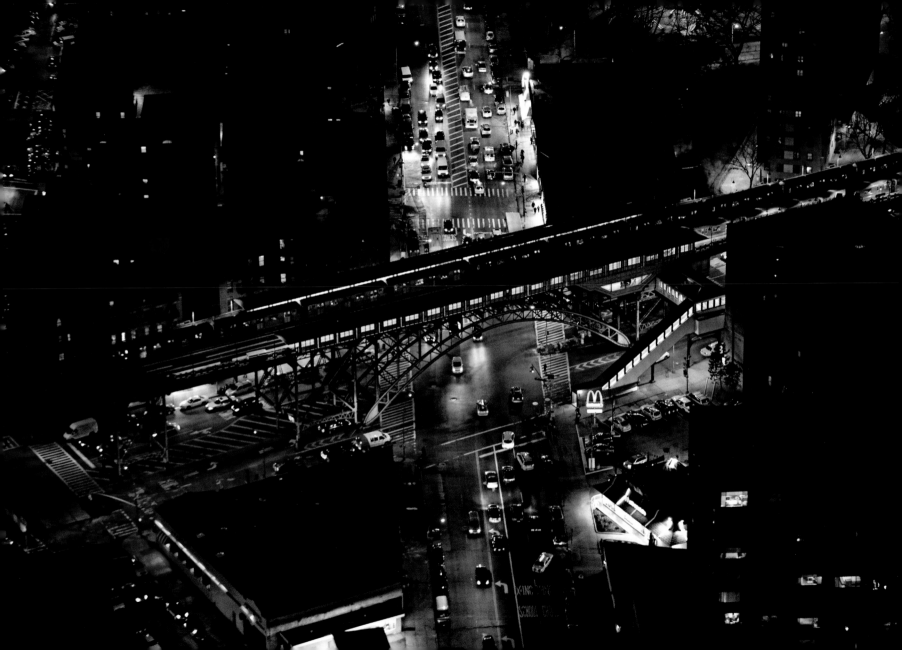

New York's "first skyscraper" is like the fabled Lost City of Gold: everybody's looking for it, but nobody's ever going to find it. Was it the first building to have an elevator? Well, maybe, but that was an industrial building, only five or so stories high—no bigger than its un-elevatored cousins. Was it the first building to use a metal frame? Perhaps, but that was a metal frame that had been stacked on top of an old-fashioned brick structure.

Despite this murky past, New York is the preeminent city of skyscrapers, at first called "cloud-scratchers" and "sky-scratchers." Although the development of the tall building is always viewed through the lens of structural advances, what really made it possible in New York was the arrival of rapid transit: the elevated rail lines of the 1870s, and the subways after 1900. It's one thing to build a lot of offices on top of one another, but quite another to fill them up. The rail lines extended the catchment area tremendously: in 1850, any commute to the financial district was impossible if you lived north of Thirty-fourth Street; by 1880, you could get there from the north end of Central Park. The subway system extended this range up to all but the farthest reaches of the outer boroughs, and that's not including the trans-Hudson tubes. If you still had to get to Wall Street by stagecoach, there would have been only one of them, five stories tall.

Real estate, it is generally accepted, is a no-nonsense, bottom-line enterprise. And yet the history of skyscraper construction is a tapestry of unrealistic, even romantic notions. The Metropolitan Life building's gold-topped tower at Twenty-fourth Street and Madison Avenue, built in 1909, was the tallest in the world for only a few years. The company paid a huge penalty for the tower's obelisk-shaped ten-story top, which contains little useful space, but was supposedly a payoff in terms of "prestige." Personally speaking, I have yet to retain an insurance company on the basis of the height of its buildings. The "tallest as advertisement" thread runs right up through the World Trade Center, which was economic only insofar as it was exempt from all building and fire-department codes.

Yet the quest for the tallest building in New York has led to the city's most distinctive characteristic—a spiky skyline unlike any other—and some of its most memorable architecture, practicality notwithstanding.

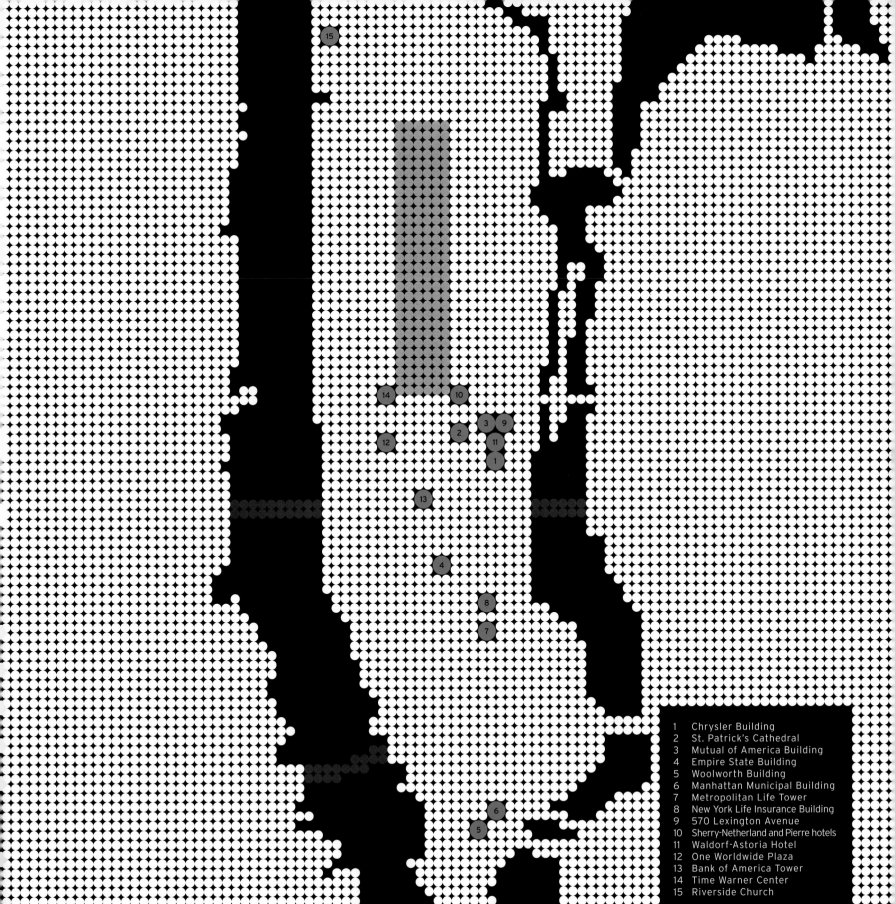

1 Chrysler Building
2 St. Patrick's Cathedral
3 Mutual of America Building
4 Empire State Building
5 Woolworth Building
6 Manhattan Municipal Building
7 Metropolitan Life Tower
8 New York Life Insurance Building
9 570 Lexington Avenue
10 Sherry-Netherland and Pierre hotels
11 Waldorf-Astoria Hotel
12 One Worldwide Plaza
13 Bank of America Tower
14 Time Warner Center
15 Riverside Church

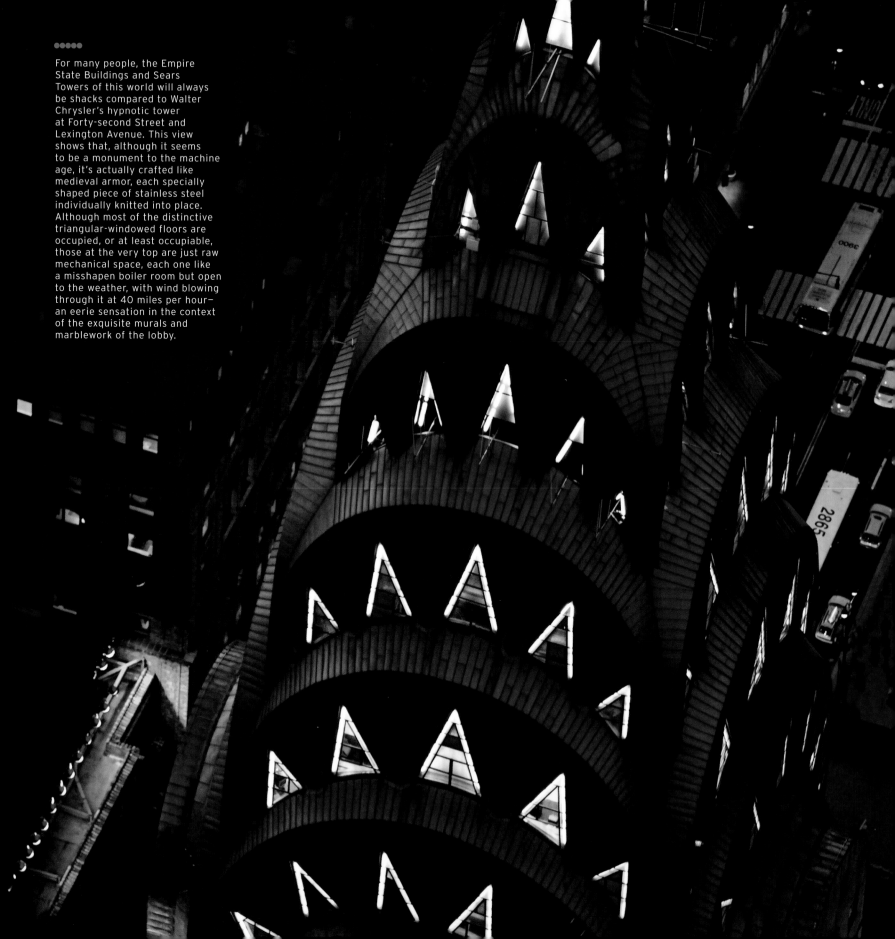

For many people, the Empire State Buildings and Sears Towers of this world will always be shacks compared to Walter Chrysler's hypnotic tower at Forty-second Street and Lexington Avenue. This view shows that, although it seems to be a monument to the machine age, it's actually crafted like medieval armor, each specially shaped piece of stainless steel individually knitted into place. Although most of the distinctive triangular-windowed floors are occupied, or at least occupiable, those at the very top are just raw mechanical space, each one like a misshapen boiler room but open to the weather, with wind blowing through it at 40 miles per hour—an eerie sensation in the context of the exquisite murals and marblework of the lobby.

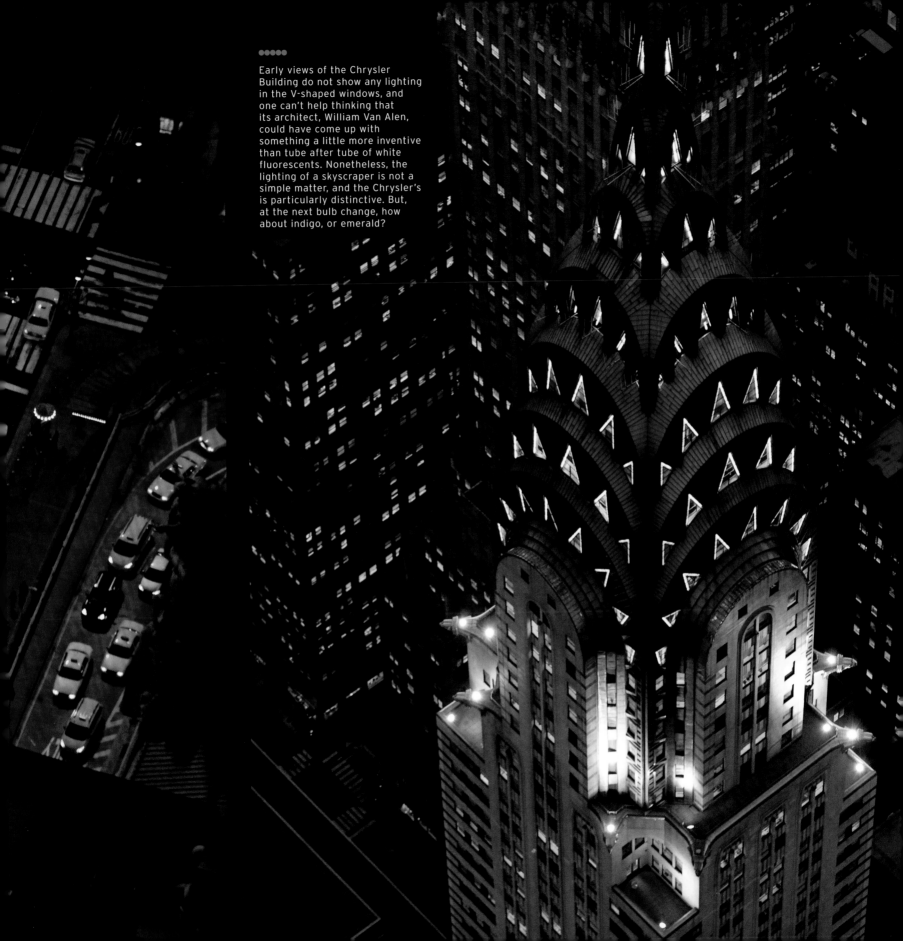

●●●●●
Early views of the Chrysler
Building do not show any lighting
in the V-shaped windows, and
one can't help thinking that
its architect, William Van Alen,
could have come up with
something a little more inventive
than tube after tube of white
fluorescents. Nonetheless, the
lighting of a skyscraper is not a
simple matter, and the Chrysler's
is particularly distinctive. But,
at the next bulb change, how
about indigo, or emerald?

●●●●●

There are several ways to light a tall building. As
one looks from left to right, the pyramidal cap of
One Worldwide Plaza glows from within like a jewel,
although, by day, the building's chunky structure is less
inspiring. Recently, the owners of the Chrysler Building
added floodlights to its triangular outlines—overkill,
perhaps? Partly visible, the MetLife Building is happy
with just its logo and name. The octagonal tower
of 383 Madison Avenue, formerly the Bear Stearns
Building, has a faceted screen of glass at the very top,
also lit from within, although it's not well distinguished
from the rest of the structure. Finally, the GE Building
uses the least ingenious solution—simple sprays of
floodlighting—but the shadowing on the severe, planar
walls gives it an effective, science-fiction character.

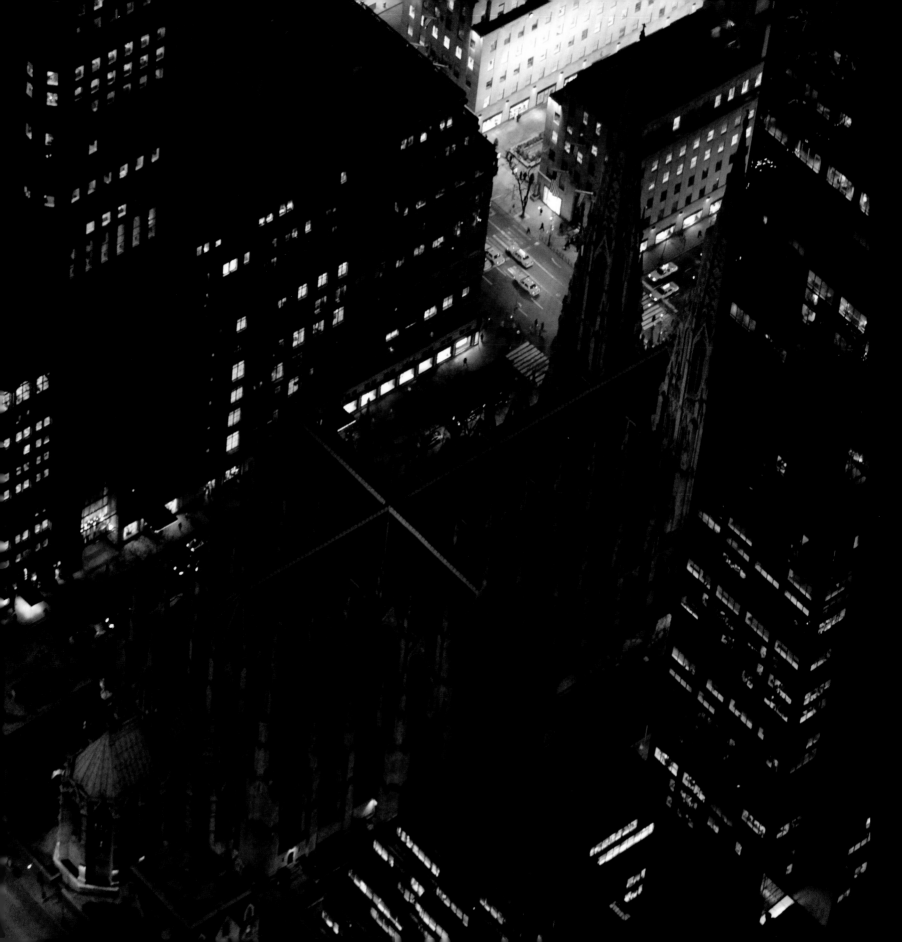

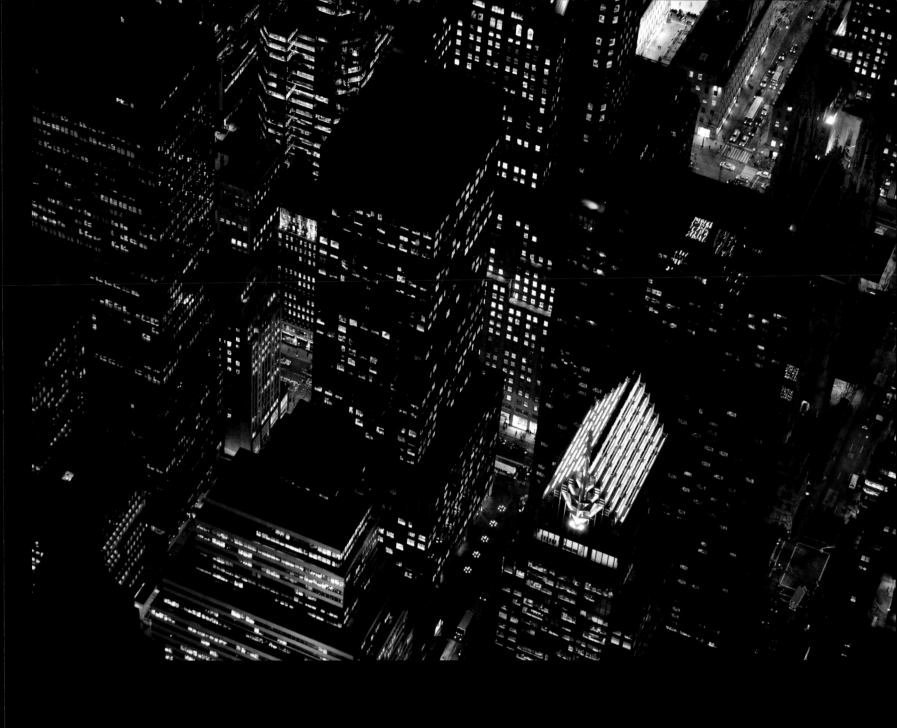

●●●●●

The Neo-Gothicism of St. Patrick's
Cathedral plays off nicely against
the proto-Modernism of the
Rockefeller Center, which stands
opposite (but out of sight) on the
other side of Fifth Avenue. Above,

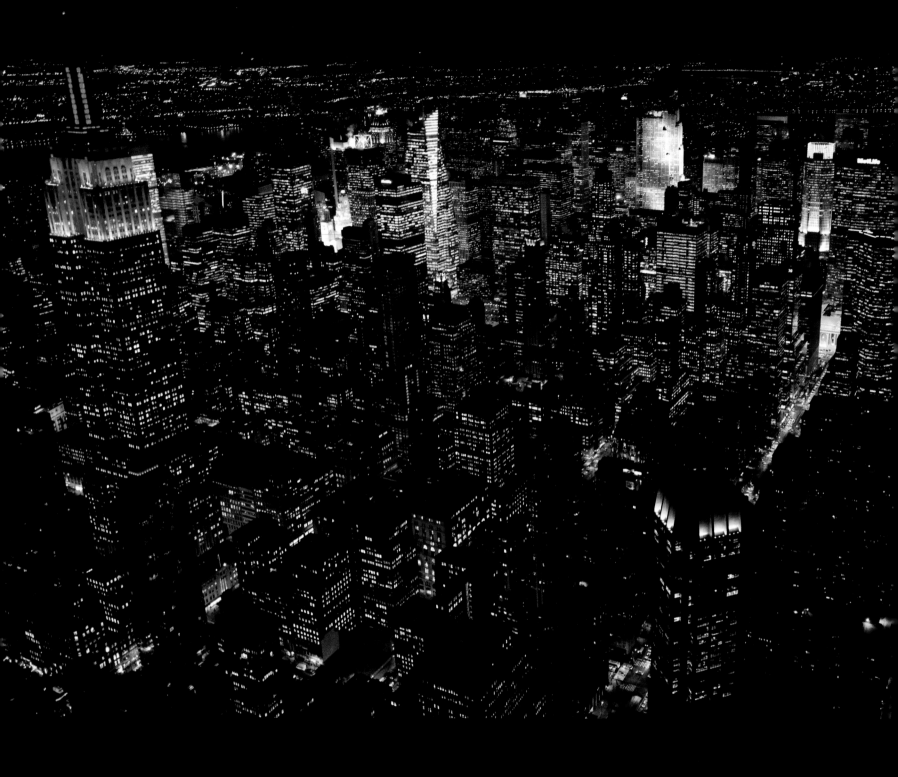

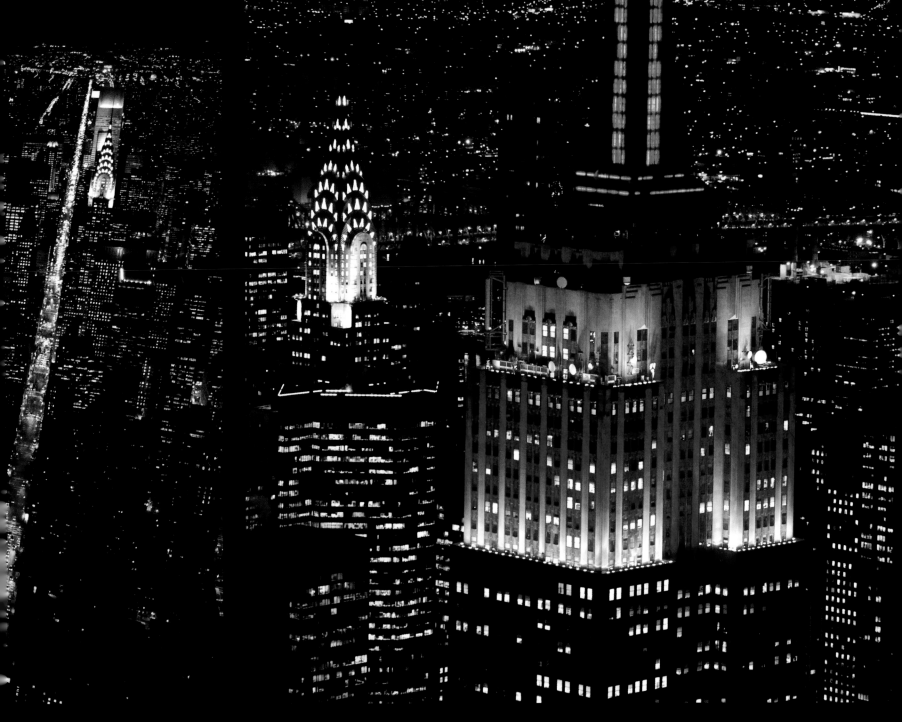

●●●●●

Look at that: a billion bucks of
skyscraper tops, and only the
Empire State Building "gets"
color. Admittedly, it can seem like
gimmickry, since the owners try
to link the colors to holidays or
special events. But it is peculiar
that, given the example, the
overwhelming choice remains
a non-color: white. Fettuccine
Alfredo is good, but would you
order it your whole life?

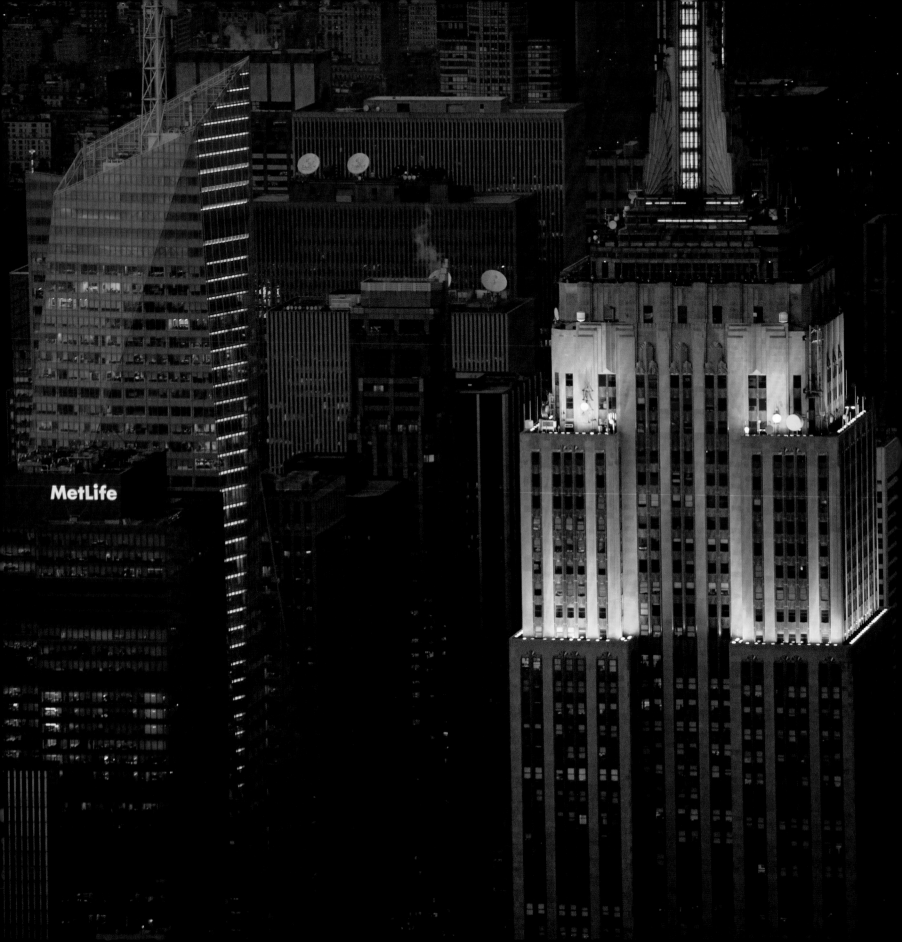

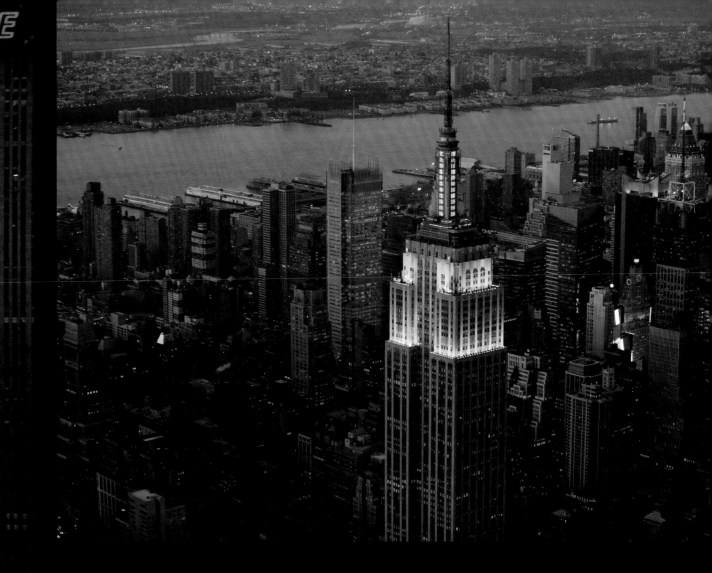

●●●●●
The use of color on the Empire
State Building can sometimes
look a bit forced, and it's a relief
when the tower adopts a less-
is-more approach, as with this
soft orangey-yellow. Here, the
building's original, red-painted
window frames show up clearly,
although why the architects
chose that particular tint remains
unknown. The restrained lighting
also highlights the Art Deco
metal crown. This was another
uneconomic indulgence: it was
presented as a mooring mast
for dirigibles, although that
idea was soon abandoned after
several unsuccessful—and hair-
raising—docking attempts. It now
forms the base of the TV and
radio transmitter.

●●●●●

Few early skyscrapers were permanently lit; rather, the
common thought was that beacons at the tops would
help to guide aviators on their way. The Empire State
Building was fitted with one of the first such beacons,
but it served a strictly ceremonial purpose, for the
tower's opening in 1931. The floodlighting began in the
1960s, followed by a red-white-and-blue color scheme
for the U.S. Bicentennial in 1976. The subsequent color
variations developed out of that one-time event.

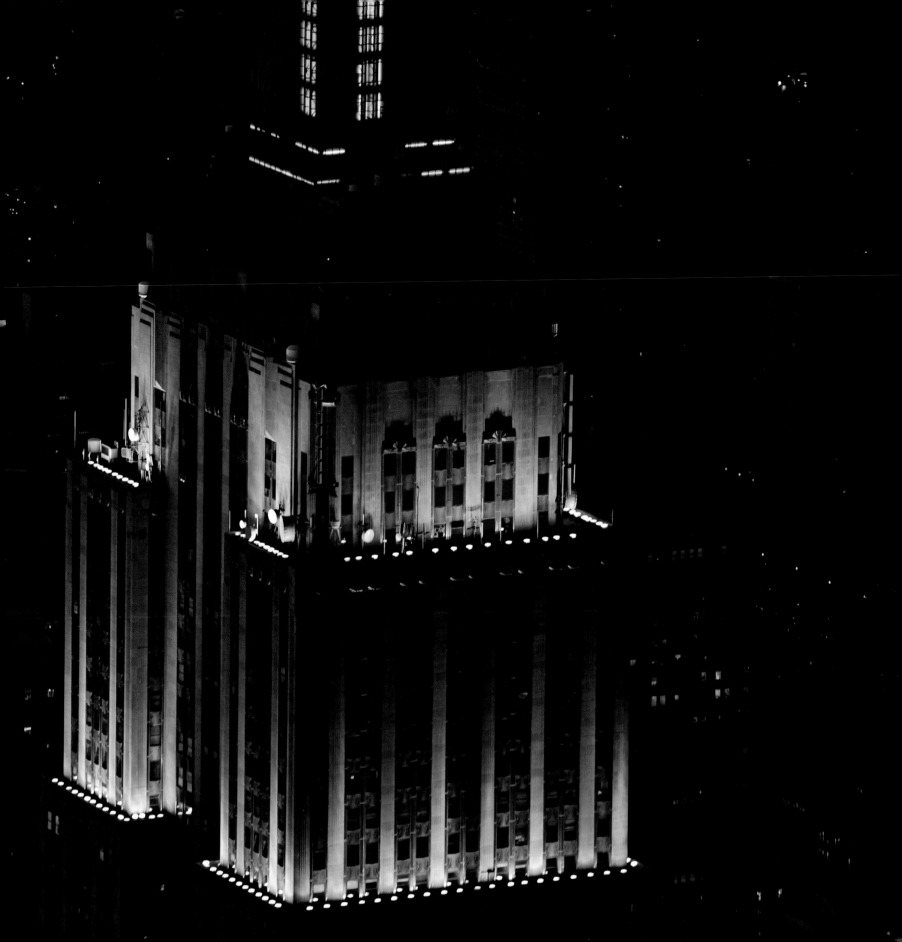

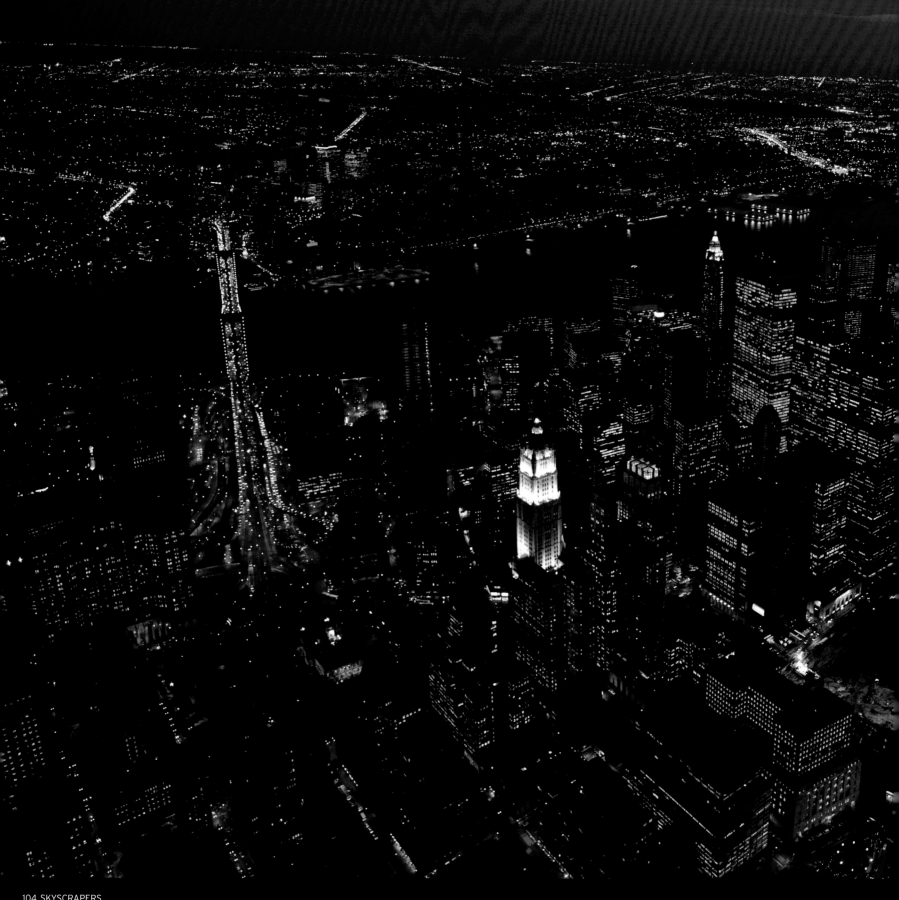

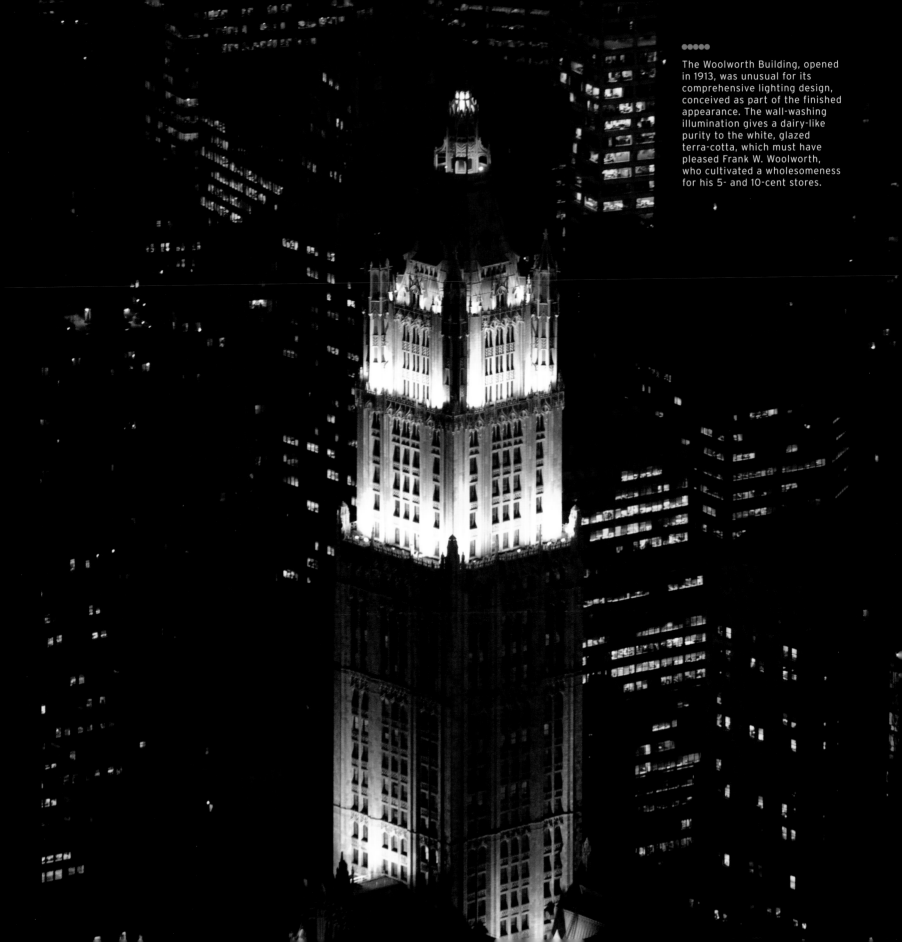

The Woolworth Building, opened in 1913, was unusual for its comprehensive lighting design, conceived as part of the finished appearance. The wall-washing illumination gives a dairy-like purity to the white, glazed terra-cotta, which must have pleased Frank W. Woolworth, who cultivated a wholesomeness for his 5- and 10-cent stores.

The *tempietto* atop the Manhattan Municipal Building is one of the most distinctive tower tops in New York. The model for the crowning statue, *Civic Fame*— designed by Adolph A. Weinman and installed in 1913— was the talented but tormented Audrey Munson, who started modeling in her mid-teens. She was the muse of choice for many important works in New York, from the *Day* and *Night* figures on the old Penn Station to a pediment statue on Henry Clay Frick's mansion on Fifth Avenue, now the Frick Collection. However, she attempted suicide in her thirties, and spent the last sixty years of her life in a mental institution–a bitter reward for beauty.

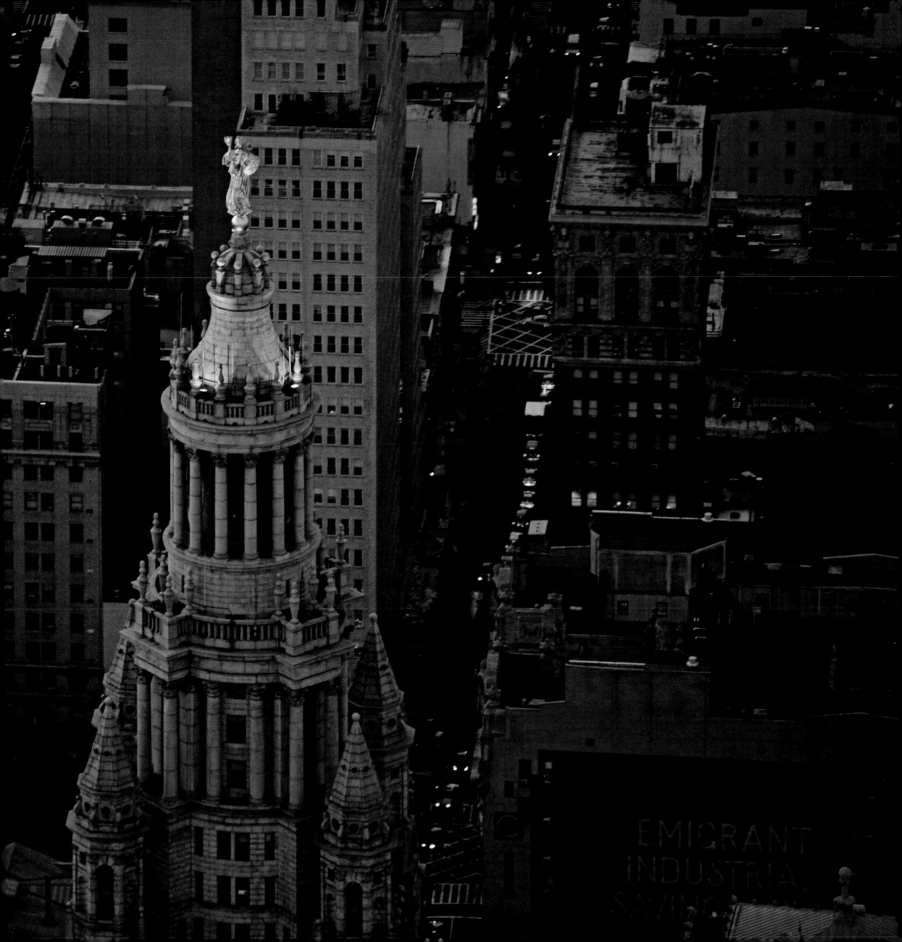

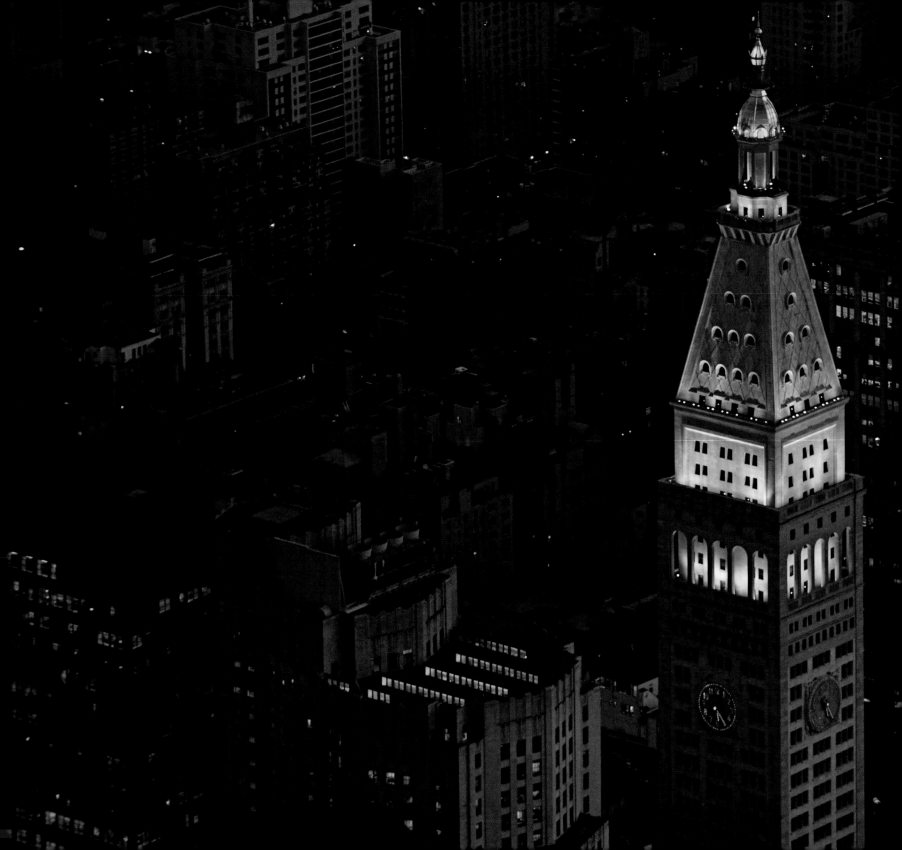

●●●●●

The Metropolitan Life Insurance Company built its tower, at Twenty-fourth Street and Madison Avenue, in 1909; at fifty stories high, it was the tallest in the world, until the Woolworth Building succeeded it in 1913. The owners did not mind, apparently, that the architects modeled it on the campanile on St. Mark's Square in Venice—which had mysteriously collapsed in 1902. A renovation in the 1950s truly scalped the building, removing almost all the detail, and replacing the deteriorating marble with limestone: what you see is really of the Eisenhower era.

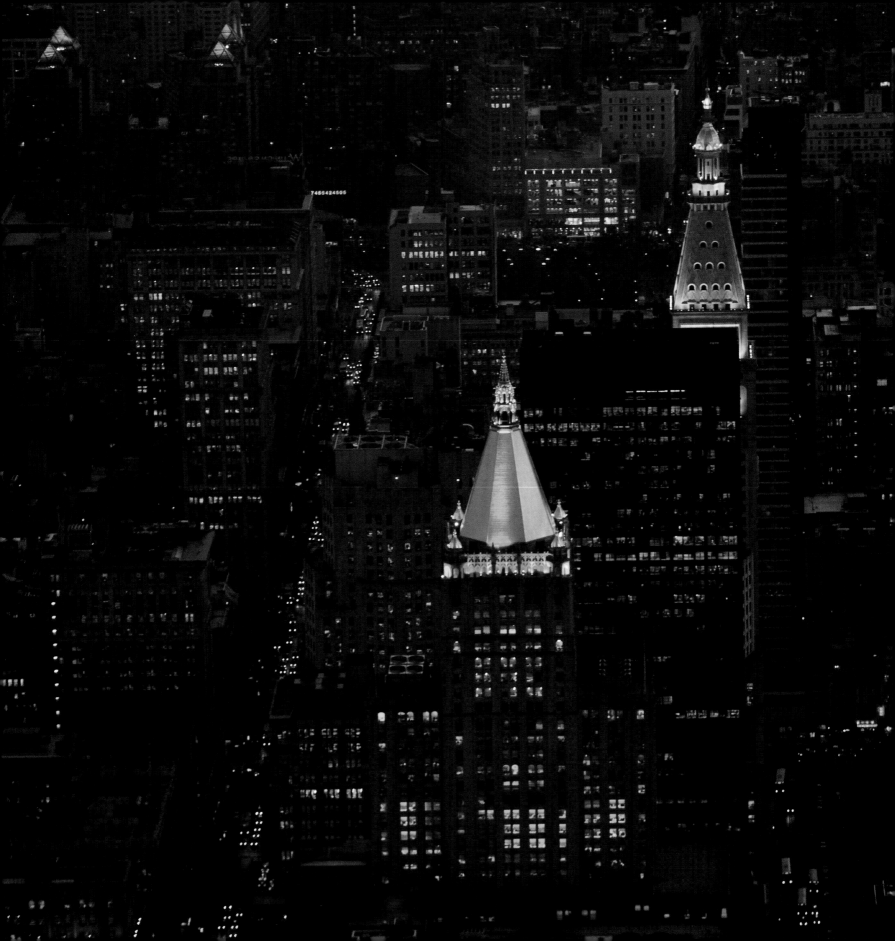

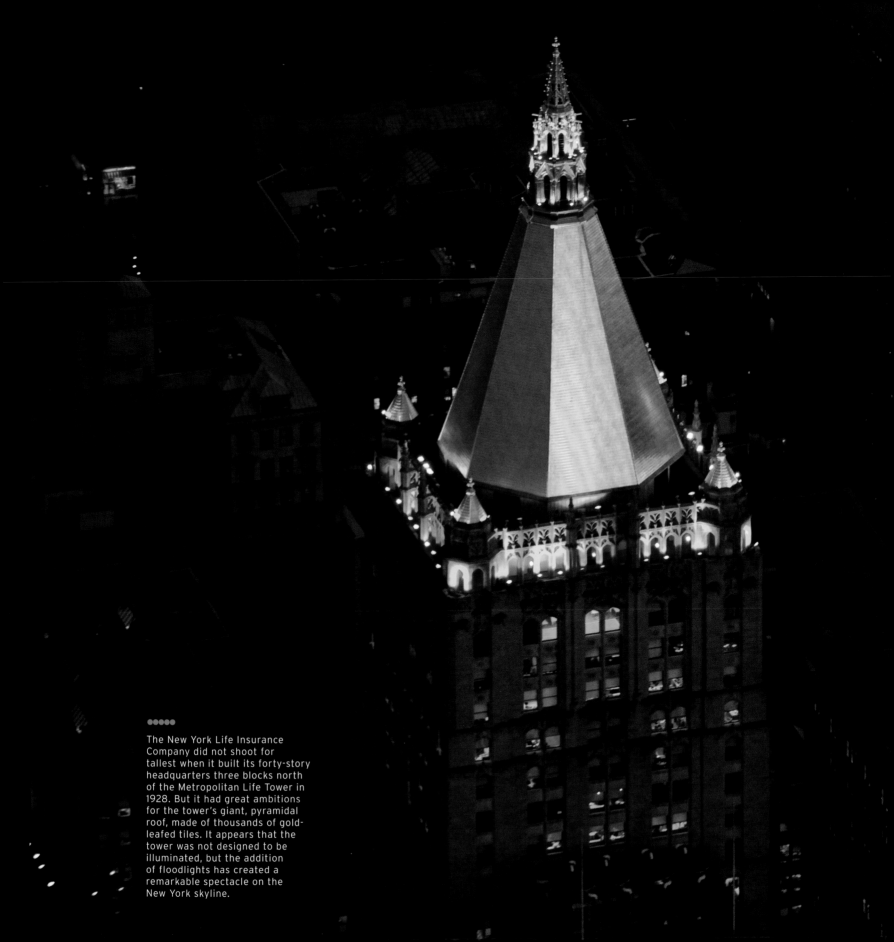

●●●●●

The New York Life Insurance
Company did not shoot for
tallest when it built its forty-story
headquarters three blocks north
of the Metropolitan Life Tower in
1928. But it had great ambitions
for the tower's giant, pyramidal
roof, made of thousands of gold-
leafed tiles. It appears that the
tower was not designed to be
illuminated, but the addition
of floodlights has created a
remarkable spectacle on the
New York skyline.

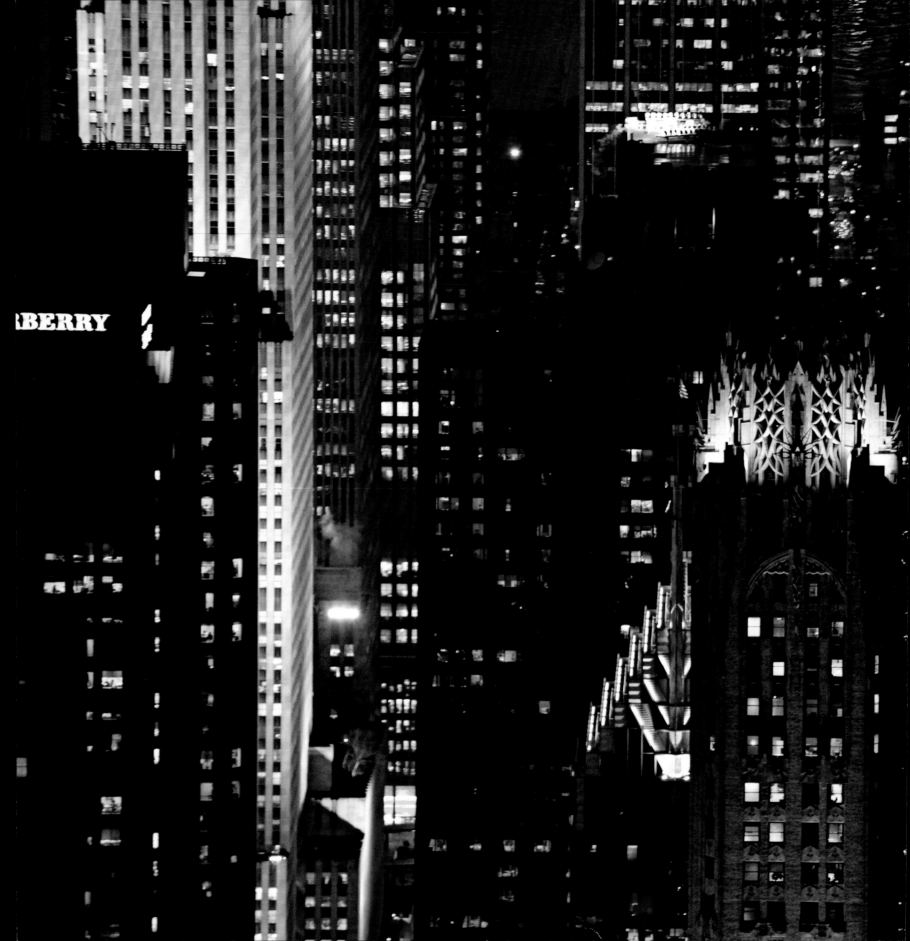

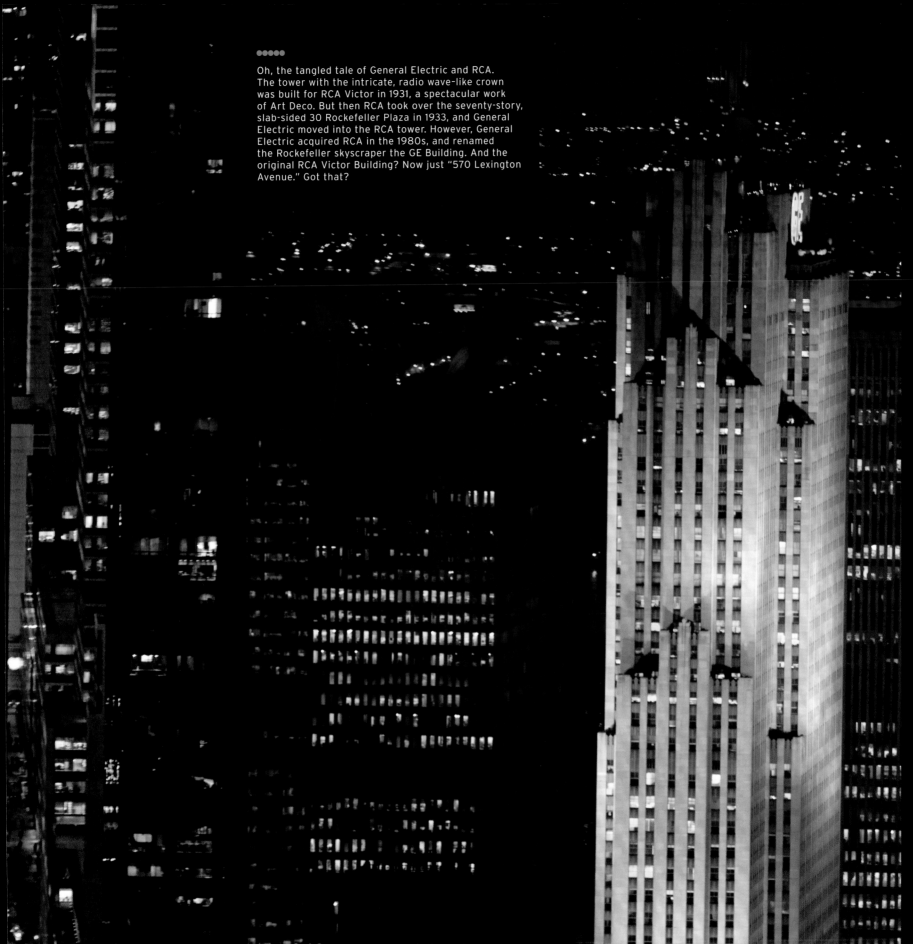

Oh, the tangled tale of General Electric and RCA.
The tower with the intricate, radio wave–like crown
was built for RCA Victor in 1931, a spectacular work
of Art Deco. But then RCA took over the seventy-story,
slab-sided 30 Rockefeller Plaza in 1933, and General
Electric moved into the RCA tower. However, General
Electric acquired RCA in the 1980s, and renamed
the Rockefeller skyscraper the GE Building. And the
original RCA Victor Building? Now just "570 Lexington
Avenue." Got that?

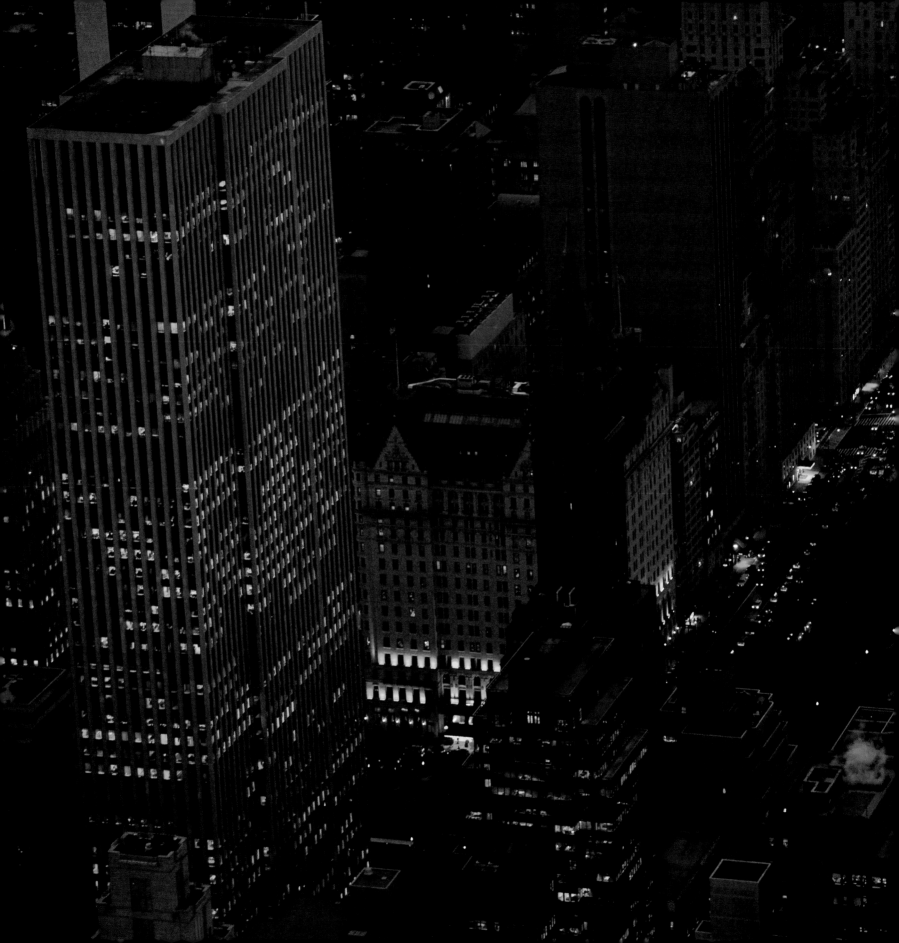

●●●●●

The monolithic General Motors Building of 1968, on the far left-hand side of the photograph, is put to shame by two Fifth Avenue hotels of the Jazz Age: the dark-brick Sherry-Netherland at Fifty-ninth Street, and the light-toned Pierre at Sixty-first. The Sherry-Netherland is a deft, château-esque fantasy of 1927; the Pierre, just three years younger, a sober, measured, even hesitant creation. But the latter's great angled top shelters a giant ballroom, part of a three-floor apartment that is among the most luxurious in New York. So different in many ways, both buildings were designed by hotel specialists Schultze & Weaver.

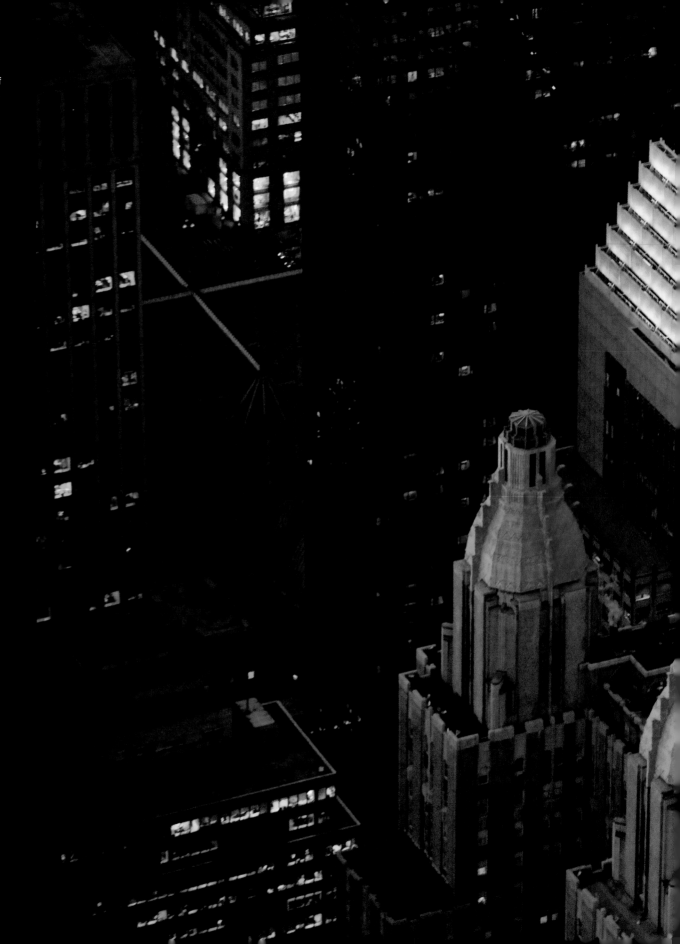

Does a tower top even need lighting? The copper-clad twins of the Waldorf-Astoria Hotel on Park Avenue often carry a luminous, moonlit glow. If the hotel hadn't moved from its original location on Fifth Avenue, then the Empire State Building—the site's current occupier—would not have been built. The Mutual of America Building, seen here immediately behind the hotel, looks like it was commissioned by Darth Vader.

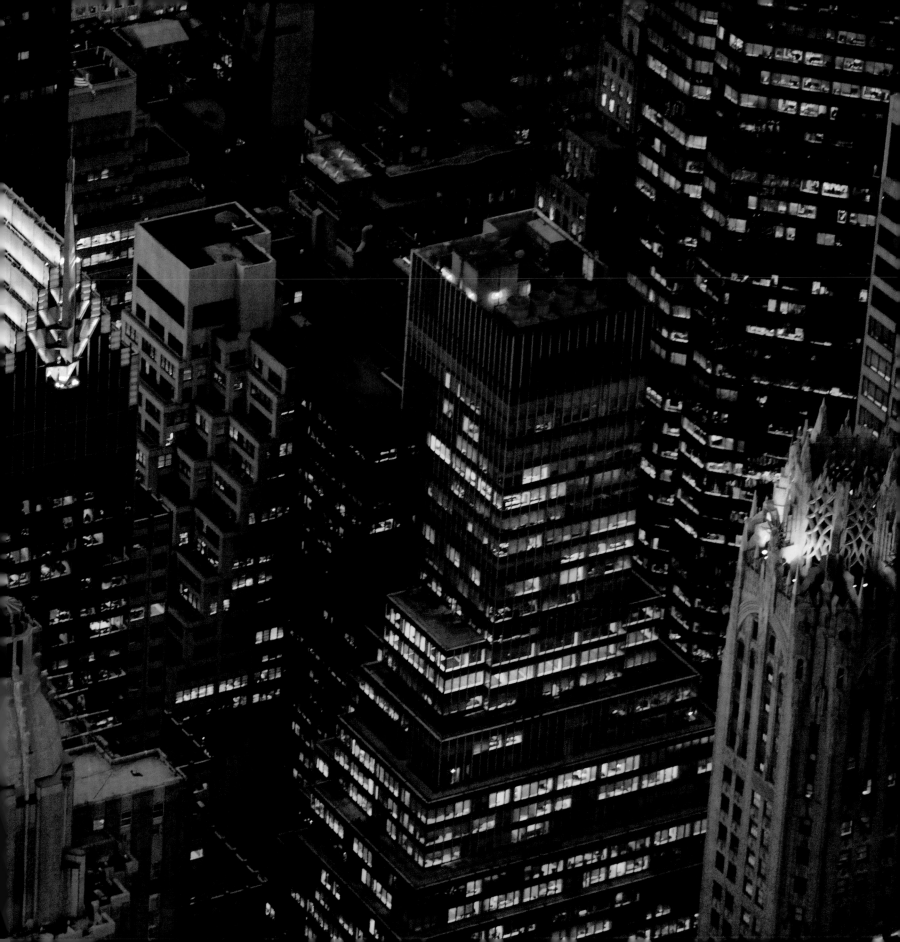

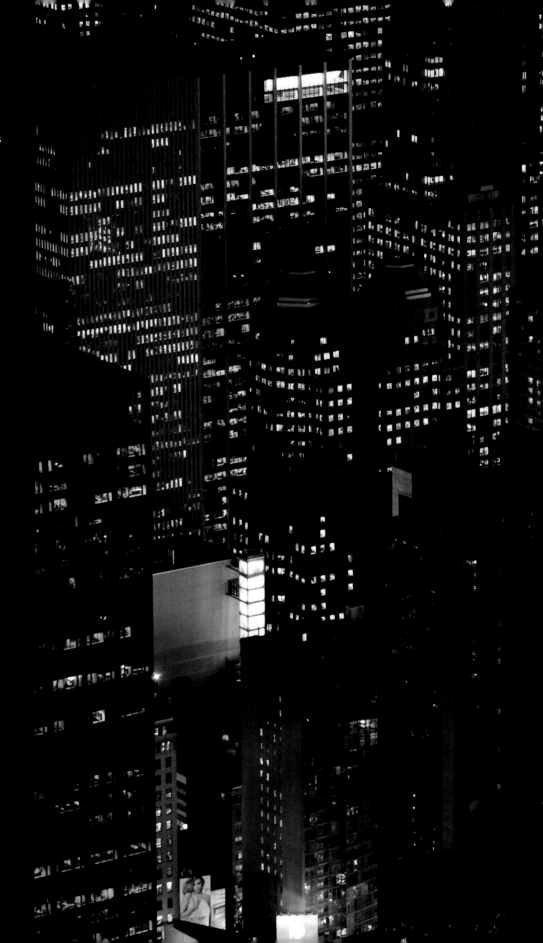

Few architects have made use of the steam rising from the cooling towers of tall buildings, but Skidmore, Owings & Merrill managed to make a feature out of it with One Worldwide Plaza, on Eighth Avenue and Forty-ninth Street. Built in 1989, it was part of a romantic skyscraper revival that gradually morphed into a techno phase with the appearance of such towers as the Condé Nast Building, an unlit side of which is just visible in the distance.

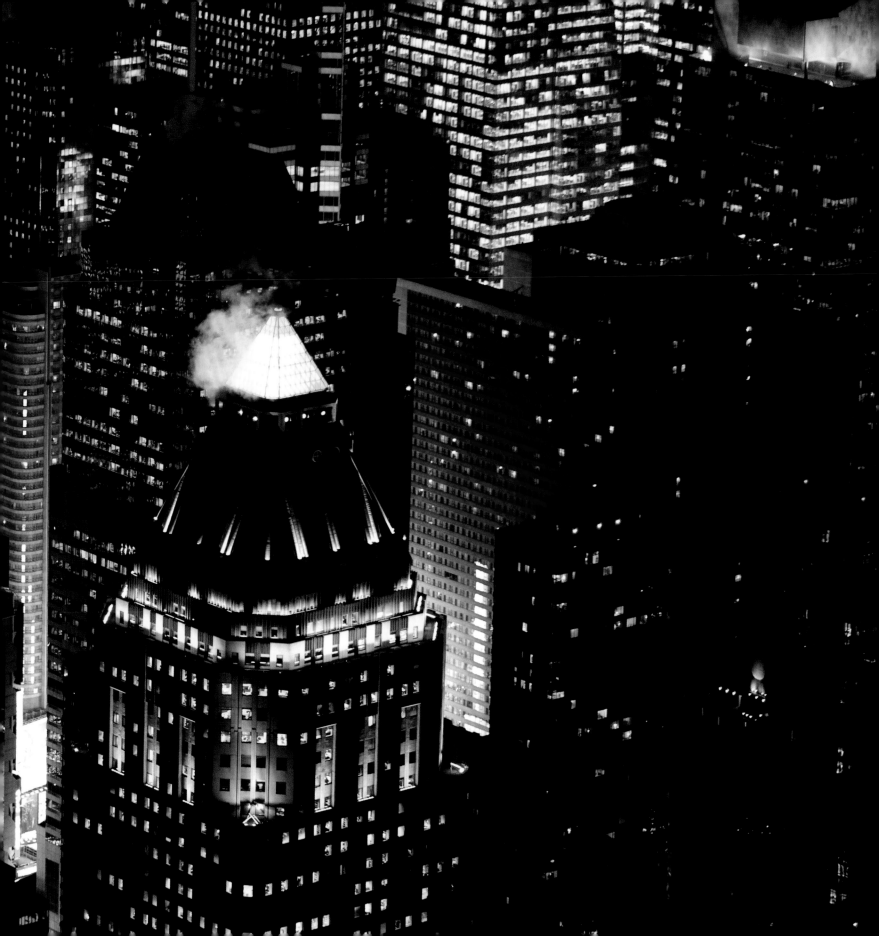

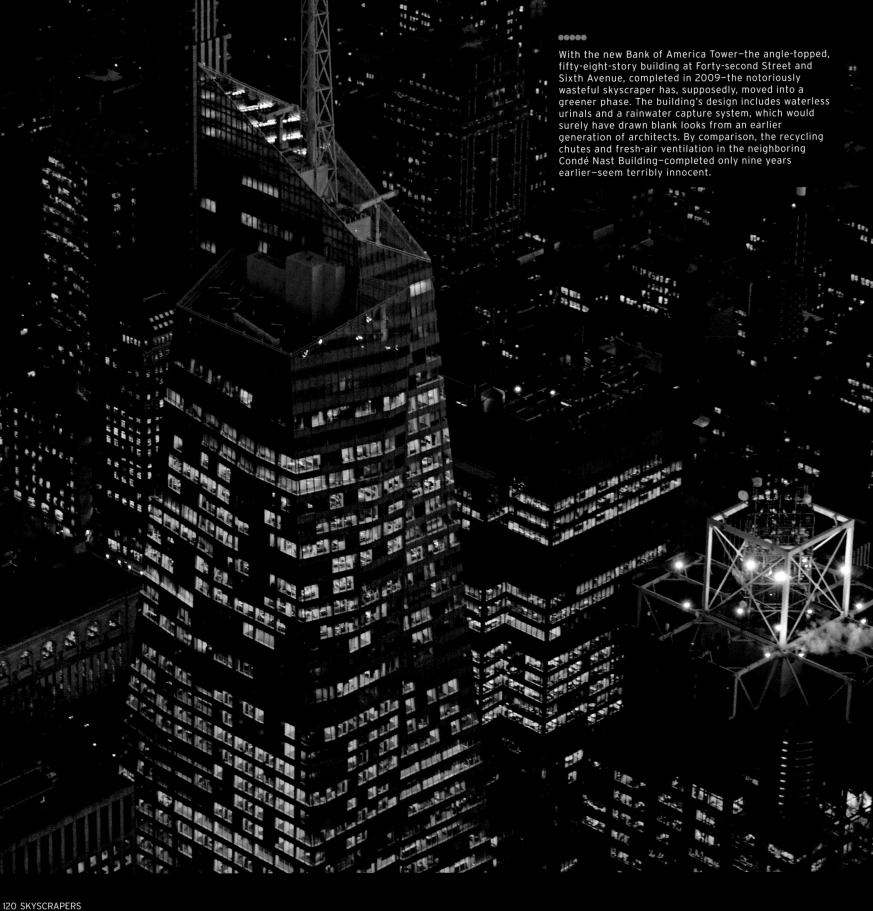

With the new Bank of America Tower—the angle-topped, fifty-eight-story building at Forty-second Street and Sixth Avenue, completed in 2009—the notoriously wasteful skyscraper has, supposedly, moved into a greener phase. The building's design includes waterless urinals and a rainwater capture system, which would surely have drawn blank looks from an earlier generation of architects. By comparison, the recycling chutes and fresh-air ventilation in the neighboring Condé Nast Building—completed only nine years earlier—seem terribly innocent.

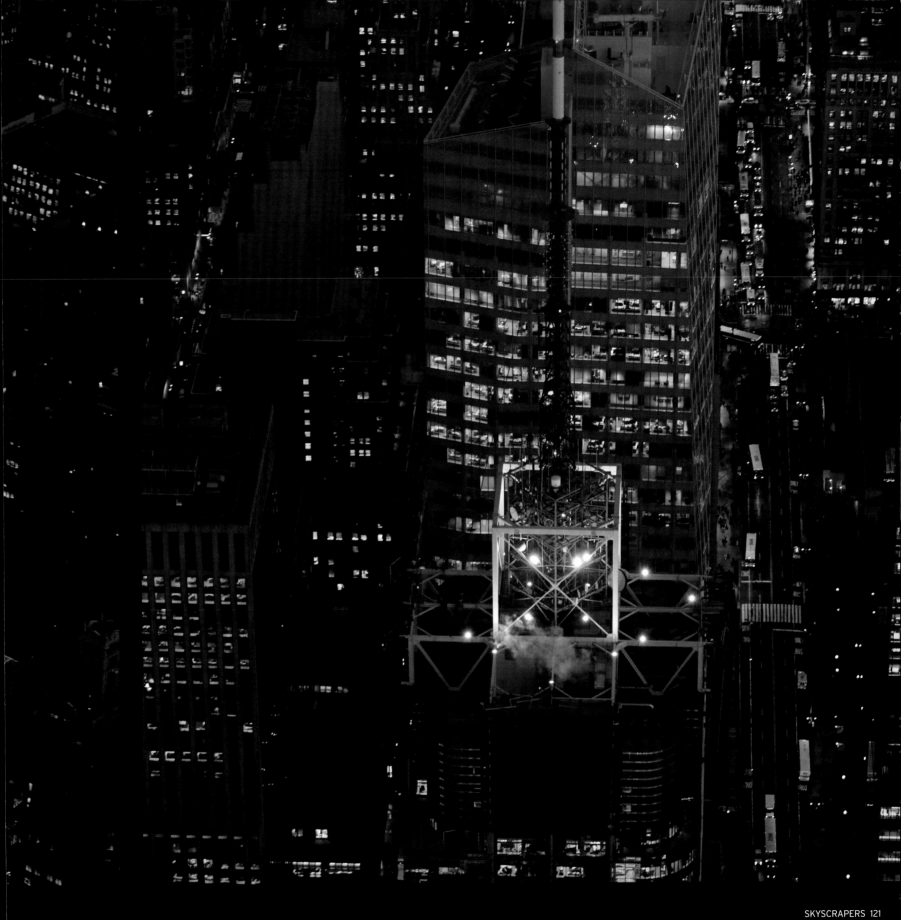

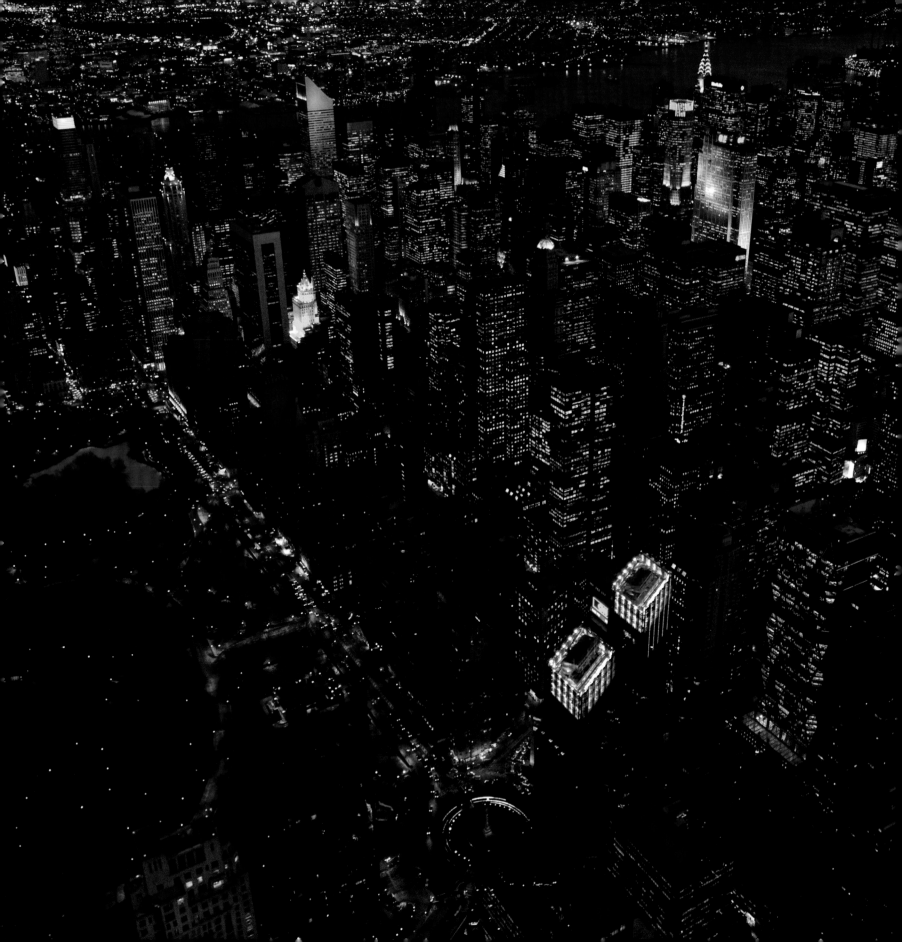

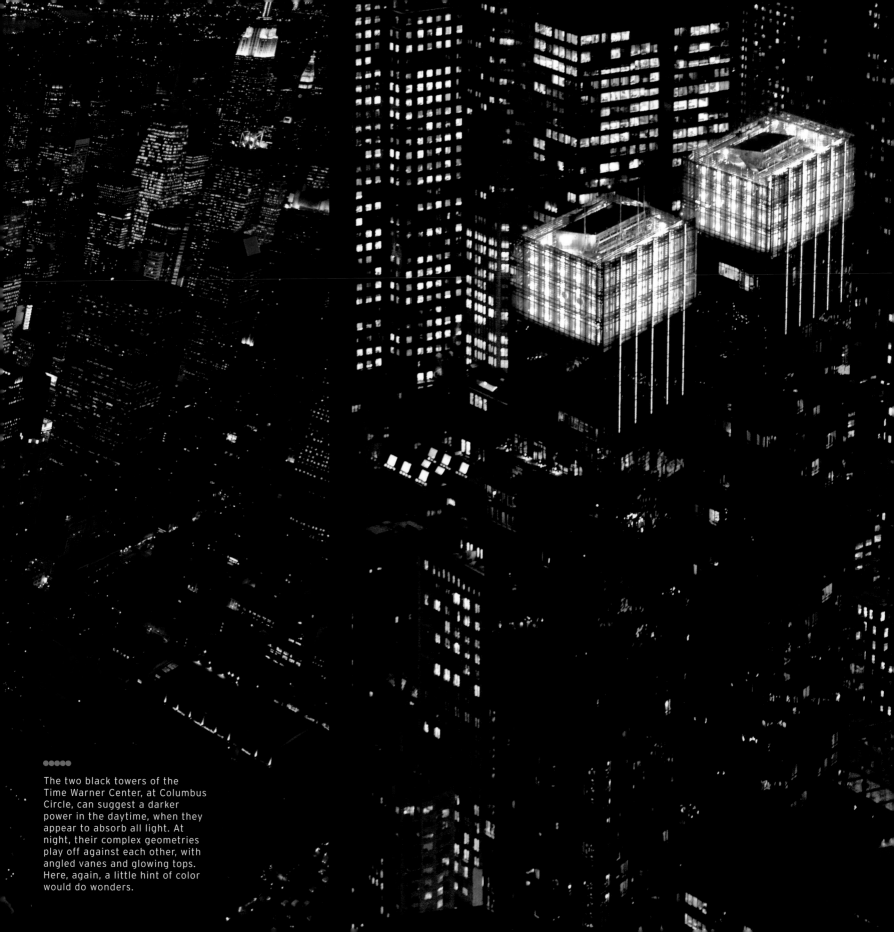

The two black towers of the
Time Warner Center, at Columbus
Circle, can suggest a darker
power in the daytime, when they
appear to absorb all light. At
night, their complex geometries
play off against each other, with
angled vanes and glowing tops.
Here, again, a little hint of color
would do wonders.

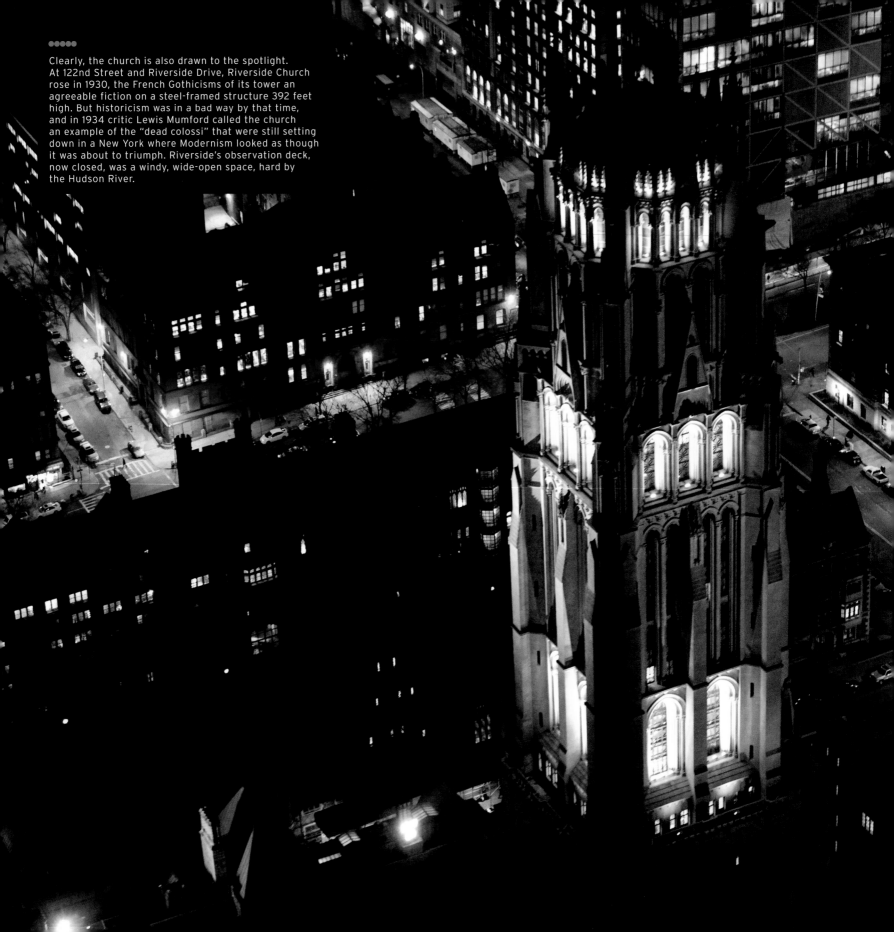

Clearly, the church is also drawn to the spotlight. At 122nd Street and Riverside Drive, Riverside Church rose in 1930, the French Gothicisms of its tower an agreeable fiction on a steel-framed structure 392 feet high. But historicism was in a bad way by that time, and in 1934 critic Lewis Mumford called the church an example of the "dead colossi" that were still setting down in a New York where Modernism looked as though it was about to triumph. Riverside's observation deck, now closed, was a windy, wide-open space, hard by the Hudson River.

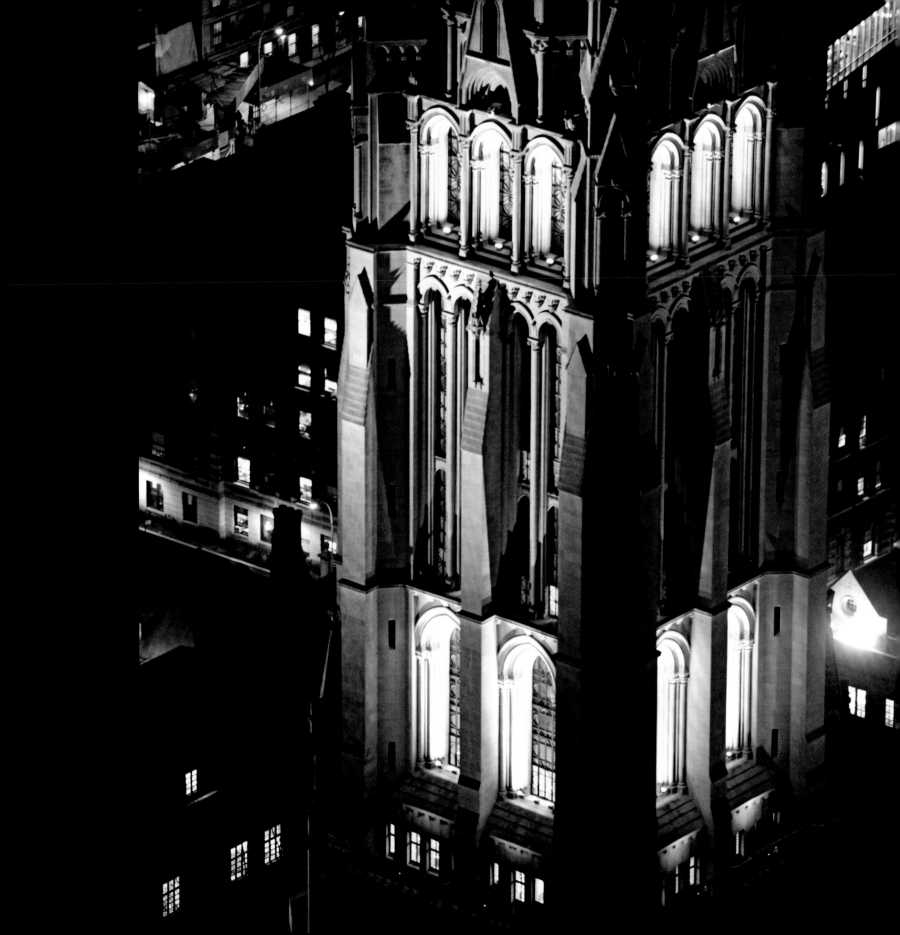

New York was born in movement, and it still doesn't stay in one place. It started with that spectacular harbor, a Grand Central Station of protective rivers, sounds, estuaries, and channels—not a bad place to stop after a trip across the North Atlantic. At that time, in the early sixteenth century, water transport was still the most technologically advanced way to travel, and it remained so all the way through to the days of the clipper and the arrival of the railroad.

Thus, New York, with arguably the best anchorages in North America, was the Silicon Valley of international trade. Except for the winters when the water froze over—rather frequently, as it turns out—New York Harbor put the country at the epicenter of transatlantic trade and communications.

When the rail system developed, in the mid-nineteenth century, it echoed the centrality of New York, complementing rather than compromising water transport. Similarly, at least at first, the car did not diverge markedly from the principles of the urban center, although within a few years it turned the streets into deathtraps:

it was not until the 1930s that New Yorkers—accustomed to horse speeds, not motorcar velocities—thought twice before stepping off the sidewalk.

The 1940s were the busiest years ever for the rail system, and not just because of the Second World War: who, exactly, was going to drive their Packard or Studebaker to Chicago or Los Angeles? Then a trifecta of transportation tragedy struck the city. Air travel made ocean passage, and then railroads, expensive anachronisms. The Interstate Highway System, built for defense purposes, made long-haul trucking a viable enterprise. And the new road culture finally defeated the purpose of the city: it is indeed a place of congestion, but this becomes insupportable when you're dealing with tens of thousands of cars.

So now no one's surprised when bananas are unloaded way up the Hudson River, when it takes an hour or more just to get to the airport, or when the car, America's most common mode of transport, is declared an enemy of the city.

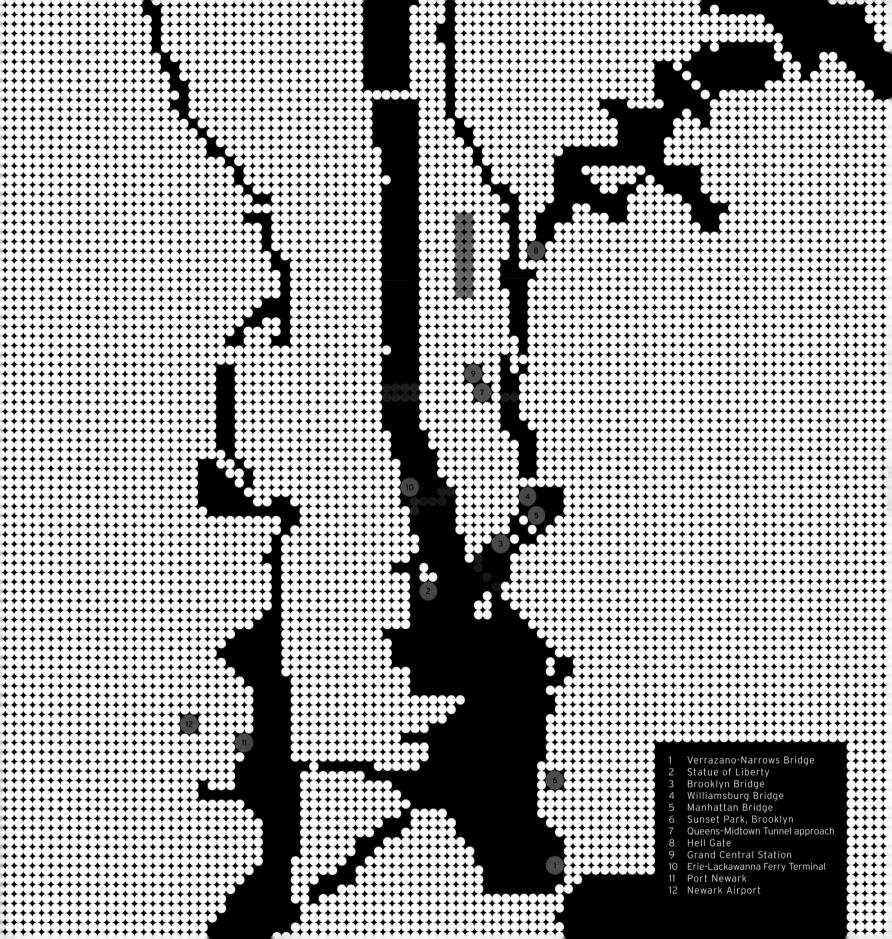

1 Verrazano-Narrows Bridge
2 Statue of Liberty
3 Brooklyn Bridge
4 Williamsburg Bridge
5 Manhattan Bridge
6 Sunset Park, Brooklyn
7 Queens-Midtown Tunnel approach
8 Hell Gate
9 Grand Central Station
10 Erie-Lackawanna Ferry Terminal
11 Port Newark
12 Newark Airport

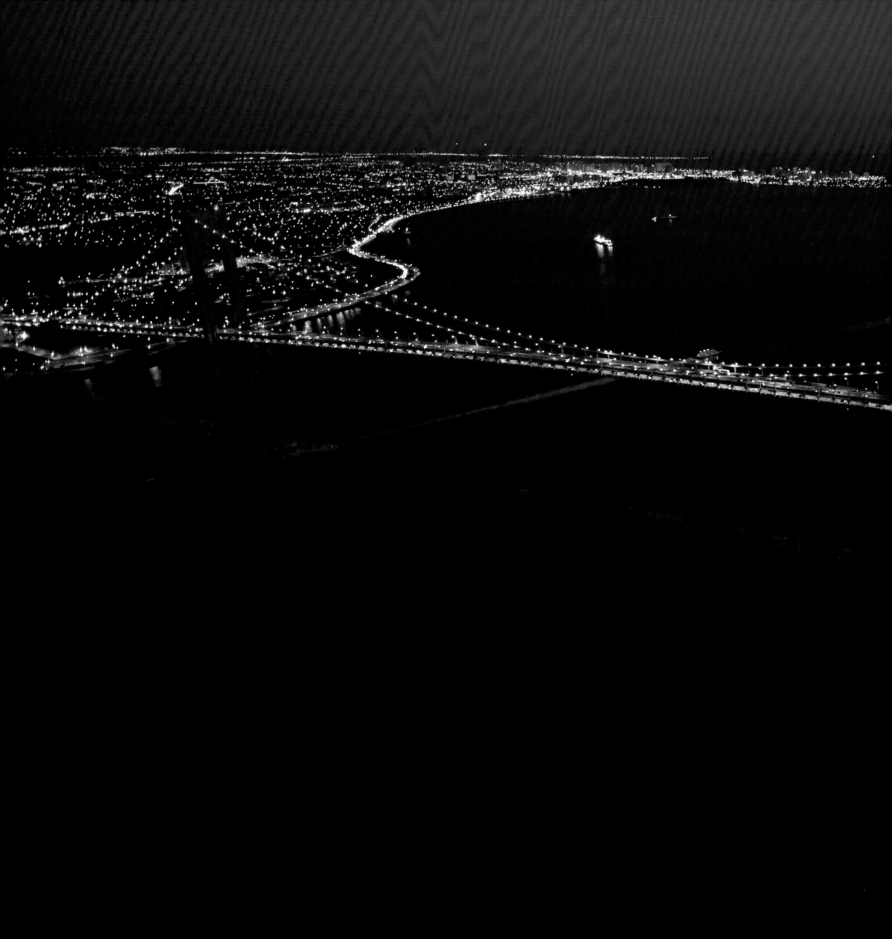

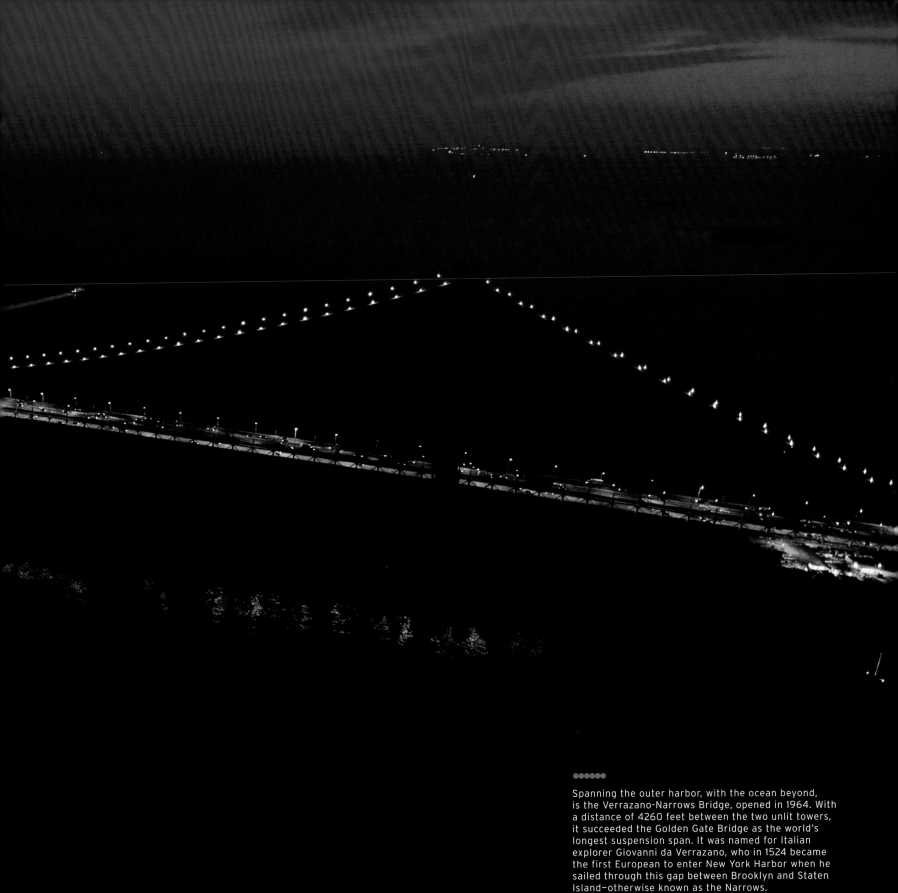

Spanning the outer harbor, with the ocean beyond,
is the Verrazano-Narrows Bridge, opened in 1964. With
a distance of 4260 feet between the two unlit towers,
it succeeded the Golden Gate Bridge as the world's
longest suspension span. It was named for Italian
explorer Giovanni da Verrazano, who in 1524 became
the first European to enter New York Harbor when he
sailed through this gap between Brooklyn and Staten
Island—otherwise known as the Narrows.

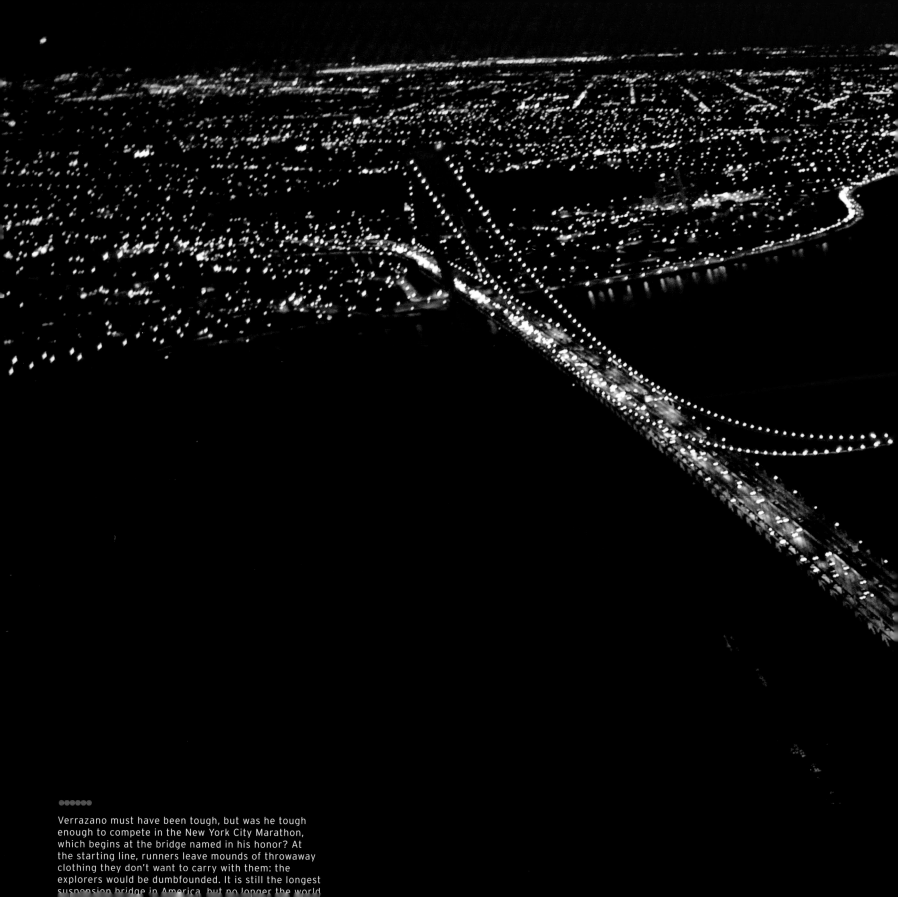

●●●●●●●
Verrazano must have been tough, but was he tough
enough to compete in the New York City Marathon,
which begins at the bridge named in his honor? At
the starting line, runners leave mounds of throwaway
clothing they don't want to carry with them: the
explorers would be dumbfounded. It is still the longest
suspension bridge in America, but no longer the world

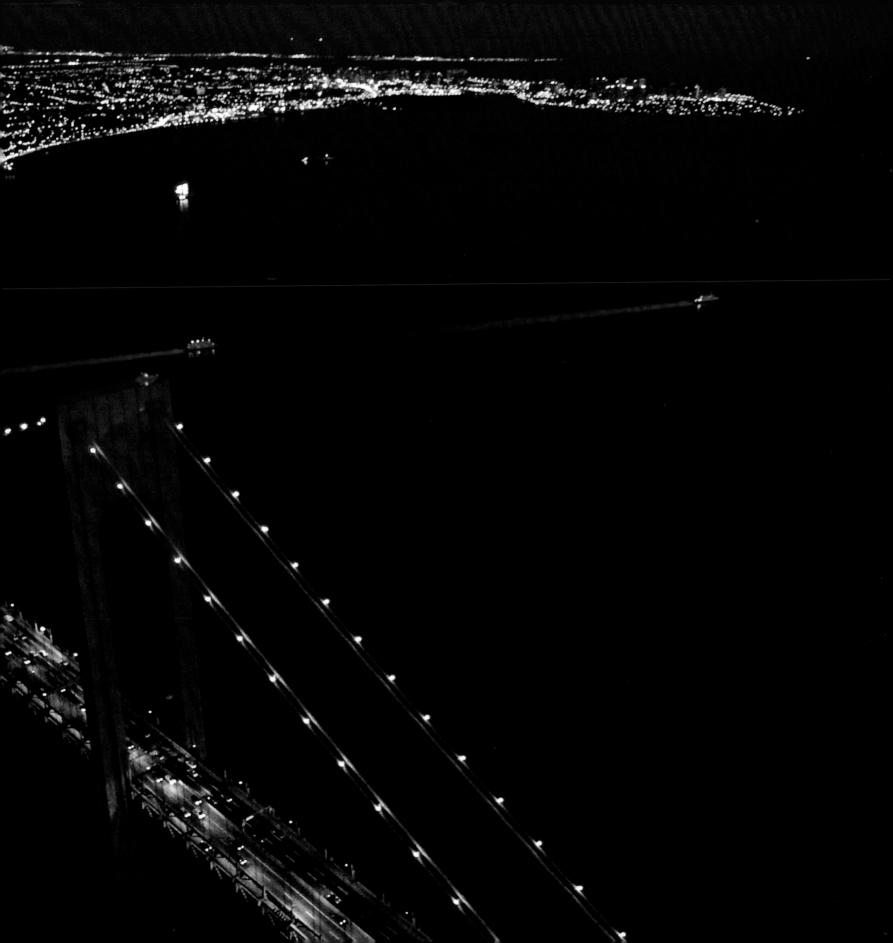

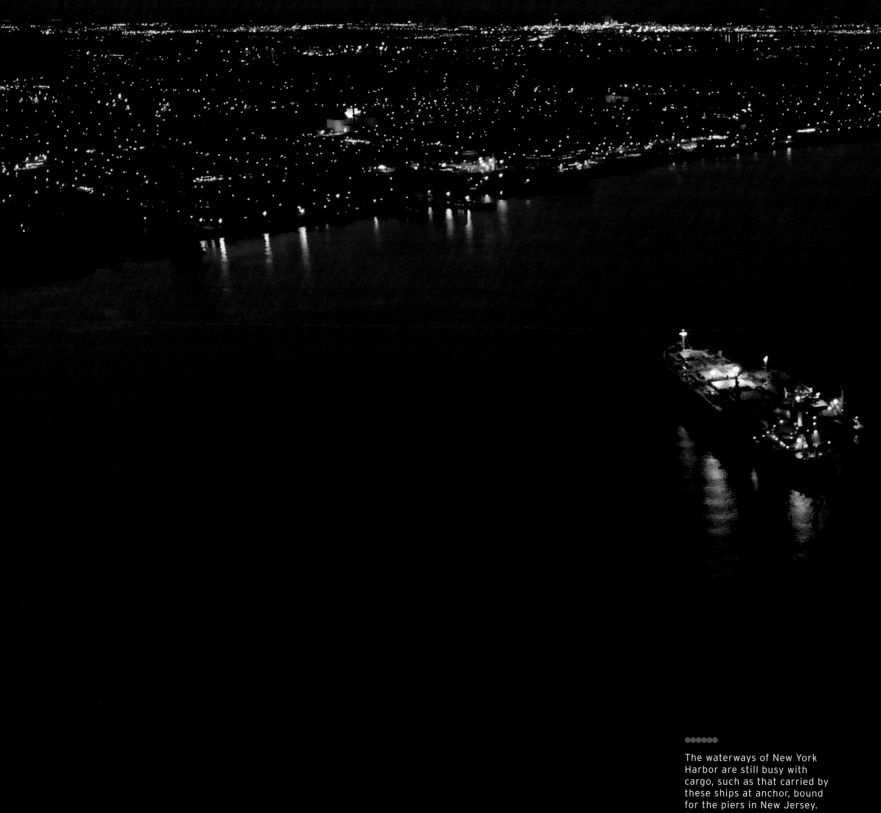

●●●●●●

The waterways of New York Harbor are still busy with cargo, such as that carried by these ships at anchor, bound for the piers in New Jersey. But the unloading machinery of the Brooklyn and Manhattan waterfronts is pretty much coated with rust. Driving trucks through the streets of New York City proved to be a dealbreaker.

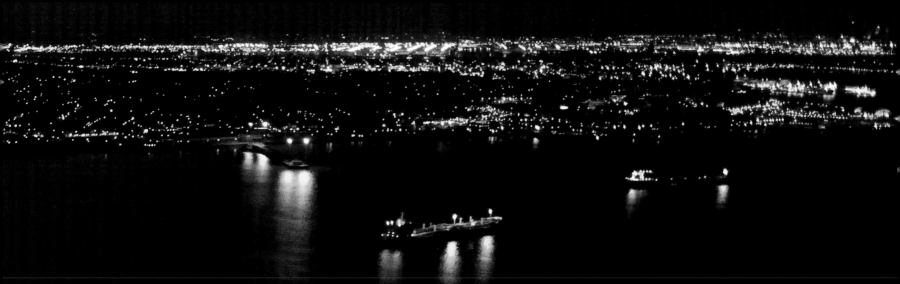

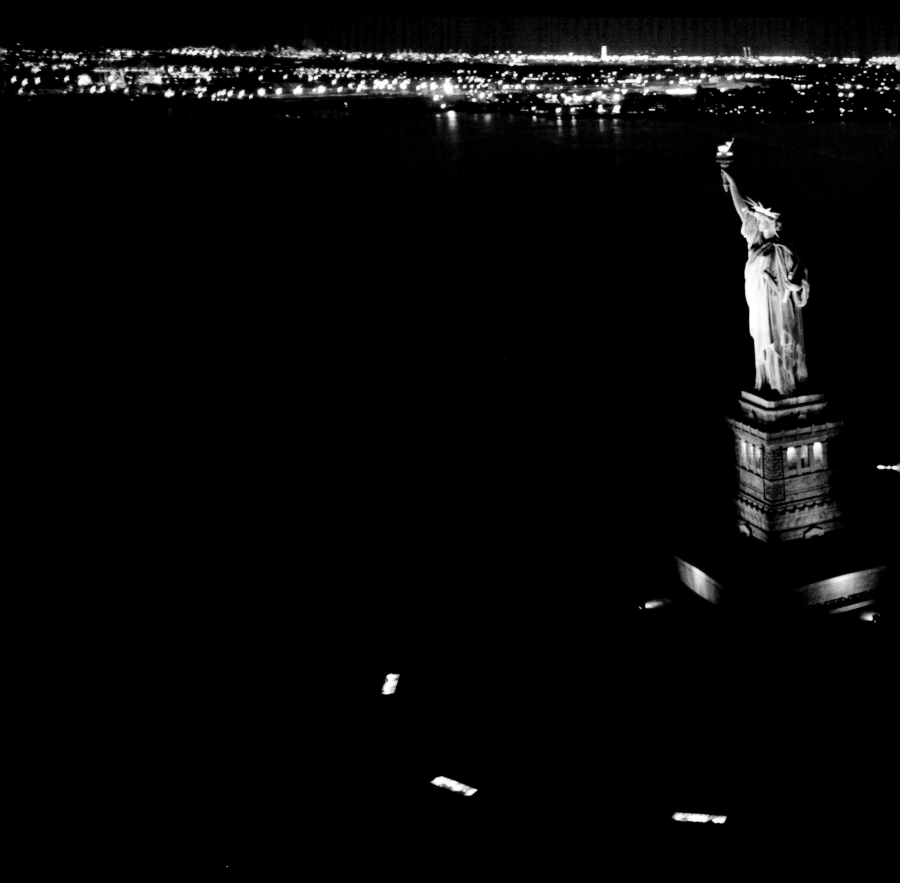

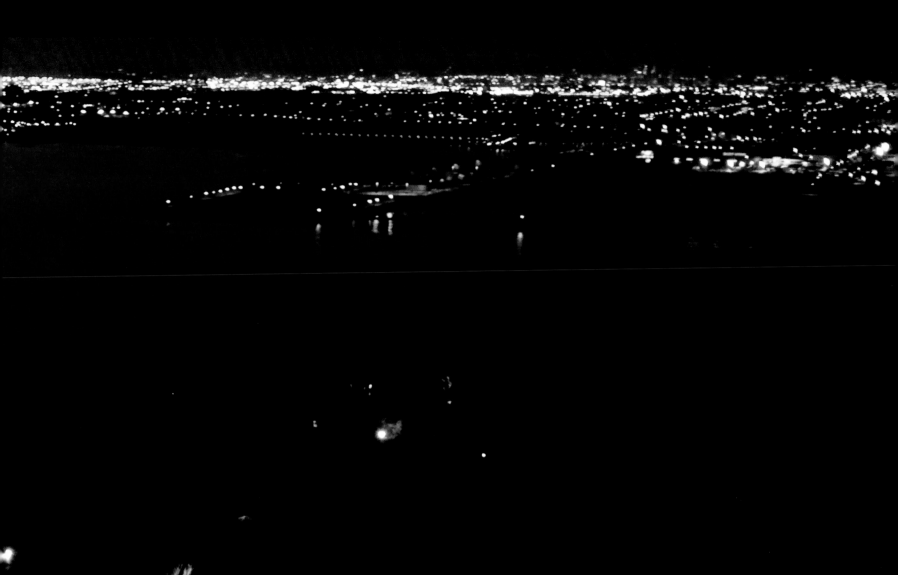

●●●●●●

More than 120 years after its dedication, Frédéric Auguste Bartholdi's Statue of Liberty is still inspirational—not least the sonnet by Emma Lazarus mounted on the inside of the statue that welcomes the world's "wretched refuse" to the land of the free. Of course, the Mother of Exiles now welcomes only cruise-ship passengers and tourists. But it must have been an astonishing apparition for New York-bound refugees of pogroms and economic upheaval.

It's hard to imagine, but visitors were once allowed into the Statue of Liberty's torch; then, following the events of 9/11, even trips to the crown were prohibited. Thankfully, the crown has reopened, and it's now possible once again to make the intoxicating journey up the teeny spiral staircases, through the giant armature, to the little windows. At the moment, there's a two-month wait for tickets, so plan ahead. Alternatively, hop on the Staten Island Ferry from Manhattan, the ping-pong route of which will just about get you within holiday-photo distance.

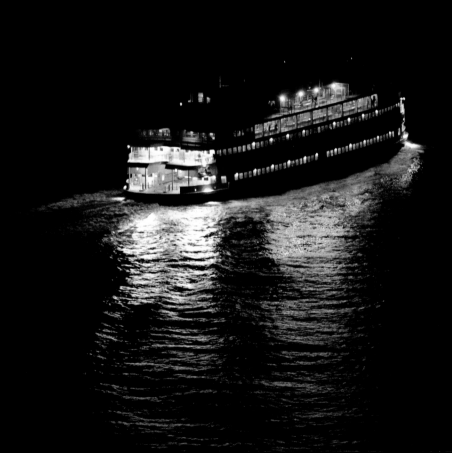

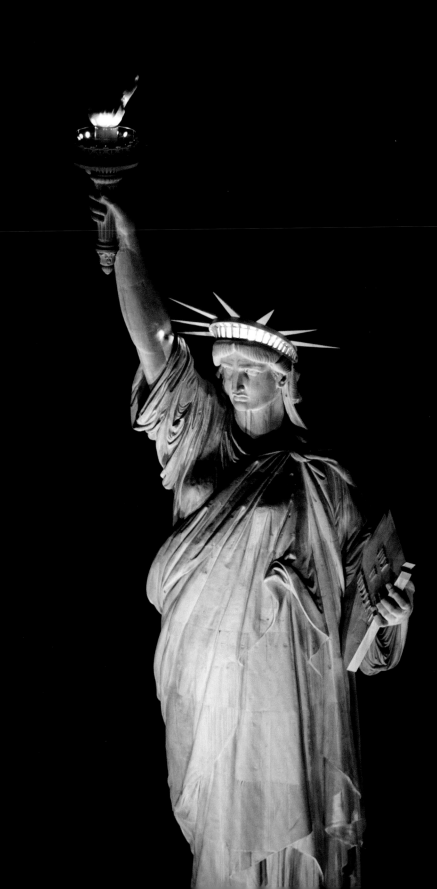

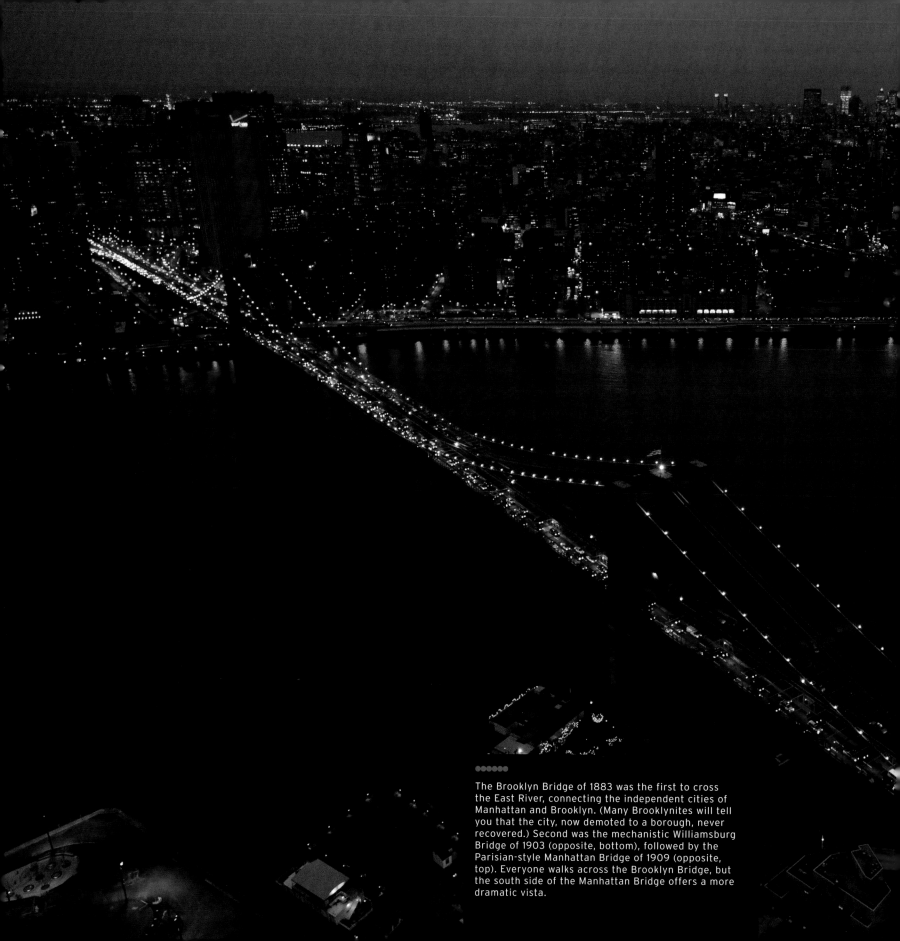

The Brooklyn Bridge of 1883 was the first to cross
the East River, connecting the independent cities of
Manhattan and Brooklyn. (Many Brooklynites will tell
you that the city, now demoted to a borough, never
recovered.) Second was the mechanistic Williamsburg
Bridge of 1903 (opposite, bottom), followed by the
Parisian-style Manhattan Bridge of 1909 (opposite,
top). Everyone walks across the Brooklyn Bridge, but
the south side of the Manhattan Bridge offers a more
dramatic vista.

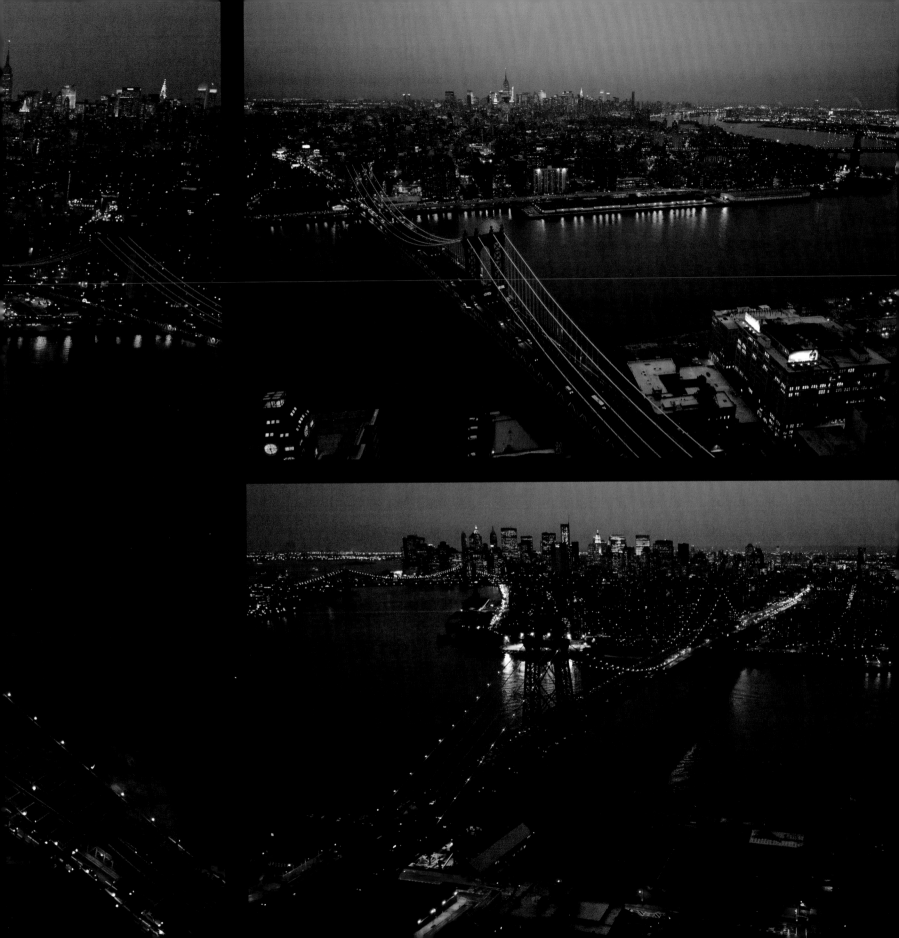

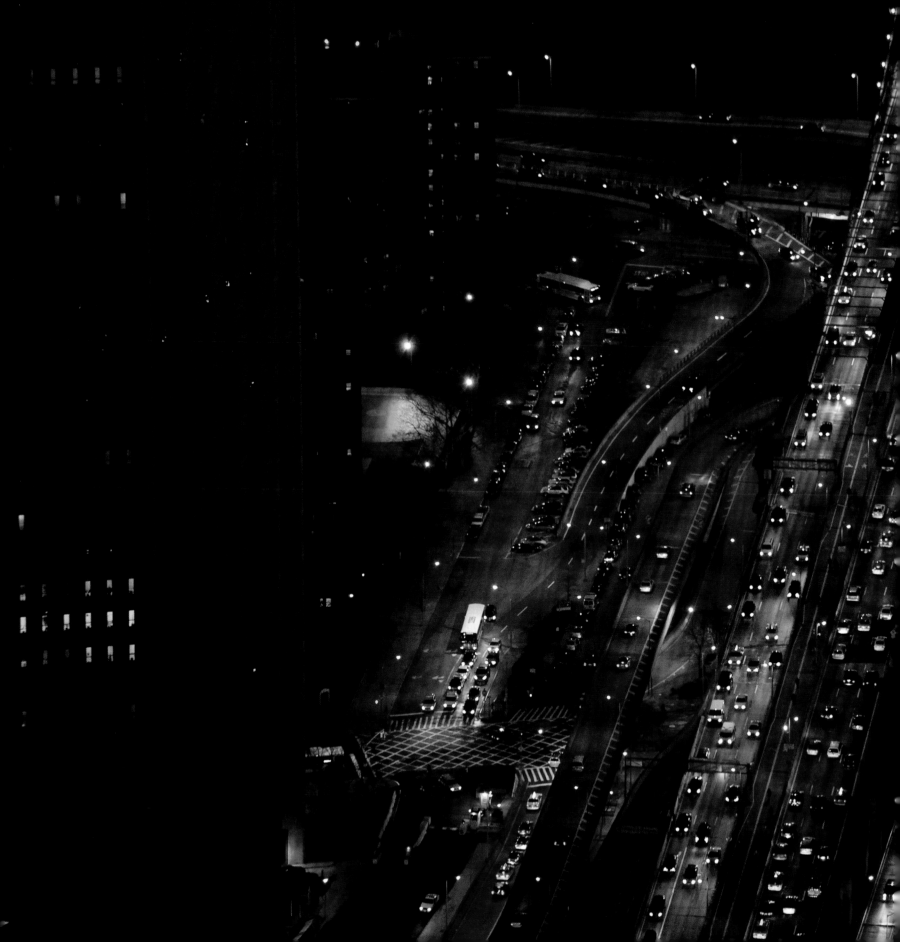

●●●●●●

The amount of light generated by the car and its handmaidens is astonishing. Here, the headlights, taillights, and streetlamps of the Manhattan-side approach to the Brooklyn Bridge throw the surrounding structures—including the Verizon Building to the left of the roadway and the brown-brick housing project to its right—into relative darkness.

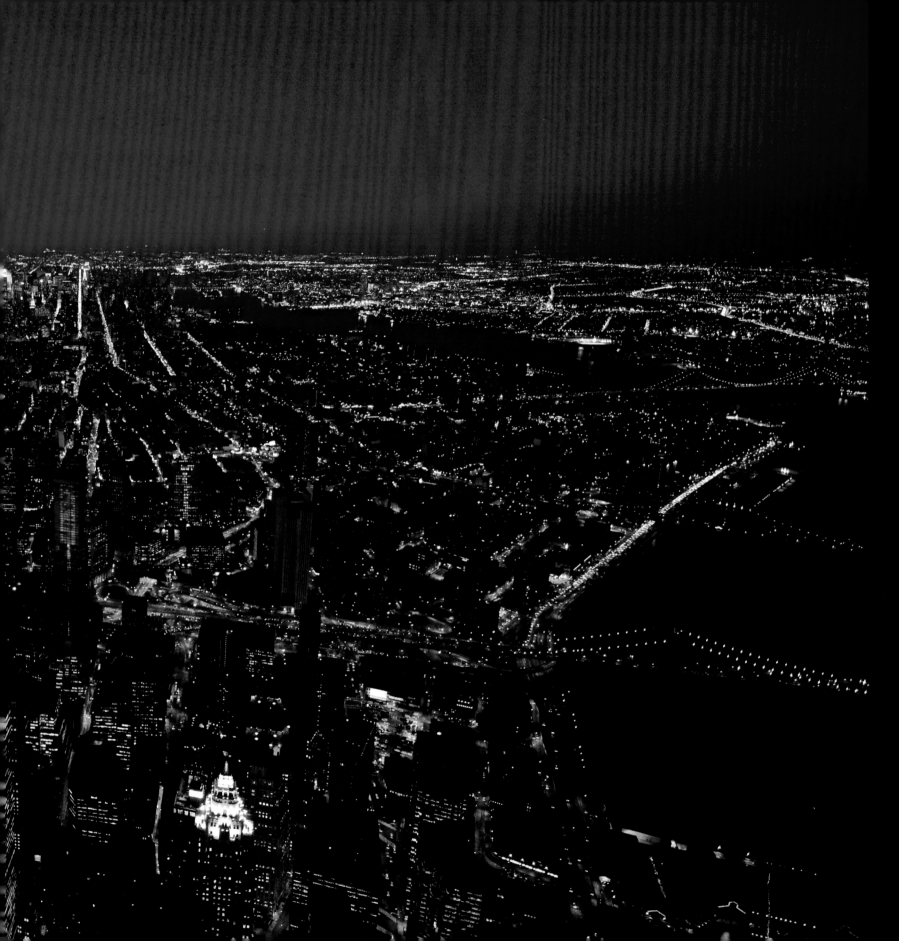

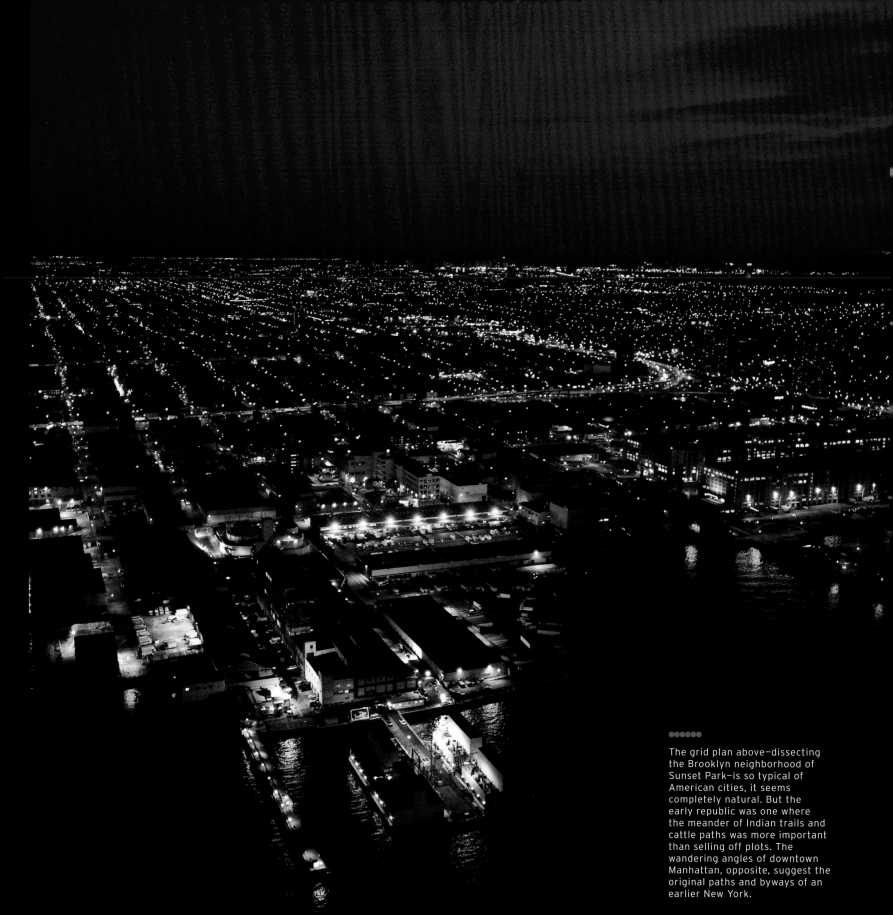

●●●●●●

The grid plan above—dissecting
the Brooklyn neighborhood of
Sunset Park—is so typical of
American cities, it seems
completely natural. But the
early republic was one where
the meander of Indian trails and
cattle paths was more important
than selling off plots. The
wandering angles of downtown
Manhattan, opposite, suggest the
original paths and byways of an
earlier New York.

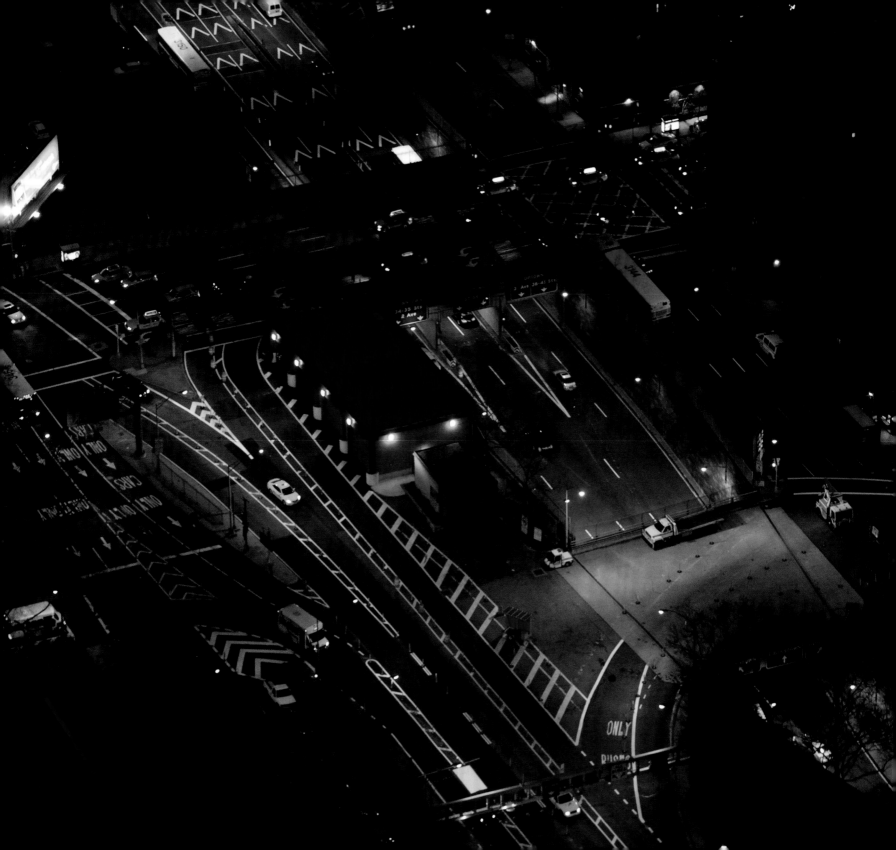

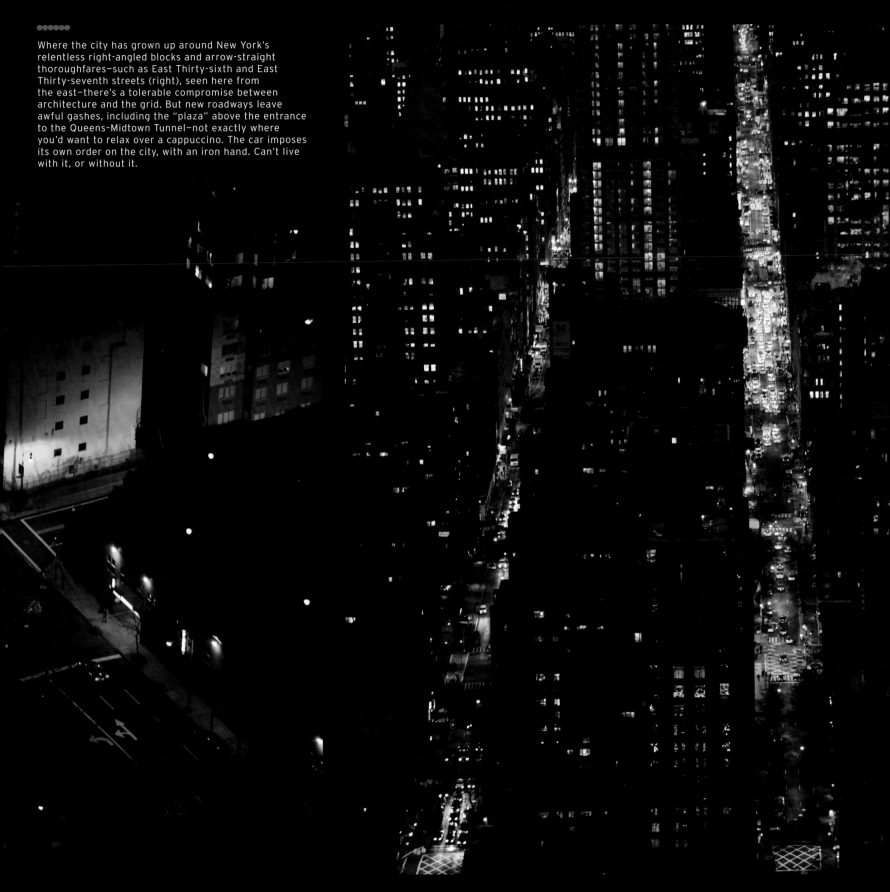

Where the city has grown up around New York's relentless right-angled blocks and arrow-straight thoroughfares—such as East Thirty-sixth and East Thirty-seventh streets (right), seen here from the east—there's a tolerable compromise between architecture and the grid. But new roadways leave awful gashes, including the "plaza" above the entrance to the Queens-Midtown Tunnel—not exactly where you'd want to relax over a cappuccino. The car imposes its own order on the city, with an iron hand. Can't live with it, or without it.

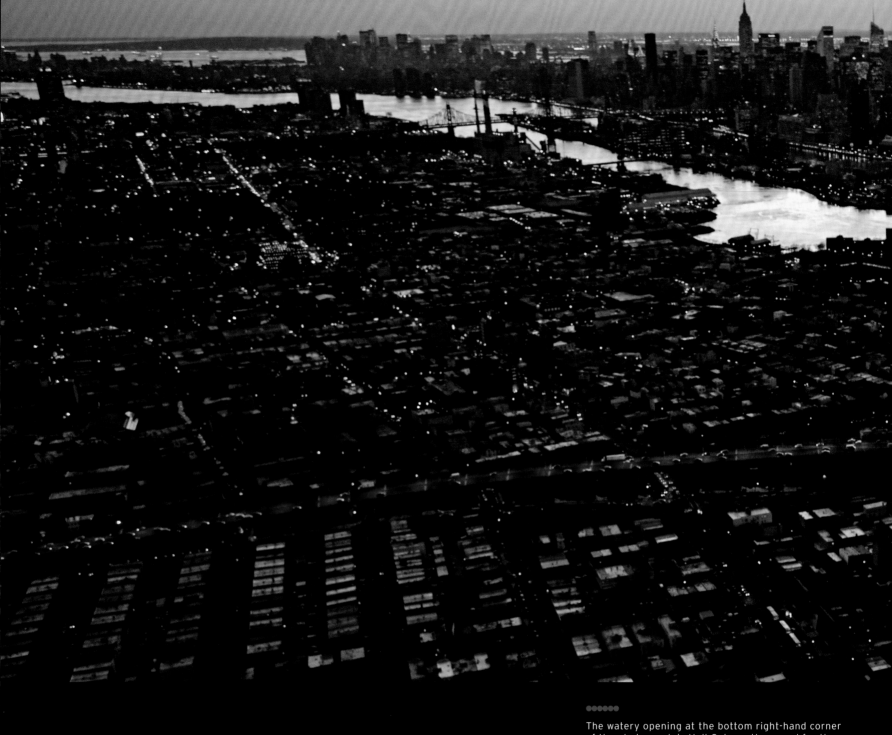

The watery opening at the bottom right-hand corner
of the photograph is Hell Gate, aptly named for the
violent currents that brought mariners to grief on
rocky, mid-channel shoals for several centuries. A giant
dynamite blast in 1885 improved things somewhat, but
the strong tides at the confluence of three waterways—
East River, Harlem River, and inner Long Island Sound—
still make it a difficult passage. Jet skiers love it, while
tugboat captains with a barge or two in tow take a
different view. Occasionally, a flotilla of red, yellow, and
green pencils swings into view: some intrepid kayakers.

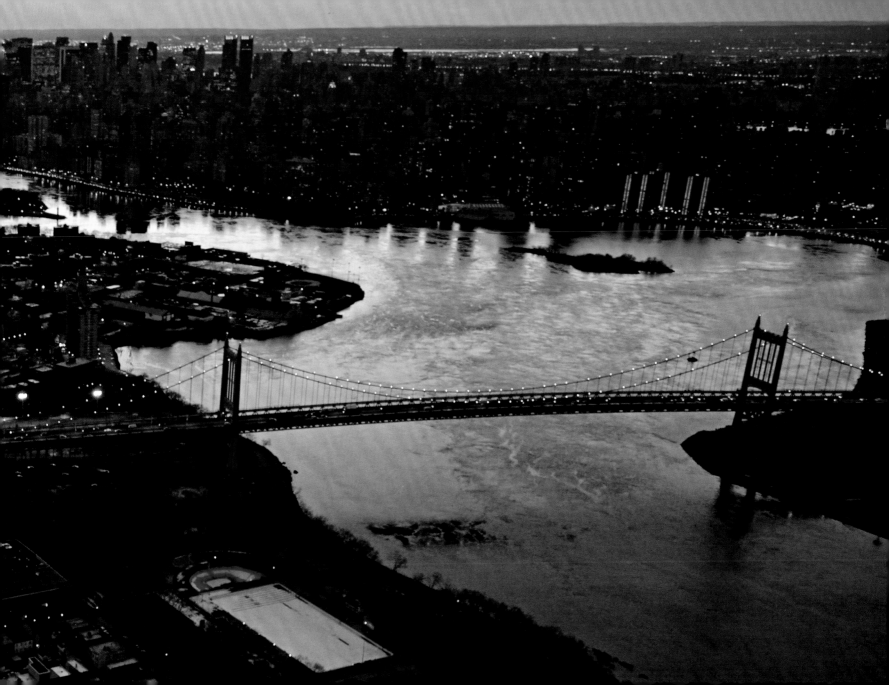

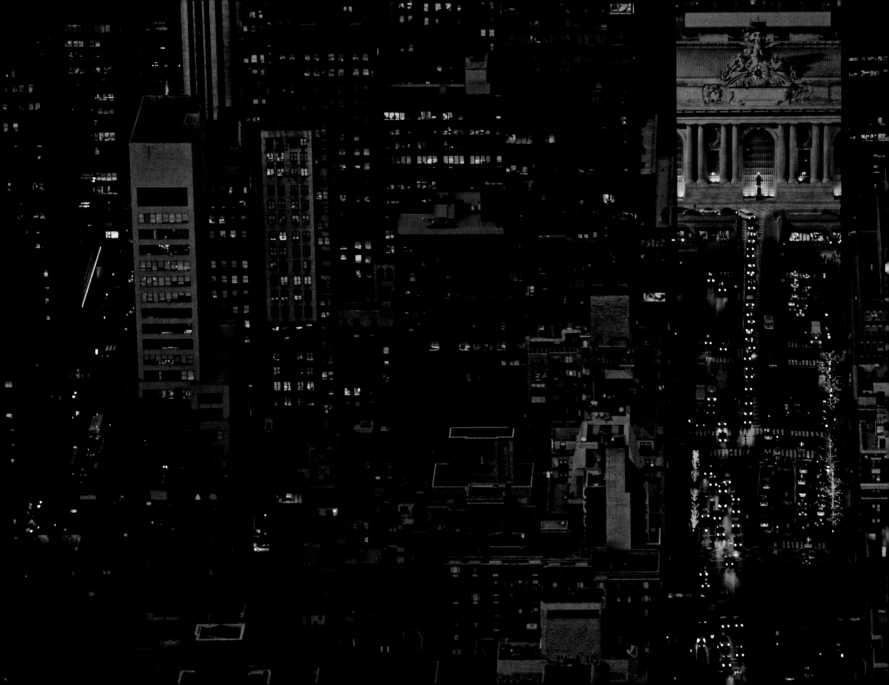

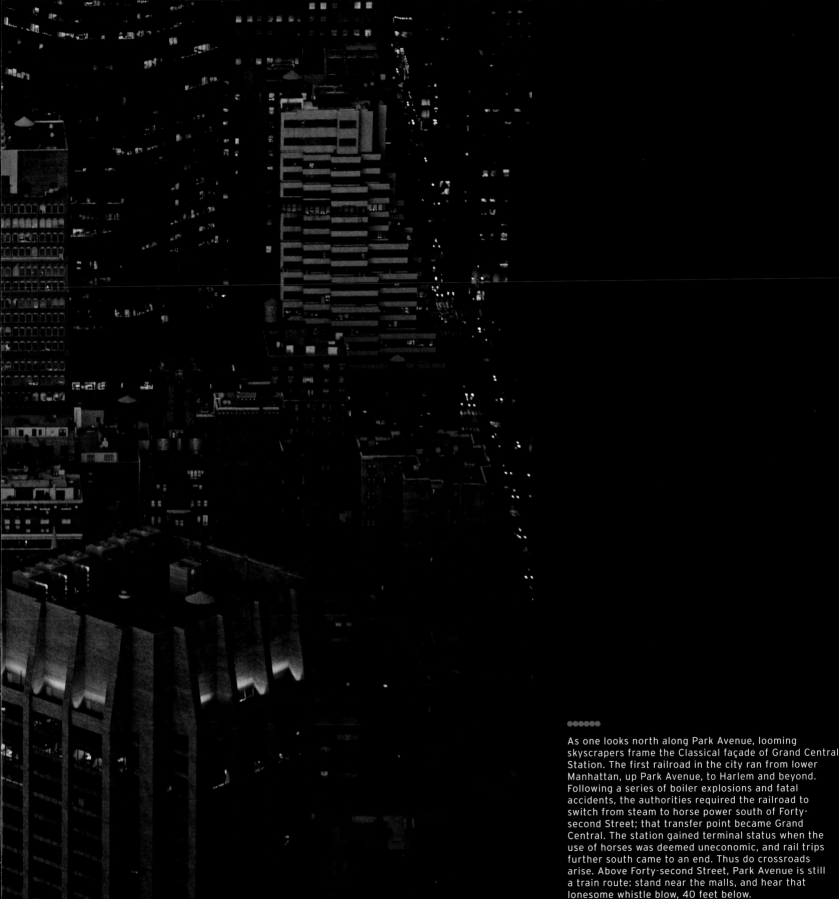

As one looks north along Park Avenue, looming
skyscrapers frame the Classical façade of Grand Central
Station. The first railroad in the city ran from lower
Manhattan, up Park Avenue, to Harlem and beyond.
Following a series of boiler explosions and fatal
accidents, the authorities required the railroad to
switch from steam to horse power south of Forty-
second Street; that transfer point became Grand
Central. The station gained terminal status when the
use of horses was deemed uneconomic, and rail trips
further south came to an end. Thus do crossroads
arise. Above Forty-second Street, Park Avenue is still
a train route: stand near the malls, and hear that
lonesome whistle blow, 40 feet below.

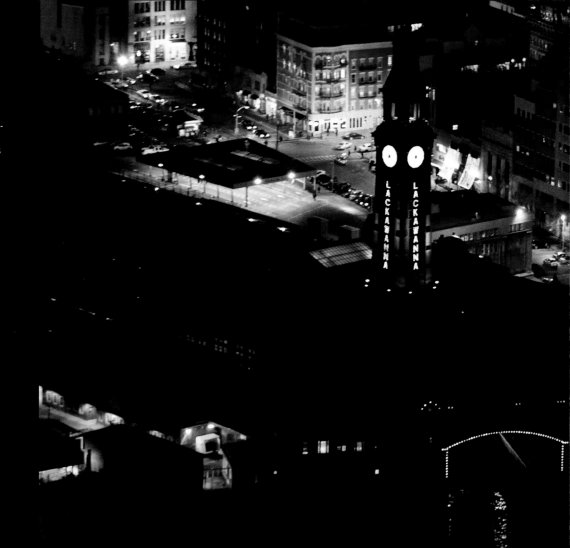

It's inconceivable now, but before the rail tunnels under the Hudson River, incoming passengers had to disembark on Jersey-side terminals and take ferries across the water to Manhattan. Sounds like an unimaginable inconvenience? Think of the one-hour-plus commute to Kennedy or Newark airports. The Erie-Lackawanna Ferry Terminal in Hoboken, New Jersey, was completed in 1907. After decades of neglect, it was brought back to life a few years ago, with a new tower and distinctive lighting. The copper cladding is now covered by the delicious verdigris of U.S. currency.

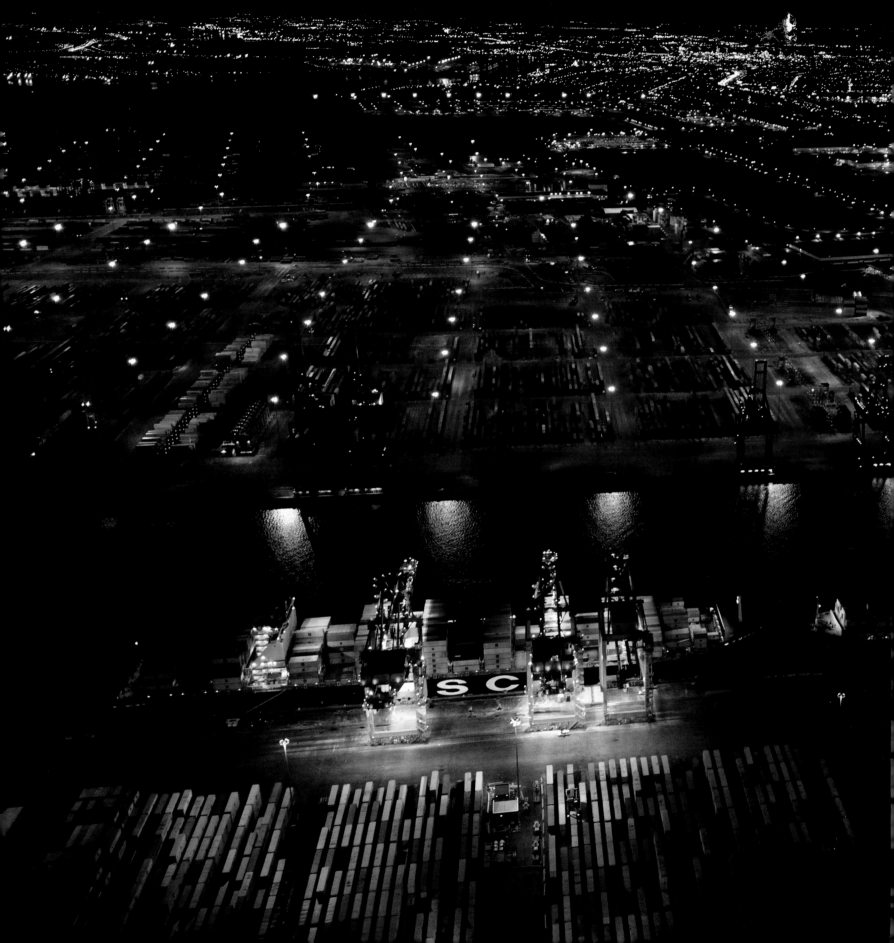

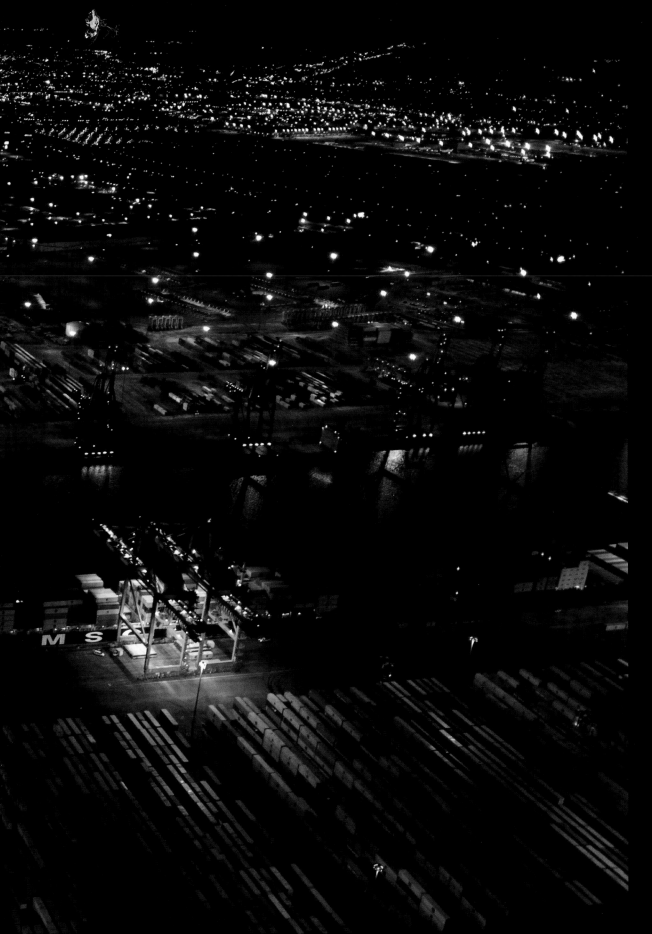

Although the quaysides of Brooklyn and Manhattan are essentially devoid of cargo, the New Jersey docks—including Port Newark, shown here—are thriving. This side of the Hudson River has one of the most active cargo operations in the United States, with miles and miles of imported cars, containers, and giant cranes. If Marlon Brando were playing Terry Malloy today, he'd be tahking Joisey instedda Brooklyn.

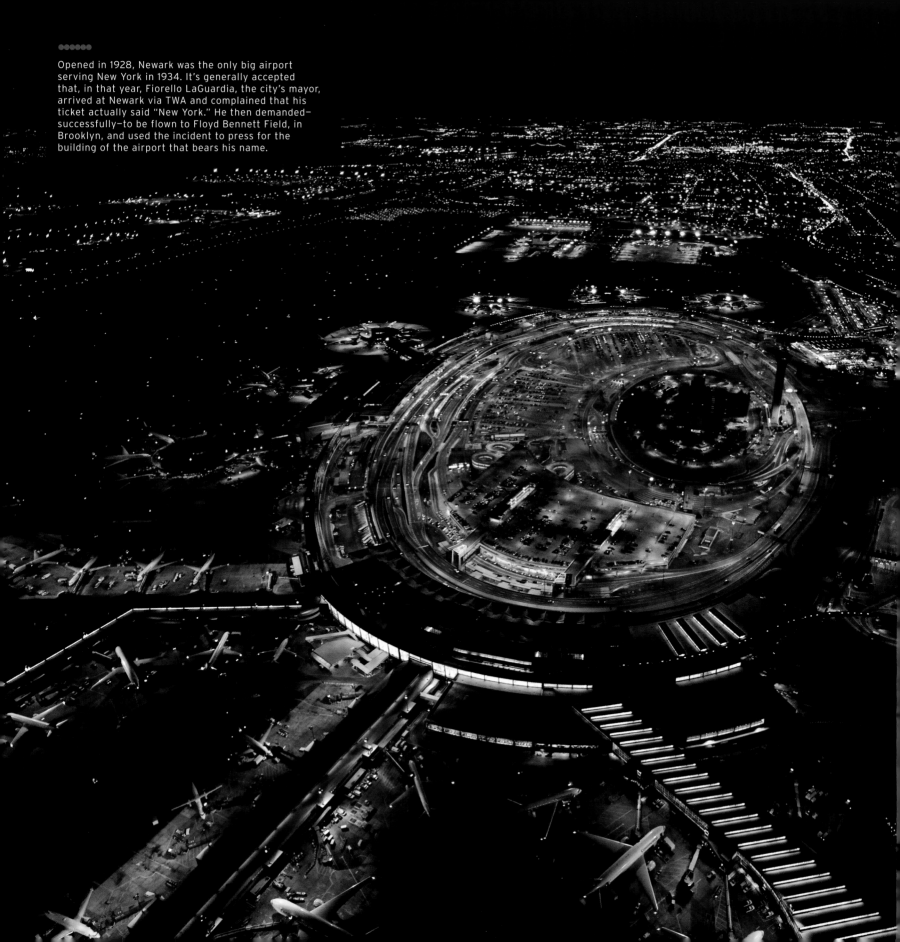

Opened in 1928, Newark was the only big airport serving New York in 1934. It's generally accepted that, in that year, Fiorello LaGuardia, the city's mayor, arrived at Newark via TWA and complained that his ticket actually said "New York." He then demanded—successfully—to be flown to Floyd Bennett Field, in Brooklyn, and used the incident to press for the building of the airport that bears his name.

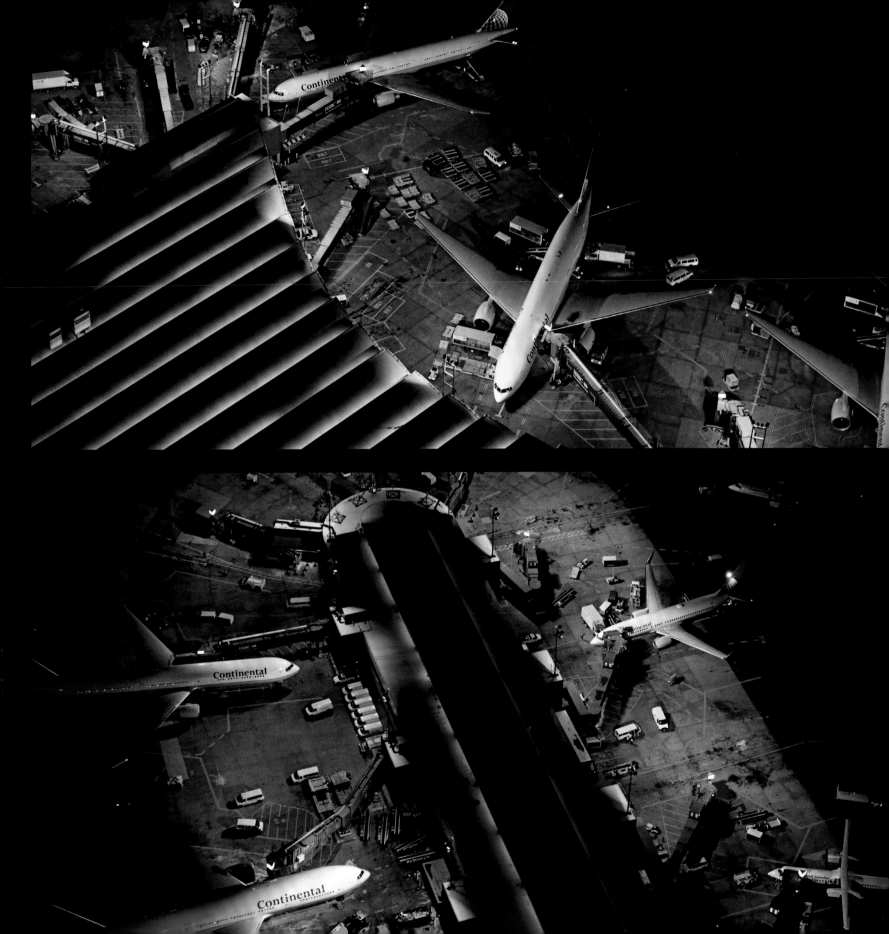

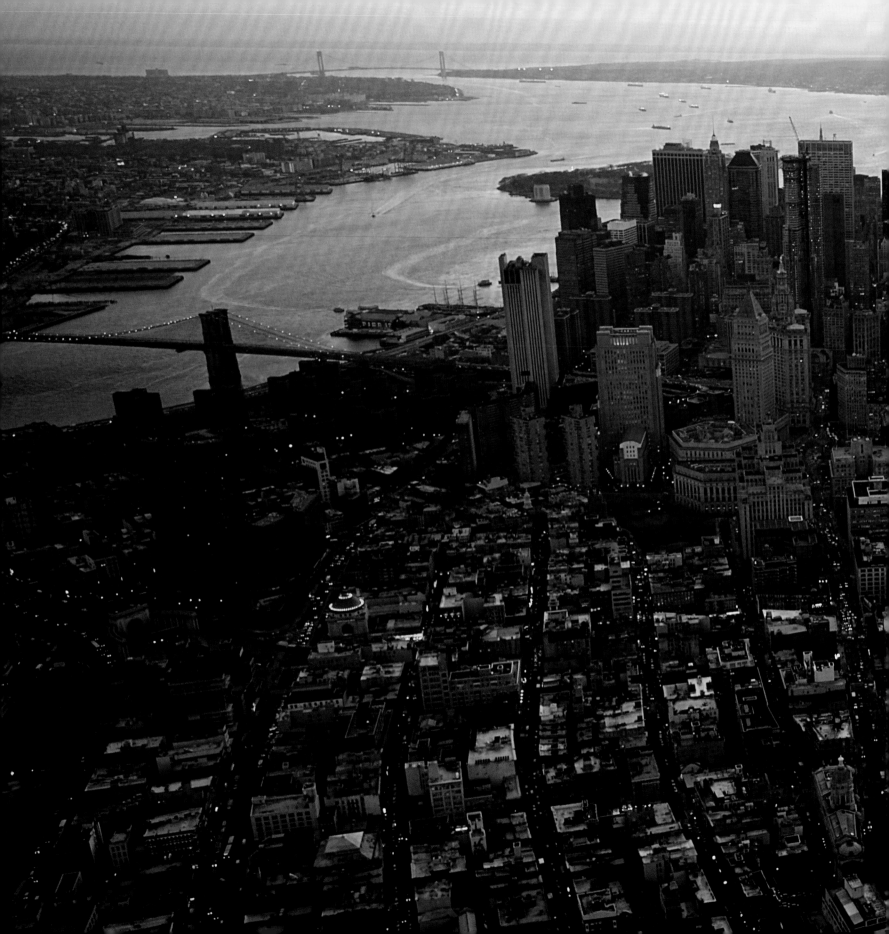

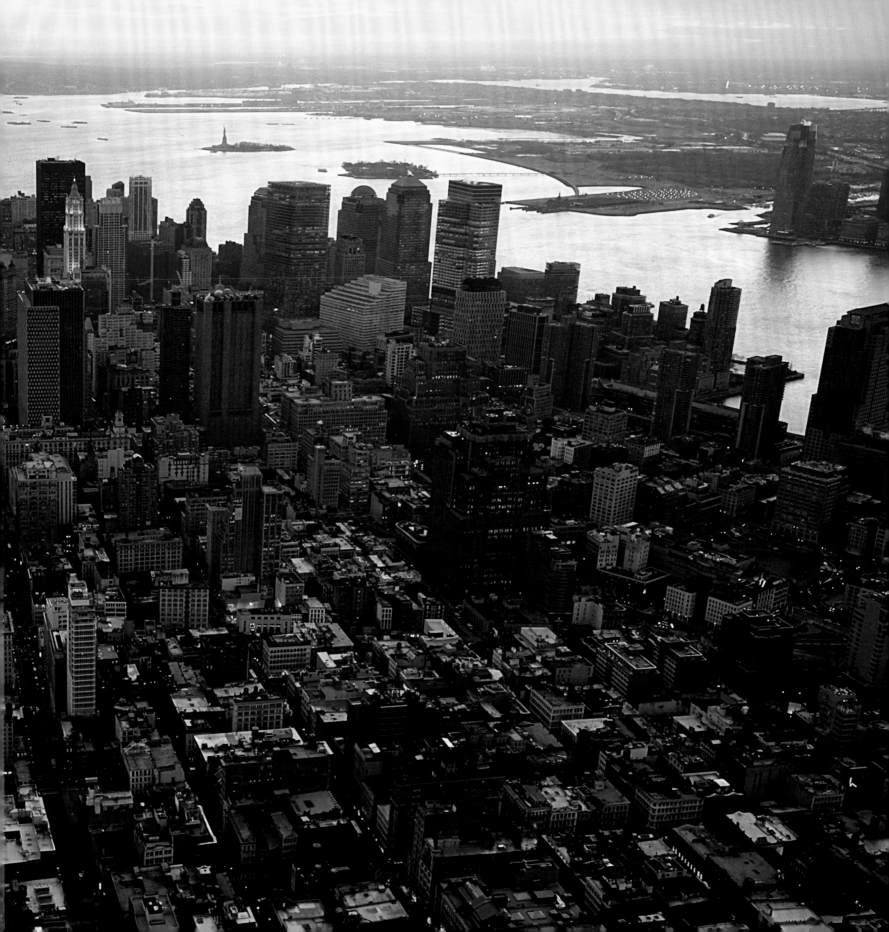

THE PHOTOGRAPHER'S VIEWPOINT

I've worked as an aerial photographer since 1991; in fact, I started only six months after leaving art college, following a brief stint assisting studio photographers in Covent Garden, London.

I tend to sit in (or occasionally hang from) the helicopter, having removed the door, which is roughly twice the size of an average car door. I am harnessed to a hard point in the helicopter, and wear a headset in order to talk to and direct the pilot. I sometimes also tether the camera to a MacBook laptop and a GPS. Given a decent pilot and an interesting location, it's not difficult to shoot some great images. The only real problem is the comparatively short time frame available. Flying in New York, for instance, in a Eurocopter AS355 (known as the TwinStar in the United States) costs around $1800 an hour, and that includes the time required to get into position. Offshore, it can be even more expensive: I remember one job in Norway where we burned through $15,000 of expenses in no time at all, flying Super Pumas (the Eurocopter AS332).

I've flown thousands of hours all over the world, and started shooting night images ten years ago, on film. The results were adequate, but by no means great. To overcome the vibration of the helicopter I normally use a very high shutter speed, with the lowest ISO (sensitivity of film or digital sensor) I can get away with. At night, this doesn't apply, and it took me many hours of testing different combinations of mounts, cameras (now, of course, digital), and processing software to achieve good results.

Various mounts are available: some sit on the floor of the helicopter, and some need to be held. They stabilize the camera, and allow the user to create sharp images even at very slow shutter speeds. They're very cumbersome and slow to work with, but can produce excellent pictures.

Over the years, I've shot with pretty much every make of camera there is, but now I use only Nikon (D3S, D3, and D3X). They're beautifully made and a real pleasure to work with. Digital

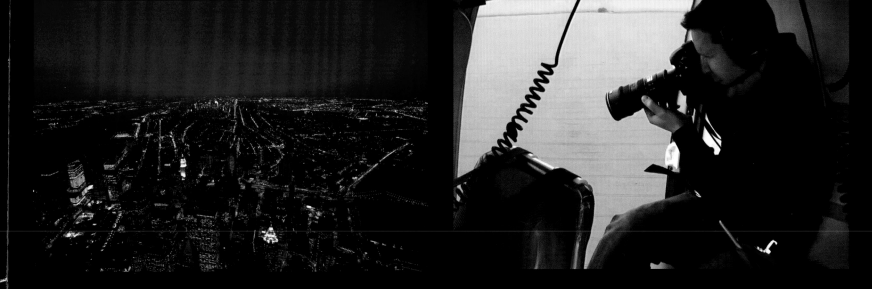

cameras have a four-year product cycle, and halfway through that period manufacturers bring out a slightly updated version of the current professional model. While it's difficult to keep up with the constant stream of new camera bodies and the very latest software/firmware, it would be impossible to produce photographs like those in this book without them. The D3S, for example, has a remarkable low-light capability; using it in conjunction with Adobe Photoshop Lightroom creates the perfect digitial workflow.

Working digitally has changed photographers' lives forever. It takes a while to put together a good workflow, which will include captioning the photographs within the image's metadata, tweaking the white balance of the raw files, and making sure everything is backed up at least three times. I use various RAID drives and then Archival Gold DVDs and Blu-ray disks.

My one fear with digital files is that they may become unreadable in time. Recently, someone showed me amazing prints of his mother as a young girl, when she lived in our house. They were taken in 1933, but the quality was stunning, with great detail, and I was thrilled to see some of the history of our house. These days, there are various schools of thought about which file format to back up with—JPEG, raw, Adobe DNG—but who knows if any will be readable in another hundred years?

Jason Hawkes
May 2010

First published 2010 by

Merrell Publishers Limited
81 Southwark Street
London SE1 0HX

merrellpublishers.com

Pages 158–59 and all illustrations copyright © 2010 Jason Hawkes
Text, design, and layout copyright © 2010 Merrell Publishers Limited

All rights reserved. No part of this publication may be reproduced, stored
in a retrieval system, or transmitted, in any form or by any means, electronic,
mechanical, photocopying, recording, or otherwise, without the prior written
permission of the publisher.

A catalogue record for this book is available from the Library of Congress.

British Library Cataloguing-in-Publication data:
Hawkes, Jason.
New York at night.
1. New York (N.Y.) – Aerial views. 2. New York (N.Y.) – Pictorial works.
3. Night photography – New York (State) – New York.
I. Title II. Gray, Christopher, 1950–
917.4'71'00222-dc22

ISBN 978-1-8589-4529-3

Produced by Merrell Publishers Limited
Designed by Alexandre Coco
Original design concept by Paul Arnot
Project-managed by Mark Ralph

Printed and bound in China

Maps throughout indicate the position of key landmarks featured in this book.
Each map shows Manhattan Island at the center, flanked by various parts of both
New Jersey and the boroughs of New York City.

Jacket, front: Chrysler and Empire State buildings (page 99).
Jacket, back (left to right, from top): New Yorker Hotel (page 51); Columbus Circle
(pages 72–73); Pier 40 (pages 30–31); Brooklyn Bridge (pages 138–39); Statue
of Liberty (pages 134–35, 137); Guggenheim Pavilion, Mount Sinai Medical Center
(pages 84–85); Times Square (pages 52–55); Chrysler Building (pages 92–95);
Manhattan-side approach to Brooklyn Bridge (pages 140–41); Guggenheim
Museum (pages 78–79); Pier 11/Wall Street ferry terminal (pages 32–33); Newark
Airport (pages 154–55); Staten Island Ferry (page 136); New York Life Insurance
Building (pages 110–11).
Frontispiece: Empire State Building and midtown Manhattan, looking north
(pages 98–99).
Pages 6–7: Chrysler Building (as above).
Pages 156–57: downtown Manhattan, looking south.